Photographs Christopher Felver

Foreword Simon J. Ortiz
Introduction Linda Hogan

TENDING THE FIRE

Native Voices & Portraits

University of New Mexico Press :: Albuquerque

Tending the Fire is dedicated to Floyd "Red Crow" Westerman and Charlie Hill

It is an honor to be writing here among you my brothers and sisters. The weaved blanket of poetry is a vast and mysterious landscape. I am reminded of those of you who represent voices and peoples who have no voice. I offer solidarity and peace from my tsistsistas people to you. It is for you and your peoples that I offer this hopeful yet guarded message. And for the poets living in exile, in prisons, in places so void of hope that only the ancient sun and moon and rivers become their bread and sustenance. Around Mother Earth poetry has appeared as a way to make sense of the world. As witness, as participant. The many varied and dynamic tribal voices in our world connect us as one indigenous family. The uses of our discipline are varied. To defend our people, all people, the animals and plants that sustain our lives, and ceremonies remains our primary responsibility. To your spiritual and intellectual capacities and potential promises for poetry that frames the purpose of your lives. I salute you. America is becoming a dangerous wasteland. Today the pariahs and "other" are many times the poets whose deepened dedication to the symbology of the other life where birds, sky, river shores, and fishes transform primordial timelessness into the everyday world. We must remind our people of the greatness from which we are descended. The many shadow relatives that dwell with us, leaning into our souls as we write. Whispering to us that when the soul sings, it sings poetry.

Mahagodomiutz, hetomitoneo
Tsistsistas
Walking badger, dog soldier
Cheyenne
Lance Henson
February 29, 2016

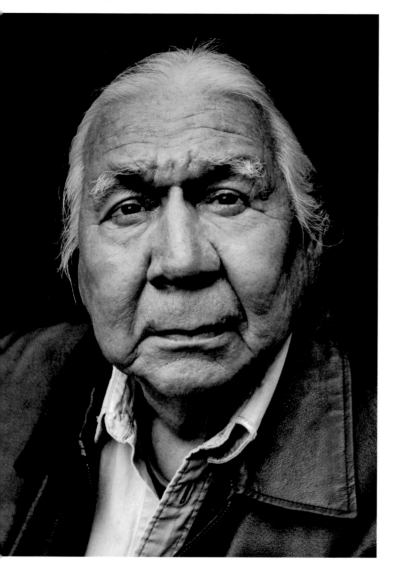

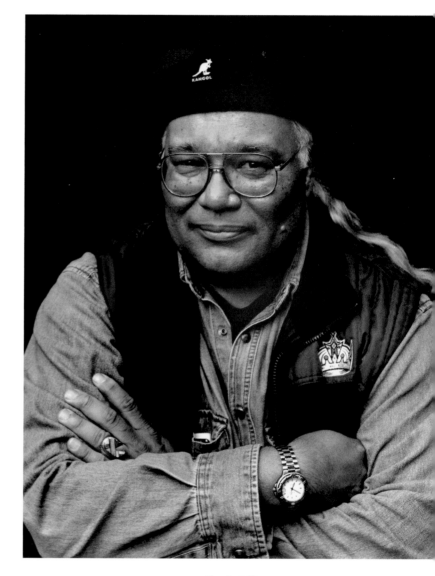

Floyd "Red Crow" Westerman
1936–2007

Charlie Hill
1951–2013

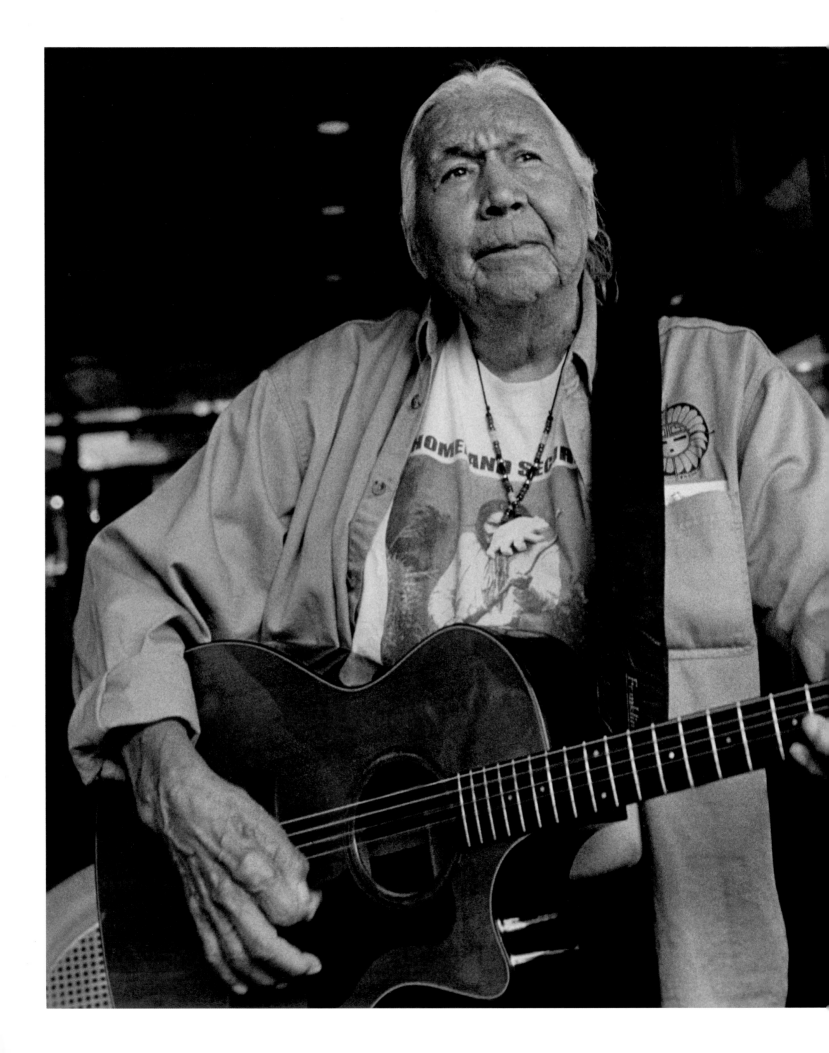

CONTENTS

FOREWORD: *Communication*

Poetry is poetry. Stories are stories. *Dzeh-nee' dzah. Ooopeh-tahnee-dzah.* Language is language. Stories are stories.

Language is speaking with voice, mouth, body motions, and other gestures with hands, head, shoulders, eyes. We speak because we want to communicate. To talk is to talk. We communicate in order to communicate. As human beings who are animate beings, we want to communicate with others, and with what is around us. Our desire is to communicate.

Therefore, everything we do and say with our voices, mouths, body movements, and gestures, including interactions with others, is poetry and story. It's called communication. And we argue too; you should hear us argue. It doesn't really matter what about: we're right, and they're wrong! Well, we're right, sorta. And they're wrong, not sorta but wrong! That kind of argument. You know what I mean.

All for the sake of communication. And what? Pontification? Well, yeah, that too. Pontification galore! Who? I'm not going to say. I'm sure you know who I mean, though. Best or worst pontificator in the world! Used to be called "Preacher" in junior high.

Okay, now that we've got the official stuff or stance out of the way, let's get to the *real*, poetry and stories. Chris Felver asked me to write a few words as introduction to *Tending the Fire*, a book, as I understood Chris's explanation, that would feature photographs of indigenous authors, leaders, personalities, performers, storytellers, poets, elders, and so forth, and their "jottings." By jottings I mean instantaneous or spontaneous writings that they happen to do or might do on occasion. Like I did when Chris and I were talking at my condo in Tempe last year and that now I can't remember a single word of.

And so that has been the case for *Tending the Fire*, a beautiful, touching, dynamic, courageous, and very humanistic, heartfelt book that is spontaneous in the way personal moments are. As I looked through the photos and jottings—some poems too, good ones too!—I came across old friends and acquaintances (I've been around more than a few years) and some writers/poets I didn't know but will come to know in person soon I hope. And I had to chuckle, smile, giggle too, and laugh with pleasure more than a time or two. *So this is where the poetry and stories come from*, I thought to myself. *Ehmee daistuh tsee shrah hanoh tyaimeeshee kah-dzehne and kowpehtaahneeshi tse daishtuu-koomuhstuh.* This is where our people's language and stories arise from.

So let's meet some of the people and hear their

words, although, as I said earlier, I do not know some of them, like Alice Crow. Alice says something so crucial it makes perfect sense: "Write for the People." Yes, we must always do so. My beloved mother who passed on years ago advised me likewise when I was in my twenties with that perfect sense: to write for the people always. Thank you for the reminder, Alice. And hello or *guwaadze* to Allison Hedge Coke, who's been busy since the day I met her at the Institute of American Indian Arts (IAIA) in 1992 and has only grown busier! Accompanying her beautiful black-and-white photo is a poem, "Harp Strings," with the line "sweet rain on old growth." Story. Poem. More like stories and poems galore when Allison is around. Sounds like Allison, doesn't it? Always hoping for the best, like me who's been saying since June, "Think and act positive; think and act positive, it works." *Aaaaaie.* It does though, right?

And there's Arigon Starr with her big guitar right alongside a comic strip she's done. Another busy, gifted woman who I met at an indigenous cartoon convention in Phoenix two or three years ago. Hi and guwaadze, sister. And talk about a "think and act positive" person, here's one for you—Andrew Jolivétte and his poem "We Remain" and its beginning lines: "No time shall pass / No secret shall remain / No night shall pass / No day shall begin." And Barbara Robidoux, I do not know you, but your eye is memorable and we shall eventually meet. Your name does remind me of a late pal, Bob Robideau. Remember how he and Dino B. were tried and acquitted years ago for the charge

that Leonard is still serving time for? Poems and stories. Names, places, times as they were then, and times as they still are. Some things change. But some things don't and get worse, too.

And here's Bruce King. Hey, how are you, guy? Long time no see. What's this? "Talisman—Sing a New Set of Blues." A poem or a song? Haven't done blues with you for a while. Back a while ago. Years gom and blues we go, ennit. I like that line of yours, though: "Physical touch—the embodiment of prayer." And Cecil Taylor is here. "Soul of Man is of Circular Form." No shit, man, say that again and again! Don't ever ask—once nor twice—Cecil to break down a piece of music and put it back together again. He does it all on the piano for hours! And right beside Cecil, no one else but the late Charlie Hill, beloved always. We miss you, we all do; you're still Charlie and always will be. Still giving you that incisive eye. You know what I mean. And then here's Chip Livingston, who I saw recently in Santa Fe with a new book. I've gotta tell him—I will eventually—to write some hard, serious writing. I know that beach-boy stuff is cool but you're no longer in the islands, guy. America is fucked up to the hilt, as we all know, so write, write, write to the edge. I see you have something called "A Proposal" with a line or two: "I am a young man, Fire. / You are a young man, Wood. / I will go with you. On the air."

And there's Dennis Banks too. What? Or who again? December 9, 1995, his post is: "Well Chris, / I'm no Angel / Nor Anarchist! / But I am part Eagle, part Elk, part Oak, part Water / Some Fire inside."

Sounds like Dennis. Stories. Stories. True. Mostly. Edgy and on the edge. And sometimes you don't know. On poetry this time. Sounds too good to be true. But true. Mostly. *Aaaiiee*. Stories are stories. True and true ones too. As well as the others. Our belief is strong, though. Unbreakable. Close though, we've been. It would be good to see you again soon. Duane Big Eagle. Haven't seen you around lately; I've been avoiding California. Especially South of Market death and drug alleys. Years and years ago that was. Bad and dark history and talk about the edge. What's that line about and where does it go? "I pull the shirt off over my head."

And here and there is my old friend—yeah, the years add up, they do—Elizabeth Cook-Lynn in a beautiful black-and-white portrait. Of her back then and *the now* as it was then. I can't read your scribbles just like you can't read mine. In fact, I can't read my own sometimes. But I think I make these out, "It makes me wonder, why write?" And, "It's just a story." Yes, our stories, our language, our communication. Always, and more alwayses than we can count.

And last but obviously not the last because there are so many more photos of authors, singers, performers, artists, and so many more poems and stories and songs in *Tending the Fire*, here is

Floyd "Red Crow" Westerman. Old pal. Brother. Friend. Talk about stories and times and the always moments. You sang better than Johnny Cash, don't worry about it. But who really knows, if anyone does.

I miss Floyd "Red Crow" Westerman and how he was so happy to sing again after his organ replacement surgery. I'll forever remember that time I was in Santa Fe walking on Washington Avenue, and I heard someone shouting loudly, "Simon, Simon, up here!" And I looked up, and it was Floyd on a balcony of the building across the street! "Come up here," he hollered. I did and it was so good to see him, and, after hugging him, the first thing I said was, "You sound so good, like new." And he said happily and loudly, "Yeah, my new lungs work and sound real good, better than Johnny Cash." Chris F. happened to be there, and if memory is correct that was the last time either of us saw Floyd. Story, Floyd was. Stories, we are. Poetry, we are too, always. Poetry and stories, you better believe it.

Simon J. Ortiz, Regents Professor of American
 Indian Studies and English
Tempe, Arizona

INTRODUCTION

Flower Song

The most alluring moon
has risen over the forest;
it is going to burn
suspended in the center
of the sky to lighten
all the earth, all the woods,
shining its light on all.

—Ah Bahm (1400–1472), Maya, early 1400s

The creation of fire is a skill passed down from our indigenous ancestors long ago. From every part of our North American continent, the first people knew which materials quickly caught fire. With the rapid spin of one stick of wood against another or with stones hit together, a spark began the first glow as it ignited slivers of kindling, cattail, or dried yucca. With those first embers a fire in its full force might be created.

So it is with our words, also carried from the original fires of different expression. As poetry, story, or song, they each hold their own spark of life. Whether it be ancient memory, history, or new music, the words of each writer collected here are part of an uncommon connection between old and new, and an important form of literature. Native literature may hold to traditional tribal poetics or erupt from current political resistance.

It may grow into a song of deep love or one of grief and loss. With this backbone collection of writing, the indigenous writers of North America spin the straw of our ancestral past into the firelight that illumines our continued presence here.

The handwritten pages here are in addition to the established literature of older writings. Many re-create the passion of love or the retelling of a history that continues to dwell in the present. The words speak the pain of solitude or the light and shadow of daily life. Whatever purpose or theme of the writing, each of the pages evinces a territory different from that of non-Indian writers; our home environment, the people from which we descend, or the kinds of thought created by different language systems and knowledge of our environment, whether reservation or urban, or mountain, desert, or ice.

The writers in this book are powerful in their ability to reveal any and all aspects of their lives.

Literature, like fire, has important uses in our lives. Some forms of fire were used to keep grasslands cleared for the buffalo, elk, and deer to graze. Traditional fire tenders know how to maintain cool fires that burn just enough to allow for tall grasses or reeds for basketry. They care for the fires that create conditions that allow for medicines to grow. Whether contemporary or traditional, the woven baskets hold what is necessary for the people: water, food, or next year's seed. And writing is truly a seed of the future. It is a contained medicine. The seeds of healing are words in the many shapes our writing may take by the writers in this book, *Tending the Fire*. These writers describe, define, and respond to a quickly changing world of flooding, drought, uncontrolled fire, and storms of record strength.

Our words, in all their variety of form and combination, will be here for a long time, and the shape of the poems, stories, and other prose are rapidly changing as new generations of writers rise up with new ideas and thoughts, the often new experimental poetics traced on the pages like shadow play. The work still retains humor, as well as historical truth-telling.

Even those who have been writing the longest have been informed by the newest writing, the unique shape words take in response to our changing milieu. We find and use infinite ways of telling and speaking, innovative imagery, sounds,

fresh dreams; stories and poetry that fit the times in which we live.

We come from long historical traditions of writers and tellers, those who understand and recall the magic of language in its ceremonial form, stories that enchanted the listeners, songs or chants that included all aspects of the ecosystem, the community, and even the constellations. All this from generations past. In this way, writing puts us in our place. It grounds us in our world, our homeland, past events arriving in the present. This is a magic that can't be accomplished in any other way than through language.

We are unique in that we have countless distinctions from other American writers. For one thing, with all indigenous writing, there is no separation between the history and the political events that have affected tribes, even the recent events continuing into the present. Considering our literature, we bear in mind that we each come from a nation unlike any other, just as Italy, Germany, and France are greatly differing independent European nations. These distinctions are the foundation of Native contemporary literature whether that is the focus of the work or not. Nevertheless, we remain nations of people within another nation and under a different legal system than European countries. This fact of our historical ground is the foundation of First Nations writing. It applies to us whether

we live on the reservation, in cities, or have been removed, relocated, or returned to our people after an absence.

We are also individual nations in our own geographic locations, with the food sources from that environment, a particular ecosystem, and our ways of knowing. Each writer sees the world first through a tribal lens, knowing this distinct history. In addition, each life is also experienced through the spark of one human being's own heart, spirit, and personal experience. No matter our tribal history, our original matrix is whose fire and drumbeat we continue to dance around. It affects our poetry, fiction, and other writing. Arguments may be made for new and experimental use of letters and space, and these, too, are present along with the conventional distinctions strongly maintained.

Words. Breath. Air. Our life through the element of air enters us at birth. Our words are like that first wind, whirled into existence on currents that express histories and forms of new creative testimony. Some carry the impact of beauty. Equally, other airflows address the impact of historical trauma. But mostly, like the seeds that need fire to open with stories and poems that hold inside them all future possibilities, so much has already been kept alive by this breath of words and the significant history we have had with them.

As wind or fire travels, there is no defined literary map that reveals the cartography of indigenous writings. The voices of fine writers across the continent are heard and read most often in Indian country, and often moving into the larger America that sees the past, and our presence, as a problematic memory or a painful middle world, without noticing the traditional ecosystem knowledge in the works, the knowledge held in the many languages, and the richness of community rarely known or seen.

Just as with traditional prayers in a sweat lodge, words are carried with smoke up toward a sky of different constellations from the Greek, different knowledge of plants, a remembered life of this planet, and dark matter known since before Western science.

Now, the most recent focus of research and information is on intergenerational trauma and history passed on to younger generations. This is also revealed in some of the new work of Native writers, because post-traumatic stress is a serious problem in Native life. Still, it is a topic mostly considered by scholars and researchers, including sociologists and psychologists, and even current DNA researchers.

Written responses to domination have given us a language of resistance. Of late, this has included the great outcry of California and other indigenous nations against the canonization of torturer and killer Father Junipero Serra, whose history of violence toward California indigenous peoples has long been remembered. Writing that remembers this history of cruelty, starvation, and slavery rides alongside writing that is committed to violence done to the life that sustains us, the environment of

other species, and to the intelligent and living Earth itself, a truth known and carried in our knowledge systems since the beginning of our being here.

From whatever tribal hearts we derive, Native writers assure us we are keeping the fire of our own that runs in our veins.

The words of the present indigenous writers are only a few among large numbers of the many brilliant writers and thinkers not presented in this collection in all their luminous presence. All the works will continue to impact the future. Our writers bind us to our "prehistories," our past and present, laughter, tears, and joy, and most of all, our tomorrows. This is true already in just the small collection of work contained inside the covers of this book.

Three generations of writers fill this anthology of photographic images by photographer Chris Felver. This book includes two art forms and is a unique testimony to where we are today. Each black-and-white photo is accompanied by a handwritten work across from the writer's image. The photo is one keen art form with strong light and shadows from Felver's sharp, experienced eye. The handwritten page appears as a calligraphic image near the photograph.

In this collection, the fire of over ninety Native writers from the four corners of North America emerges. They come from different climates and "material cultures." The geographical locations and histories of these writers greatly differ.

This brings to mind the seven generations that the Haudenosaunee emphasize when they speak of both the past and the future. But our literatures go back more than seven generations. They go back millennia.

When I say millennia, most readers think of richly recalled oral traditions, but here I mean written literatures, those carved in wood, stone, writing on birch bark with quills or pine needles as well as many kinds of written materials.

Poetry, stories, and songs were not merely spoken many centuries ago, but also written. Sometimes, when we think of the oral, we think of that which has been passed from formal storytellers, ceremonialists, or others who held knowledge for many centuries before the invasions. On a casual note, we may even think of our large families sitting outside telling stories at night with fireflies and frogs, or indoors drinking hot coffee or swamp tea, listening while protected from winter cold. These oral stories are what our grandparents may have passed on, or even more recently, a single parent raising a family on bare wages, but still passing down the remembered stories.

However, very few consider that writing existed in many pre-Columbian times. We do not know the meanings of the Nazca Lines, or whether some rock art or carvings exist as forms of communication. There is some certainty about the California arborglyphs and the animal effigies concentrated near

midwestern waters. These are similar to the effigy mounds near the Mississippi waterways that are found from the Gulf all the way north into Canada.

No one can argue that these creations are not a language across the land, an expression of love to the cosmos, because with some, the shapes have been deciphered as matching particular astronomies, the cycle of the moon, mythologies, and are easily seen by the holy sky. Whatever their meaning, creations like the great pyramid Monks Mound and the seventy-foot-high eagle mound of Poverty Point in Louisiana were created with extremely advanced architecture. They survived the New Madrid earthquakes of 1811–1812 completely intact, an earthquake that caused the Mississippi to run back toward the North and also formed new lakes on the continent. The pyramids and many mounds remained undamaged for all these centuries from flooding and other natural disasters, while the Washington Monument cracked with a single earthquake. Only human devastation was the destruction of the Mississippian mound sites.

But thinking of writing, these are not the most distinct forms. Neither were human bodies tattooed of that same southeast region. Pictures of the tattoos were sketched and painted by the invaders, then the pictures returned to Europe for royalty to see the savage, nearly naked people of their new world. However, the people in this location lived with weather conditions that would have allowed for no other survivable form of writing. The climate destroyed wood and cloth. Nothing but the living body could carry a story, a life, or the sun, moon,

and stars tattooed across the heart with great precision and indigo dye. Of course, later scholars would have found many arguments against these tattoos as possible memoir.

Closer to scholars' preferences would be the complex Mi'maw and Anishinaabe scrolls of birch bark with writing punched in by porcupine quills or pine needles. This written language had at least 5,700 characters, or letters. Once understood by European missionaries, these creative "glyphs" were used to Christianize the people. This form became religious scriptures and the Lord's Prayer, although children were observed writing with it in the 1600s. Except for the large number of letters, this writing form is not so different from the origins of the English alphabet.

In Alaska, the Yupik had long ago created their own form of writing and literature. The Cree in Canada had, and continue to have, a distinct alphabet. These existed long before the Europeans arrived. As with the others, their forms of writing were transformed into Christian scripture.

When considering the many forms in which our literature have appeared through the millennia, we need to include wampum beads as a visual form of writing used to write and read rituals, forms of correspondence, and numerous other forms, including the treaties made with Americans, and how this form is strongly connected to the spoken word. One of particular interest is the two-row, or two-path, wampum, which declares that the people would coexist in peace, but they are separate lines and not merged, declaring that the people will hold

to their own ways of being, their own traditional life, in spite of America's desire for sameness. Stories and long orations are part of wampum belt representation and these existed for uncountable generations, and some have to do with the laws and right relationships humans keep with the earth.

Perhaps I could even make a case for the southern paintings on hides of deer and buffalo that allowed for the recounting of events through time, at least as early as the 1500s, and those winter counts of the Northern Plains, opened to reveal to others the story of a single year of events and life retold by the elders, both men and women. In this case, they were reading the pictures. Numerous forms may have once been considered forms of storytelling and literature.

Centuries after European invasion, Sequoyah created a new Cherokee alphabet. It was distinct from the English and stories were passed along with the new publications soon created in the Cherokee language. The Creek, and soon other nations and groups, followed his example with newspapers.

Even so, it is still hard to omit the power of the spoken word from the great men and women orators who spoke words worthy of attention in more than two or three languages. Honest seers and truth tellers from all regions of the continent included Tecumseh, Red Cloud, Sitting Bull, Chief Joseph of the Nez Perce, Gertrude Simmons Bonnin, and Chief Seattle, who spoke a powerful form of literature that not only remains but is often repeated and quoted.

If all these many forms are not the tools of an ongoing Native literature, what would we call these stories and forms of poetry and witness? As John Mohawk says in *Thinking in Indian*, we still suffer from the long-enduring epidemics of earlier times and from being colonized. He also points out that some of us are academicians who have forgotten to speak for those we come from.

⊛

With this collection, we have those who are speaking. We are aware that writing is a method of decolonizing ourselves, and this is clear in the book we have in hand.

Each of the writers in this collection comes from a long ancestral line of original people who, in addition to passing along their creation stories and other traditional forms, have also told new stories, created poetry, and sang new songs. We all contain and hold together this history, the histories and culture(s) woven here, visualized, and still doing the work of healing despite the long dark times we walked out of as whole and strong beings.

Many centuries of fire travel through each writer, from those cool burns that kept invasive plants from overtaking the medicines and maintained the bear grass, sweetgrass, reeds, willow, and other materials we grew and helped endure through time.

This history of first fire, first growth, first people, the memories we carry and store within, the pain of history binds us together as people each with an important narrative to pass on.

Puente	Bridge
extiende	extend
los brazos	your arms
extiéndelos	extend them
que toquen	until your hands
tus manos	touch the edge
mi orilla	of my body
yo recorré	I will travel
tu cuerpo	across your body
como quien	like someone
cruza	who crosses
un puente	a bridge
y se salva	and saves himself

(from Ya Vas, Carnal, by Francisco X. Alarcón)

NATIVE VOICES
& PORTRAITS

Our art form is not often through the lens or focus of photography, but through the lens of imagination. In this manner, we write our resistance. Our genetic intelligence of what has happened in the past forces us beyond all the once-exhausted fatigue into speaking again about the changes in those earlier climates.

For many of us, it is a form of survival, justice, and transformation. We know that the survival of our environment is linked to our own. Our sisters and brothers in the North and the South are forced to move away from their homelands in the midst of environmental change, assault to the earth such as the tar sands, and violence by the money-people. At a time like this we know we must take the side of the earth for the survival of all. Our work, after all, is writing toward balance and harmony, as part of the life-force of the world.

It is sometimes startling to realize how many retain the original knowledge and how it appears to us once again when one woman writes about the almost forgotten mounds on the Great Plains, or when one man uses his nation's traditional ceremonial poetics, or an elder writes bilingual books in Creek and English.

Intelligent people of the past spoke many languages, knew the waterways, the trading paths along land, and were able to read the constellations.

Always there has been the question of forgetting the original knowledge or seeing it replaced by Euro-American ways of being and knowing. Interestingly, writers indigenous to this very earth and land are able to work in either form of knowledge and literature, or combined ones, as American writers who have more than one cultural identity move easily between these.

Who, other than indigenous writers, would have believed that arcane knowledge, a new and ancient poetics, and the telling of any story could be an event that has helped keep us from disappearing and allowed us to keep our people known in the strongest ways? It is a testament that we have not only resisted vanishing, but we have also documented the many attempts against it in our journals and books. The number of writers of our time is increasing, it seems, and more writers than ever before speak and write their own poetics, the true stories of reservation life, urban Indian life, the factual environment, stories of love, and now even the new speculative fiction of imagined realities and Native futurisms.

All our ways and memories are revived and revitalized in our words. Our history, along with the chaotic present, is here in full being. The writers represented in this collection are voices to remember, revelations of our time, voices that keep the tribal fires burning in countless ways. They are the fire of literary truth of the three generations contained inside the covers of this book.

These are singular pages from those who offer to American letters work that is brilliant and shining, and that in other countries might be considered masterpieces of their literature.

Linda Hogan
Idledale, Colorado, 2015

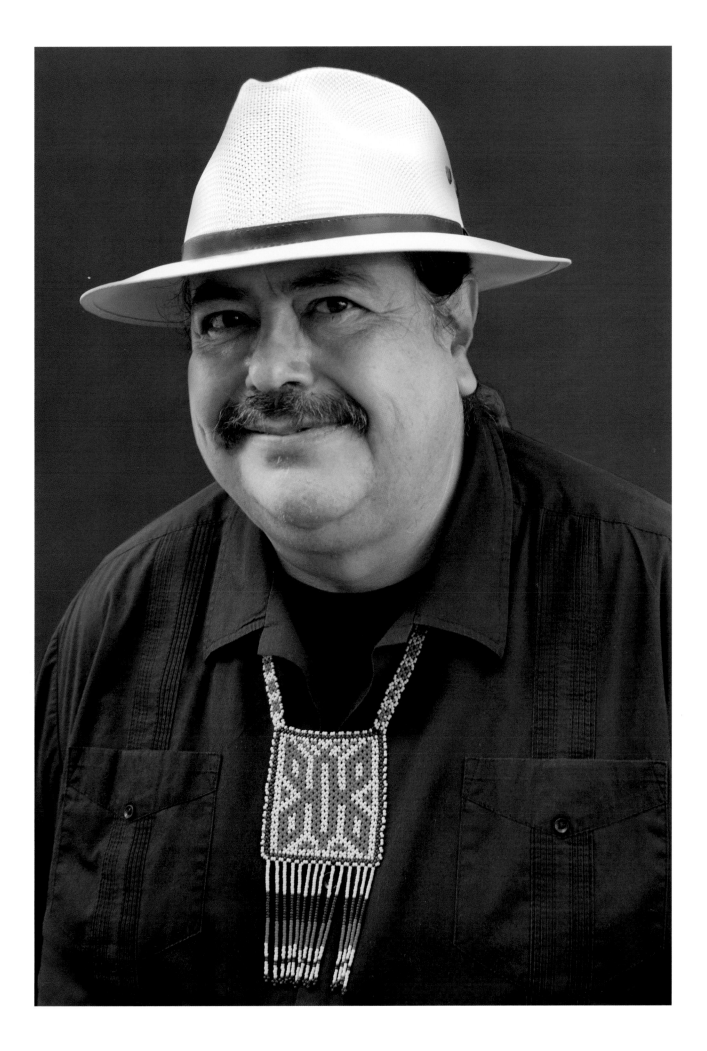

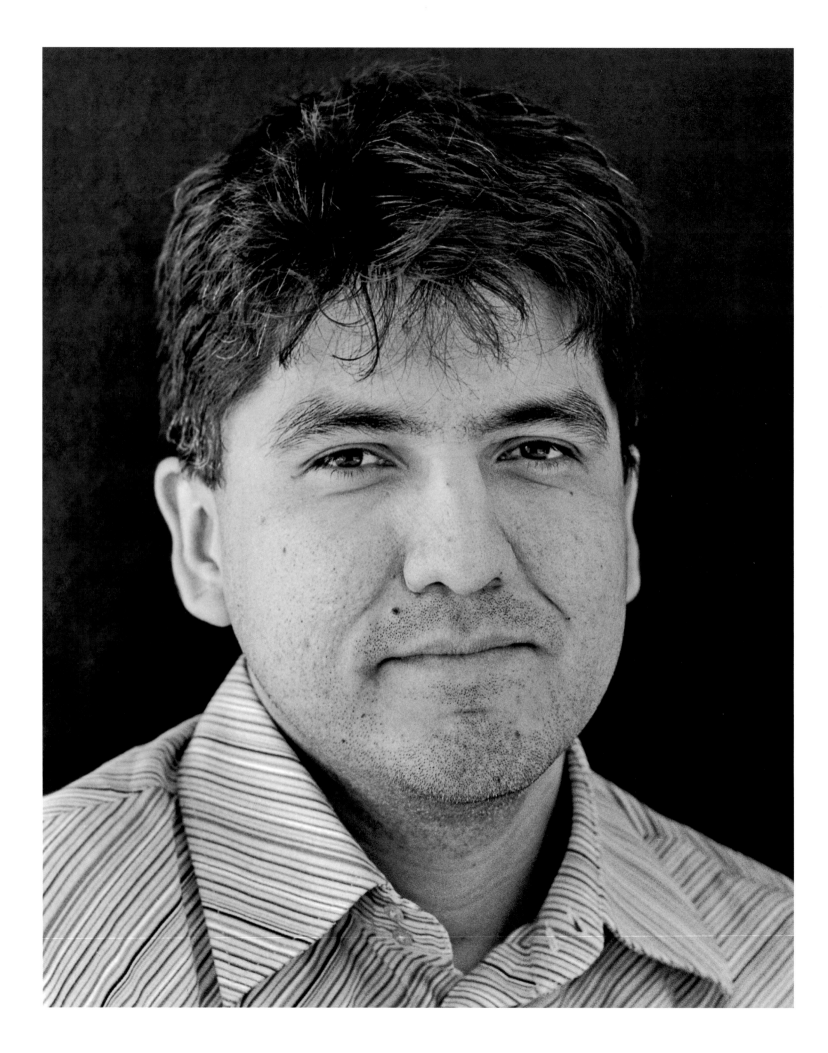

The basketball court where
I learned to play is no longer there.
Weeds and roots and water
Have replaced my father
And my father's jump shot.

When I was six, he taught
Me a rolling hook
That I, a glacial-moving crook,
Still use to score
Over players who are more

Graceful. How strange to know
That I am as old—
No, older—than my father was
When he last beat me
One-on-one.

It wasn't fun
To scoop
That winning shot through the hoop
And sing my victory song.
My father has been gone

For eleven years.
But I have inherited his dark
Vision: Look! That city park
With its abandoned courts and baskets
is a ceremnoy of caskets.

And there's my father! Look at him!
He is a ghost as rusted as those forgotten rims.
If you want to be a good son or daughter,

Or a good teammate or father,
then you gotta pass the rock
And talk, talk (tell your loved ones you love them) and talk.

New Corn

In the old time
a seed was planted
when man was sleeping
so I could grow up over his heart
as an ear of corn
Selu
the first woman

but new corn cannot remember
my origin story
it stands in sterile rows
with no relations
stalks thick enough
to twist the helix
into impostors for husking

new corn cannot tell
how once
the two-legged
children descending
with silk & pollen
in their mouths
crushed milk
from my kernels
to make prayer
tremble tassel gold.

— Indira Allegra —

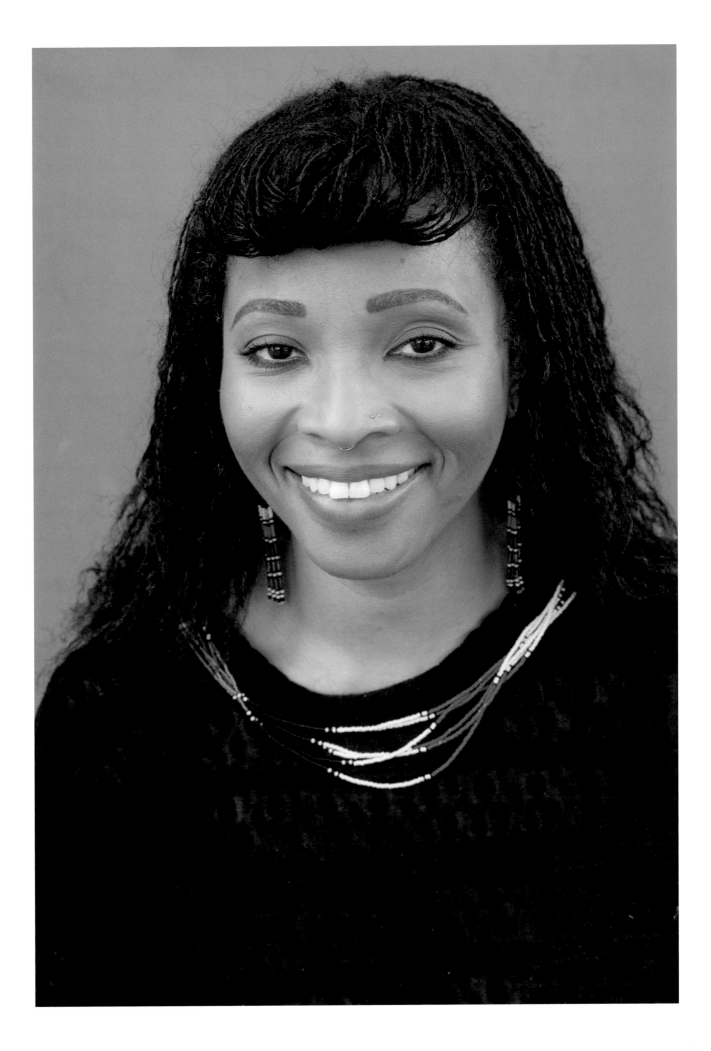

Journal 12·10·74

Unity of design
 elements - pieces put together into coherent whole

 distortion & so coherent alive
 comes about by changing angles of line as well as
 pieces of space & their colors

 and if the design is perfect (mine's not) the
 total color area of each kind will appear
 to interlock with others so page looks
 life 4 moving colors carving out own places
 & all together (equal force & weight) a

 social drawing — democratic vista & all that

 color #3 has least sense of wholeness on
 my plate
 #2 is best from this standpoint
 the black space is too fragmented

 white is tripartite & not very interesting
 seen wholistically
 but it is good because it moves & moves
 like a forming star
 & the white at the top left corner interlocks
 perfectly with grey - grey & black to make
 very interesting formation (geo)

Paula Gunn Allen

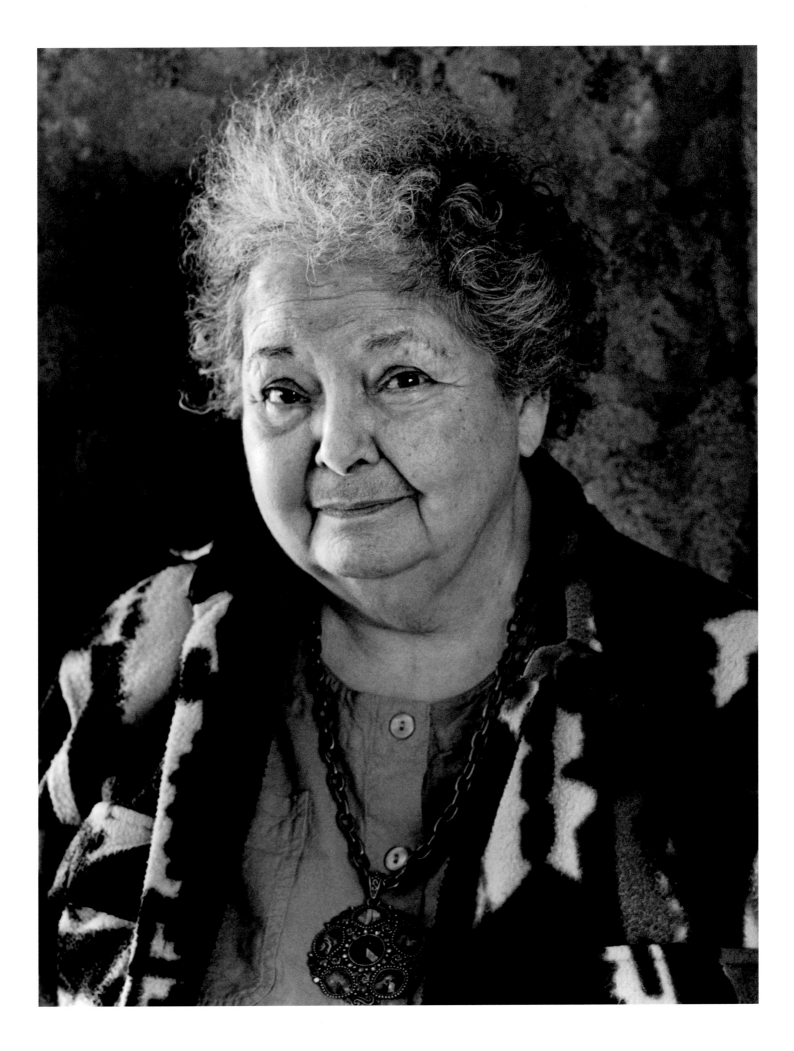

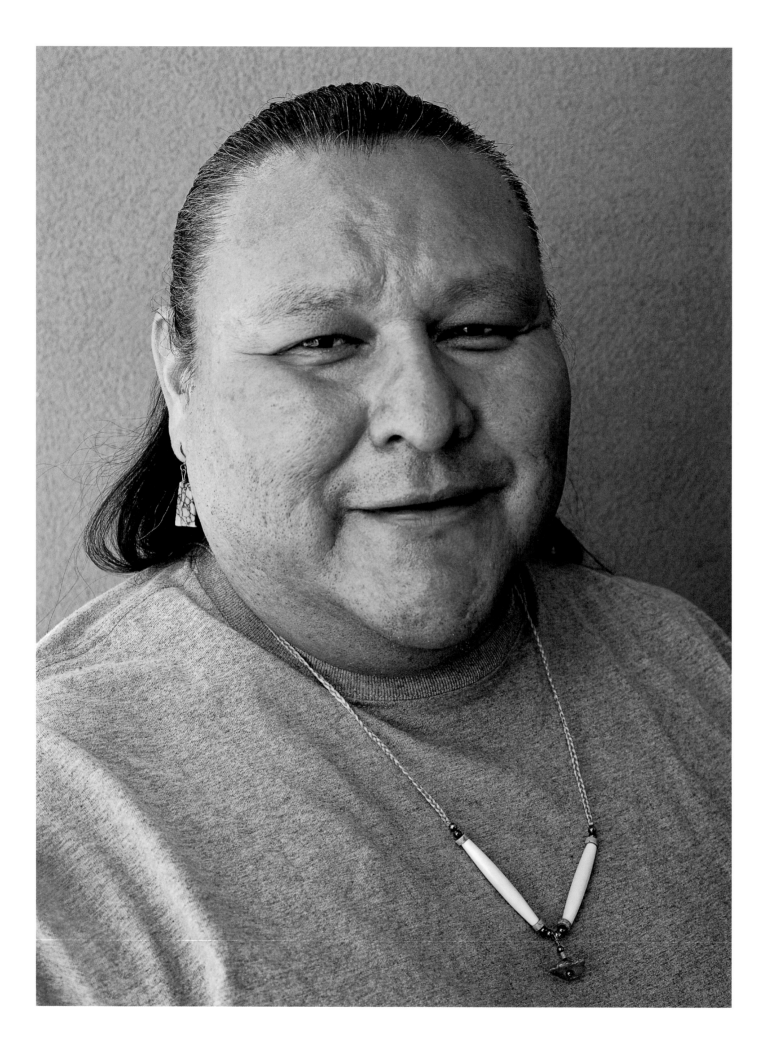

> Once again a full moon
> positions itself between
> the Earth and Sun
> absorbing all the glory of
> his rays, emulating.
>
> Satellites launch for the
> first time into Earth's
> orbit and on lunar
> capsule plunge into the
> sea.
> Life emerges, guulí
> [birth].
>
> August 01, 1971, 00:00 to
> August 07, 1971, 24:00 UTC

emergent emanation from birth, like a cosset lamb
placed inside a shoebox, no constitution of place
towards ts'át / ts'áál, cradleboard
towards gugha / hooghan home
towards Ndé bikeya / Diné bekeyah homelands
towards Nndéhizne / Diné bizaad Language
life aquisition of identity toward x
oppugn to mesal gathers, burnt wood gathers, sheep harvesters
after salt is extinct, towering house topple.
a return to origin, beginning, center fire, home
 Whirling

daancest'agu [everything ripens]

ix: nineteen seventy-one

 daa 'ikt'idá 'ádaajindi

Crisosto Apache —from, 'Whirling'

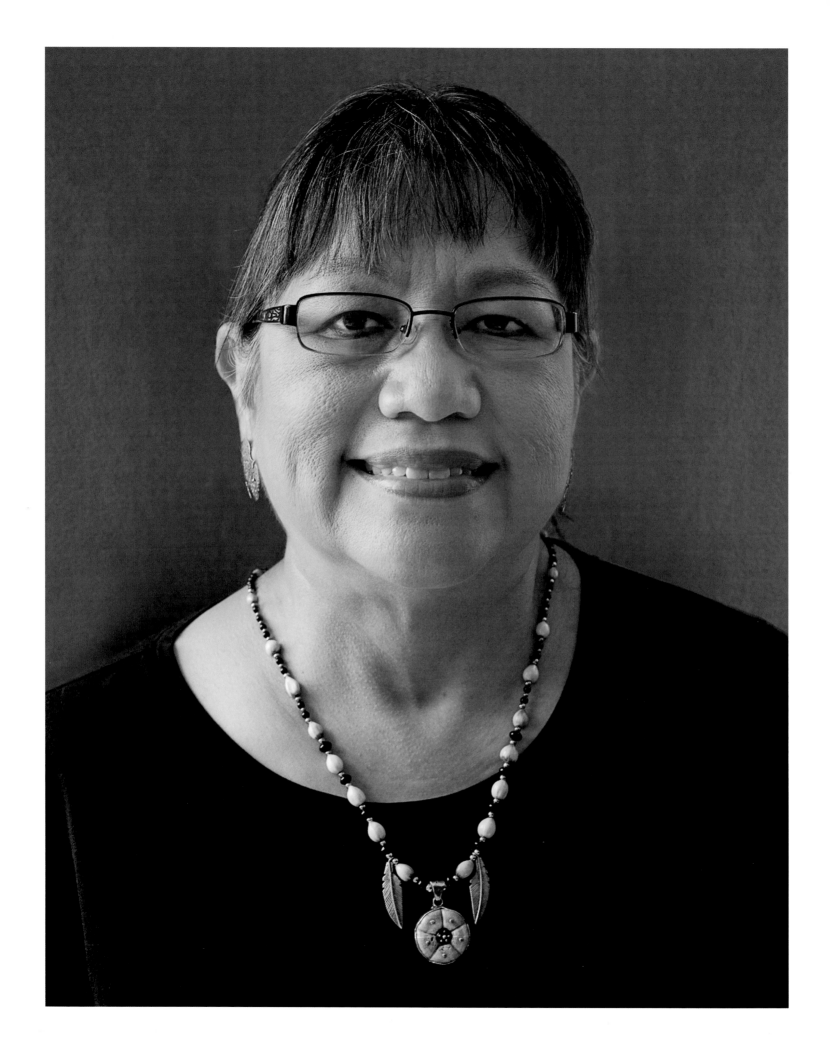

Writing Ceremony

Whirlpool birth

 warm voices
 deep
 from dawn
 shaped by blue

desert mesquite
cattail pools
gulf lifts horizon

tobacco offerings bundle between
 tradition and capture
 summer and fall
 school and life

weave and comb
 tangled dreams
 classroom myths
 spill empty

clinched fists
 braid gentle words
 that shake
 swing
 fly

Annette Arkeketa

Just A day Nov-13-15

Starts in the semi dark -
 in bed
thinking I shouldn't fall asleep
with the radio on -
 all about ufo's
aliens in my dream
 gesturing me

come come come with us

 and I think, communicating
 telepathically
 never invite a poet
unless you want
 to light up the cosmos
 hear stories about village life
 share wine, break bread
 and dance.
If you're looking for anything else but love
 gotta invite someone else -

Jimmy Santiago Baca

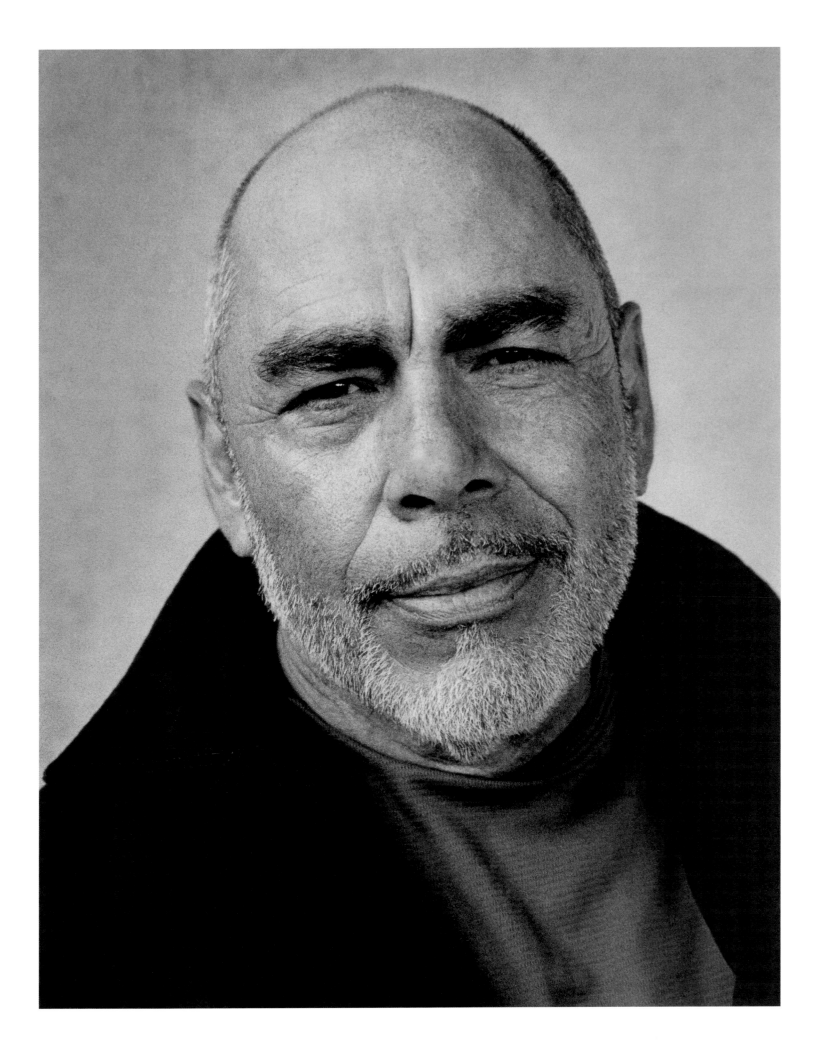

Dec 9 '95
IN CALIFORNIA

WELL CHRIS,
I'M NO ANGEL.
NOR ANARCHIST!
BUT I AM PART EAGLE, PART ELK
PART OAK, PART WATER, PART SOIL
PART AIR.
SOME FIRE INSIDE.
MY EYES SEE FAR BEYOND THIS
UNIVERSE, BUT CANNOT SEE WHY PAIN
WAS INTRODUCED TO BE AMONGST US.
I'M NO ANGEL
NOR ANARCHIST
I AM ANISHINABE FULFILLING THE
DUTIES OF BEING PART OF THE
GREAT SPIRIT. THATS ALL I AM.
 NOWA-CUMIG Dennis Banks

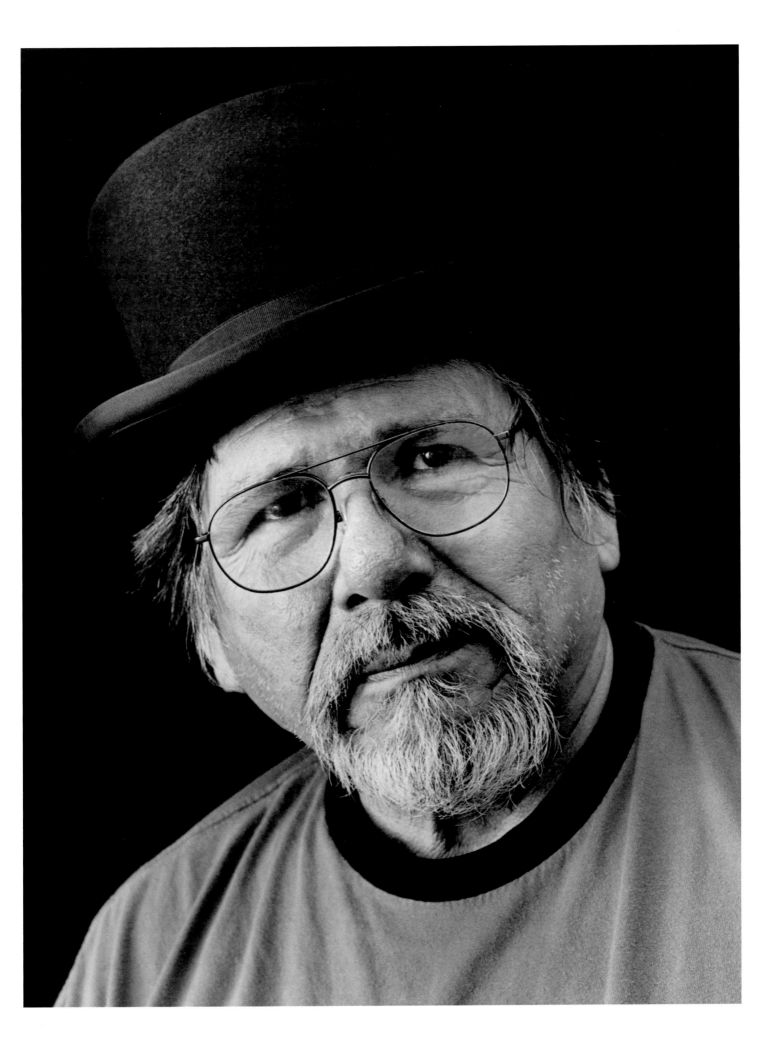

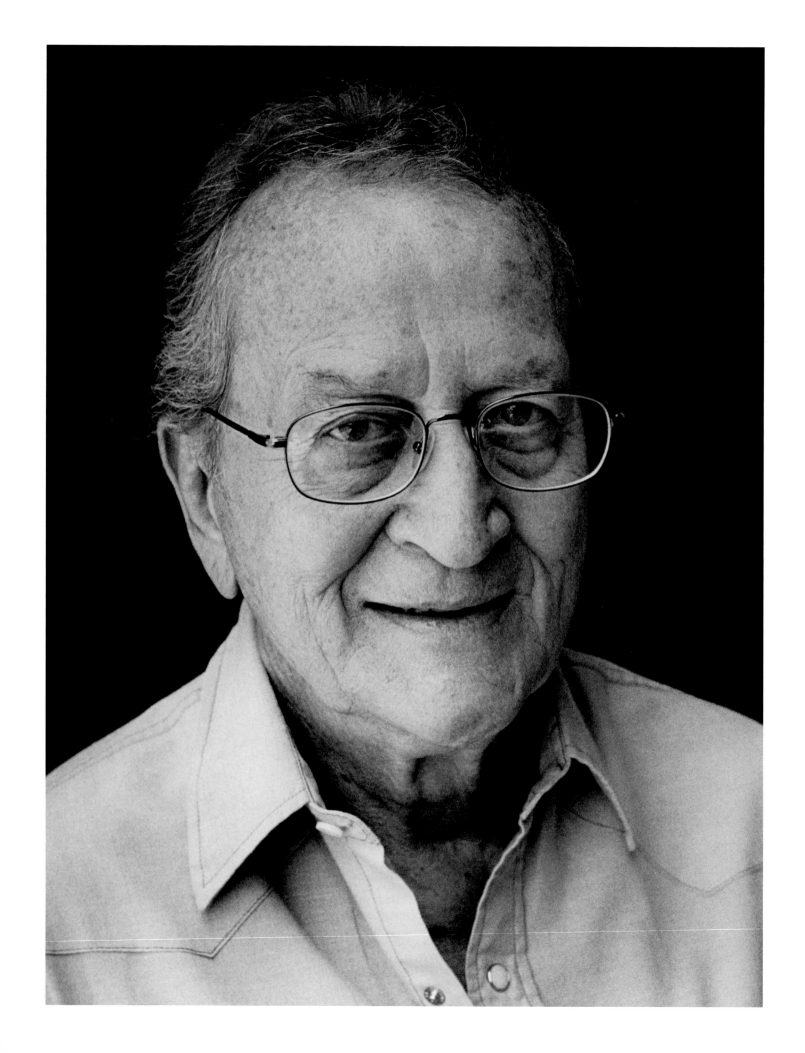

AFTER the GREAT Plains

Nothing remains the same in this long land.
Bird fox, gully, grass, all are history
as soon as the moon rises or the wind climbs,
tales told by shadows leaning toward a vista
few eyes discern.

What strikes the windshield hardest as you drive
across is haze, distance claiming being
as absolute as the grasshoppers crushed on
the glass. There is no sameness to a land
that paints itself

different each dawn. The wind in your hair
today becomes a mouse's breath four states
beyond tomorrow. The river you ford could not
be any river. Particular, it flows through
the heart of the land.

After the great plains you are not the same.
No matter which way you cross something stays
firmly with you, a sense hard to name, like
a pebble in the toe of your boot you can't shake
out in this life.

Jim Barnes

...Some words lost on the Trail
have been found
They lived hidden in baskets,
in pockets, in the very tassels of corn
(Selu, Selu)

Now the words live again
See? When I say nogwo it is 'now',
both the now of then and the now
of not yet...

(from "Language Class")

Kimberly L. Becker

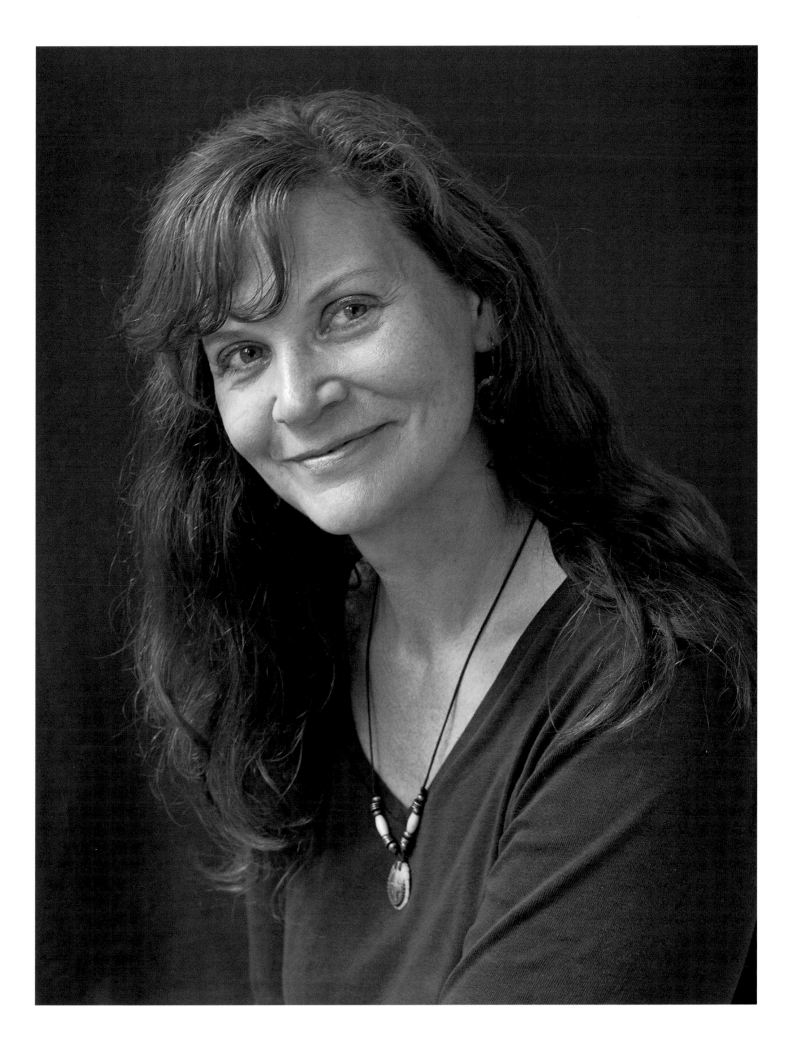

Pull

I pull the shirt off over my head,
pull the covers up,
pull feathers from my fingers,
circles of smoke from my eyes.
I pull dawn from sleep, generosity
from the last bell of my strength.
I shake debt out of my shoe.
I lean back and loosen
the rope from around my neck,
from around my feet
splashing down shallow creek beds,
from around the spirits
flying back to their home in the sky.
I unbutton the top button
of the store house of linen,
the hiding place of all night dancing,
the pathway of necessity and tenderness.
I open the back door of summer night
sip turquoise light
from the leading edge of storm,
and pull long black hair
in writhing strands from the wind.
I pull names from silence
a strong heart from laughter,
and dreams from the nubs on raw buckskin.
I pull Native Nations and the good Red Road
from the spirits of the People
dancing and singing around me.
I grab time from the hands of the clock,
bend it into a hoop,
and give this moment back
to the pure, bare, original day.
 – Duane Big Eagle

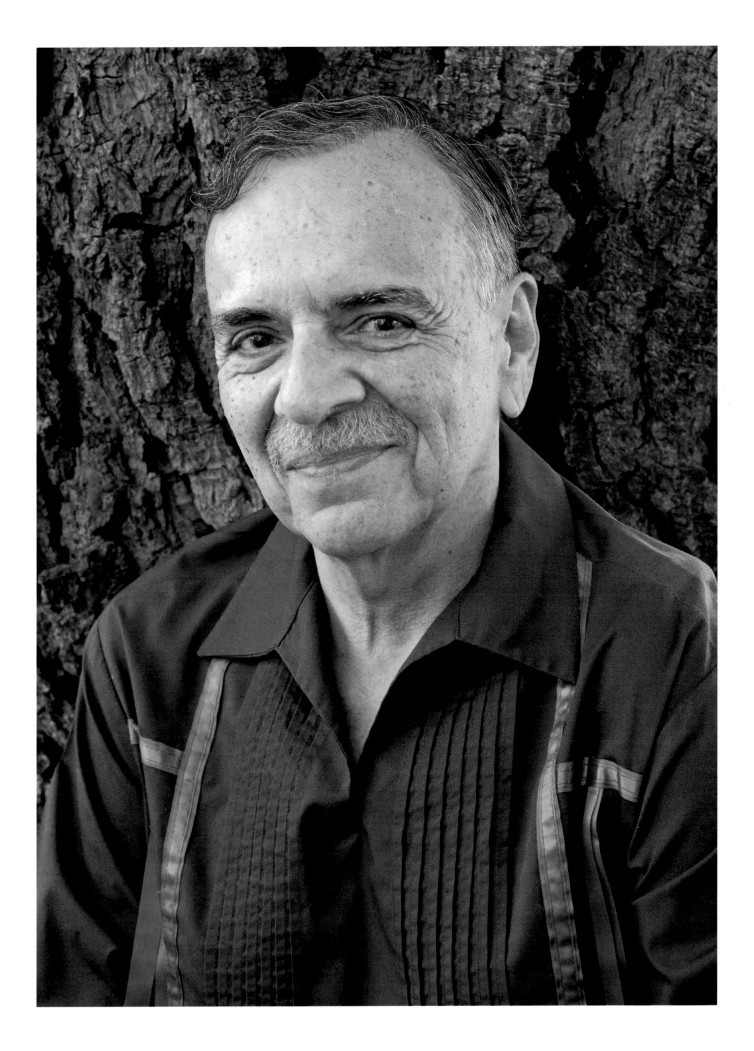

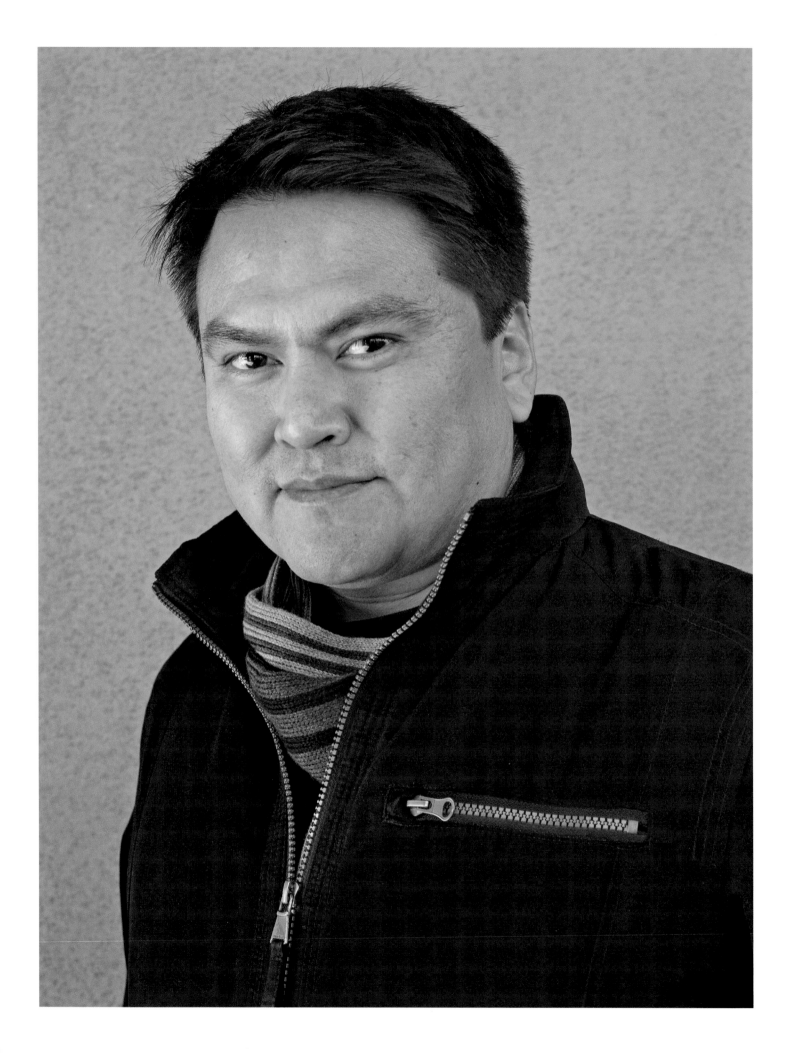

Dissolve

How the map must look
when black water is ladled
 from white water,

when it is your face
 that ripples silver,
not mule deer skipping
 across the creek's forgetting.

How it might be then,
 to look through silicone eyes
 see a worm's spigot maw
 dangling atop the periphery

 of an axe blade's slumber.

talking Horse

I related to the horse because I couldn't see
what was in front of my face
I had forgotten how to write poetry
The bowl of oranges was there
but it was so clear
how I couldn't have one
actually, it might have been a bowl of apricots
I couldn't tell because their faces
were turned from me
I didn't know how to be clear
I obfuscated my words
I suffered and I enjoyed my suffering
I communed w/ the horse
because we couldn't see the thing that was right
in front of our face
 I forgot when wine comforted me
I kept changing the station
never satisfied w/ the song
every day a day went by
 — your own face —
 charred ice
 treats its purse like a fanny pack
Sparrow in the tree laughed at me, and rightfully so
I wanted to be the opposite of Rilke
supposedly praising Orpheus
Rafa with his gigantic left arm
picked his ever-present
& imaginary wedgie
 — violets undulate in watercress
 gilt carriages —
I collapsed into a false swoon

Julian Talamantez Brolaski

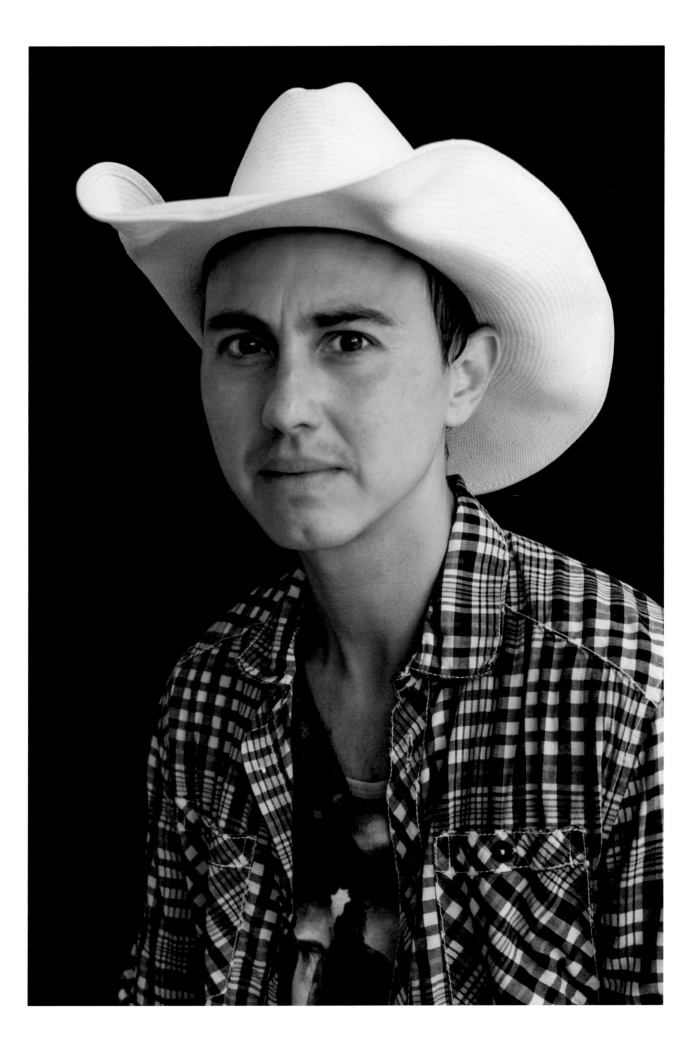

LLB 26 BD Poem for Paula

I wanted to give you a gift
for my birthday
After All mama, you did all The work
Oh I suppose That The spirit of me
Collecting into matter
was a task
Yet, because you were willing to hostess
This culmination ··· I have form

Whether it was forethought, or just instinctivity
 Here I be — I know no other way
Sometimes its like I know not anyway
Yet here I stand, here I am, here I breathe

I wanted to give you a gift for my birthday
But what Have I to give That is most precious
What have I but words?
And these are those, as Though you have received
what is given unto yourself
From your very own self 26 years later
with love

 Lauralee Brown
 6-6-1987

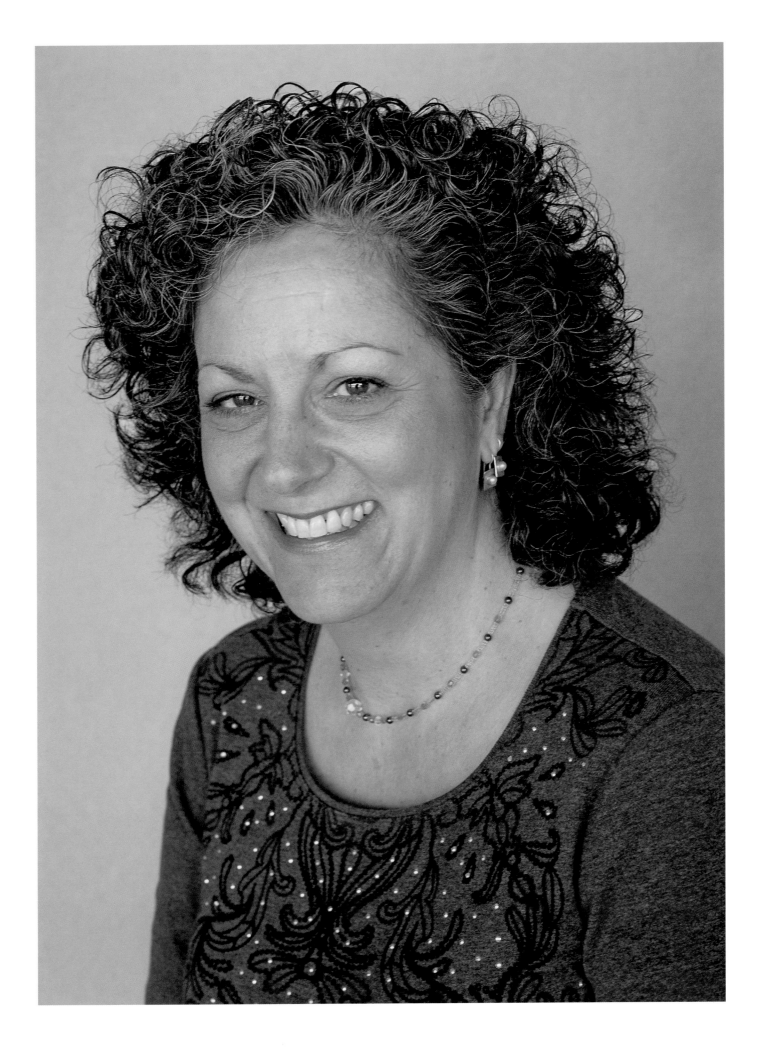

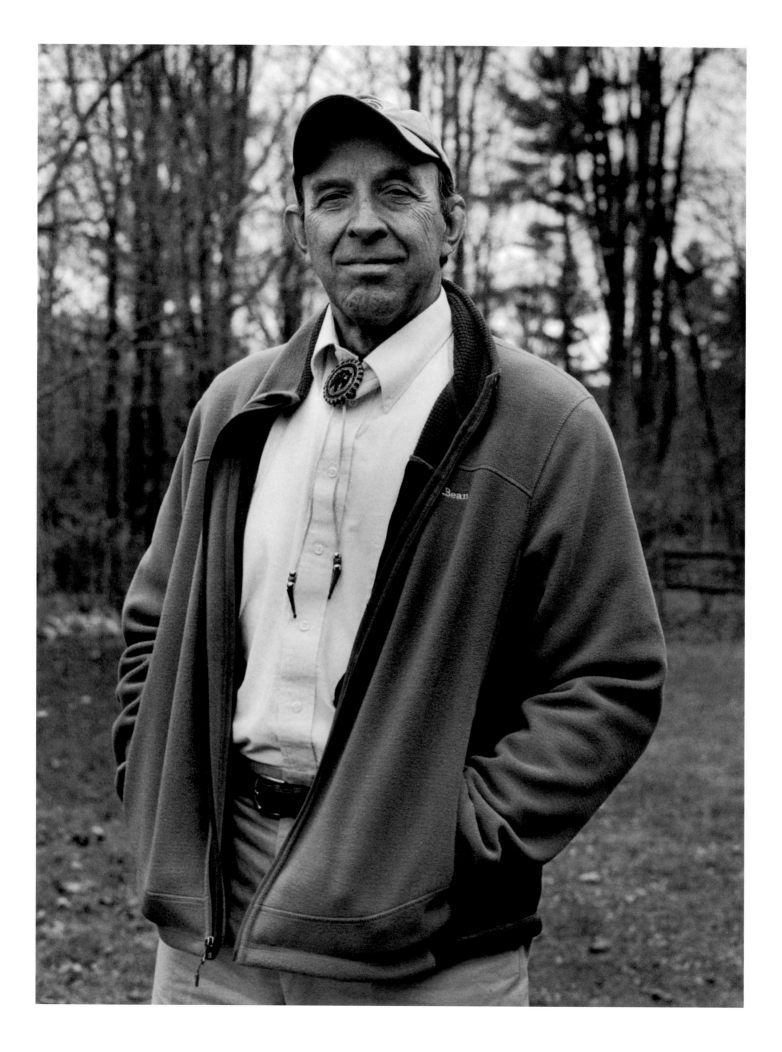

Season's End

This winter, the hardest one I've known
your heartbeat left this world.
The snow was deeper than dreams of sun,
it covered our windows, filled my throat.
The cold was strong enough to choke
all the words I thought I owned.

Late March has come, a new rain thrums
the canvas, makes the dark woods moist.
Mouths in marshes open in ancient chant.
My hands know it will not be long
before they spin the bow drill again.

The fire will glow, the lava stones
look at the world with eyes of flame.
Within the sweat lodge we will drum,
remembering we are promised nothing.
It is reason enough to join our voices,
my sons and I, for dead and living,
our breath reborn into song.

Watching her was like watching a summer storm's lightening charge, the flash that illuminates the sky. The bolt that strikes fast across the horizon, downward toward its target, an unsuspecting lone tree whose roots are no longer its security, but rather become the very circuit for which the charge swells. The energy's force overcomes everything idle and ordinary. And you know it from the moment the air vibrates with warning thunder. Her future, everything that would come after her nineteen-year-old existence, was too powerful for most of us to follow. I knew that the first day I saw her... years ago as a small child playing in the cool shallows of the Oconaluftee River, downstream from where I fished for speckled trout and dug crayfish from beneath slippy rocks. —Annette D. Clapsaddle

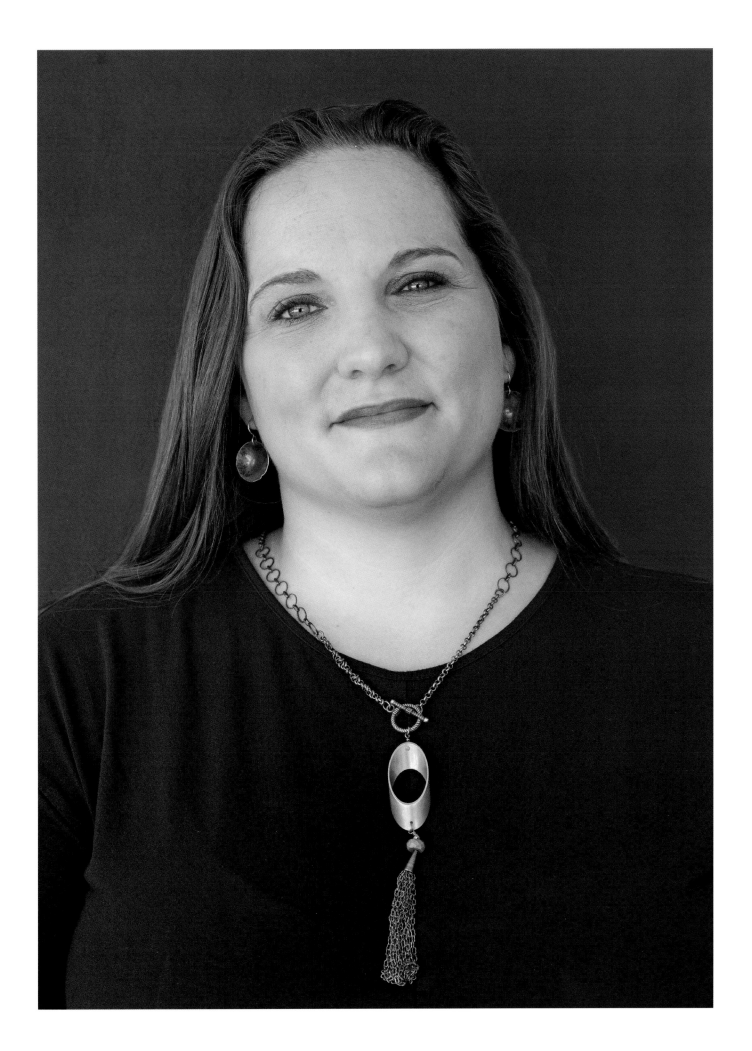

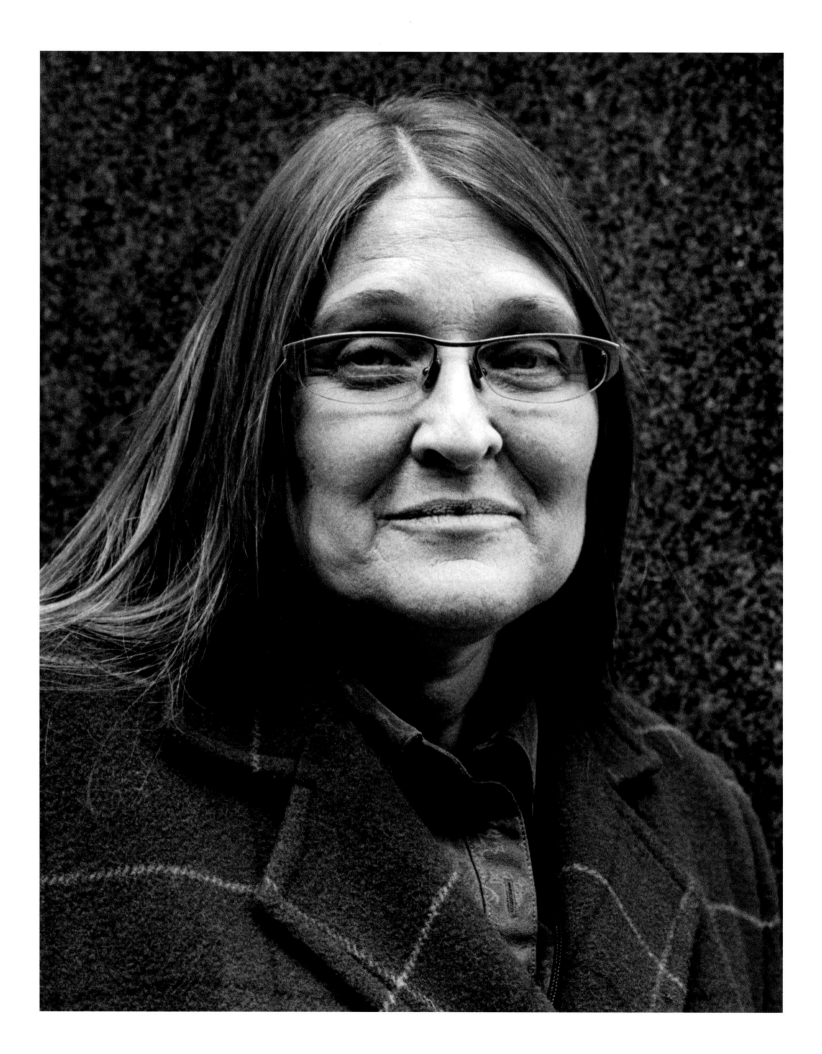

Harp Strings

Sweet rain on old growth sweeps past in fanning sheets.
This morning each veil brings joy, like someone strumming.
mist releasing song, falling to branch above hummingbird
dashing in, out, grabbing nectar in the wet, wet music.
Dashing in, out, grabbing nectar in the wet, wet music.
Mist releasing song, falling to branch above hummingbird
this morning, each veil brings joy, like someone strumming.
Sweet rain on old growth sweeps past in fanning sheets.

Allison Adelle Hedge Coke

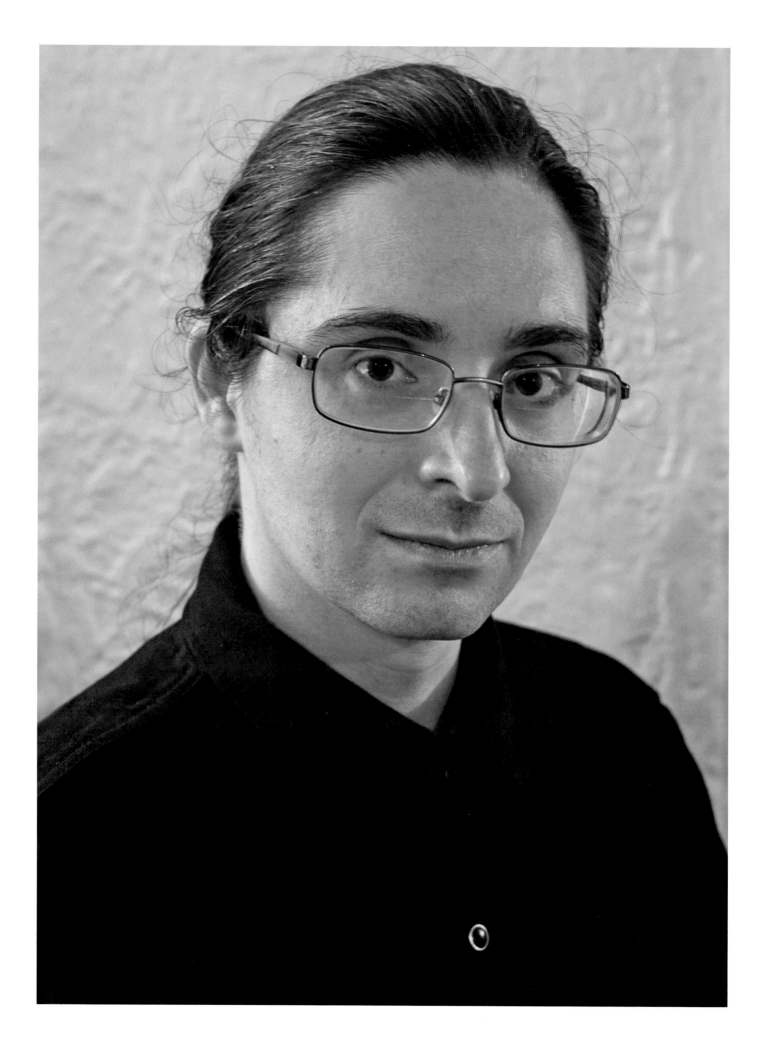

God and Pony Show

Back when the grasses were tall
I only saw a couple of you
Goddamit! this is important!
 This is Flea Market Country
Giveaway Land
 giving it all away
when the grasses were tall

Hey Blondie! Hey, Yellow Hair!
we're dead in time we're dead
Mild ill
Bang we're dead

This is for wearing that shirt
This is for eating those bones
grinding grandfather's bones
into shapes of imaginary men
faces made for money or pawnshop portraits

until we heaven no rhythms remaining
 no reclamations come

I first published a little fiction — that Guy Wolf Dancing.

More than any other piece, it made me wonder — "why write?"
It's just a story ———— not the "Dead Sea Scrolls"—
But— with great regard, I wrote this prefix:

"This Story is dedicated to those of the indomitable
Generations who lived vividly and taught us how
to make Art of life's inevitable Companions —"

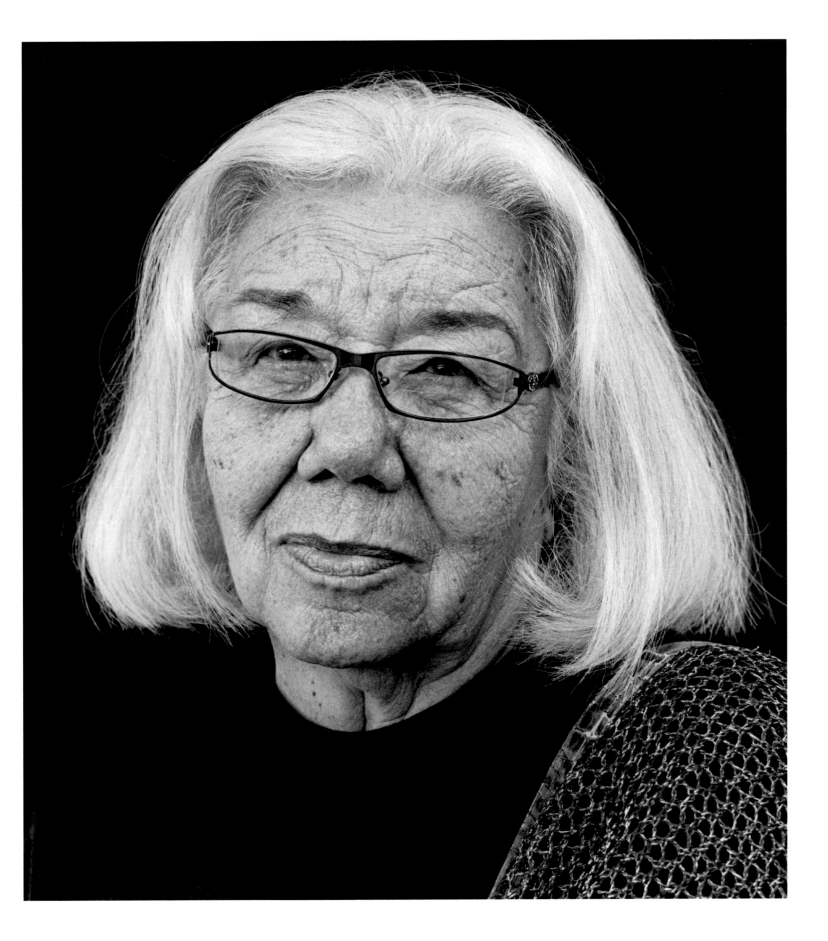

I woke up before the Sun at our hotel 10 miles north of Valentine, Nebraska. Early december and had lost one of my winter gloves the day before on the road. They were a christmas gift from my wife who had bought them at the Passage du Havre on Rue Saint Lazare in Paris. Last time I recalled having them was filling the tank in Martin, SD.

that morning we were having a second interview session with the great Albert White Hat and I had a 2½ hr window for glove searching. Spent the 82 miles to Martin coffee-less (non-existant that early and tough to find any time), delirious, squinting at the sunrise, pushing 100, passing noone and thinking of questions for Albert. In our first session with him he spoke to us about Boarding Schools, his being in St. Francis, SD. How he was ridiculed by teachers and priests for speaking his native tongue and how 28 years later he returned and was hired by that very same school as it's first Lakota Language + Culture teacher.

He talked to us about "Zuya", when young men would venture out into the unknown for the first time and return to camp describing to all everything they had seen + heard. Were there mountains? a creek? They recounted exactly what and where and shared this with the people. When reservations were later created, when fenced in like animals, they couldn't do that Zuya anymore. Albert told us his dream; for the Human Nation to finally gather as one like the Bird Nations sometimes do. He told us he'd spent his whole life trying to understand what "mitakuye Oyasin" (All my Relations)

truly means.

I pulled into the gas station at Martin, searched the trash and asked around but no glove. Fried Gizzards were prepped for Lunch. Grabbed a couple Starbucks Double Shots and headed the 82 miles back towards Valentine. Pulling out onto Highway 18 I spotted my mangled, busted Zipper but otherwise intact glove waiting in the ditch. Three years later I packed those gloves for Washington where we had the privilege of screening "Across the Creek" at the White House. Albert had sadly passed on between that time but his big unmatcheable voice, his Stories and dream were with us, telling the gathering all he had seen and heard on the long journey.

- on location, South Dakota
for "Across the Creek", Dec 2012

Jonny Cournoyer

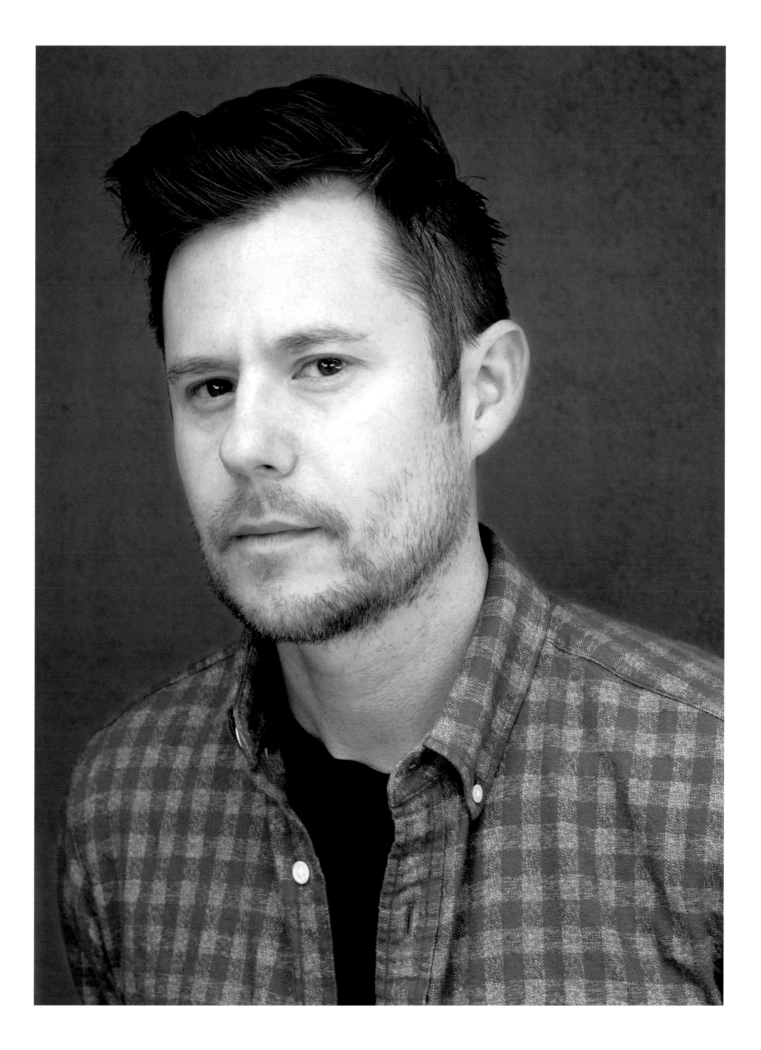

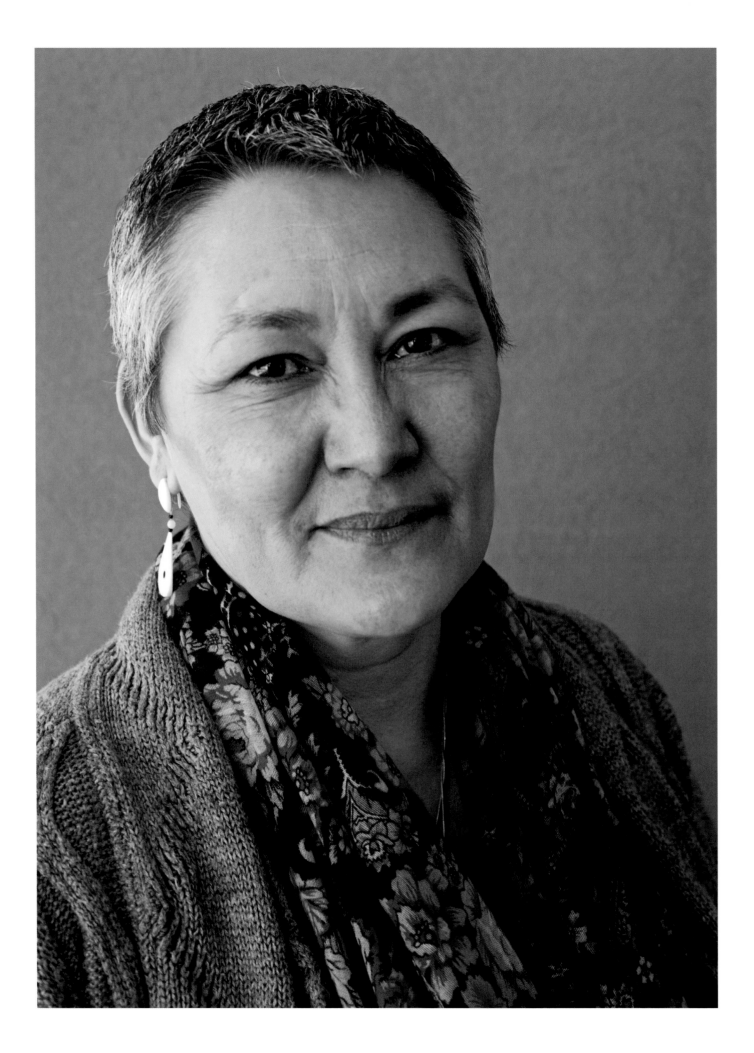

The Shrine of
Our Lady of Guadalupe

Our Lady of Guadalupe,
Please intercede before God
for my intentions below:

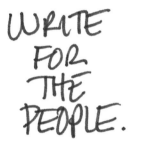

WRITE
FOR
THE
PEOPLE.

Ali Crow
Maaráq

After writing your intention, please put it in the
Prayer Box by the statue

Welcome Home

Welcome home to Mashpee
where snapping turtles
 and painted turtles bask
on logs in the marsh amid water willows,
ferns, and pickerel weed with purple flowers
reaching up from the shallows.

Welcome home to the place
where your great-grandfather whispered
to trout he caught at Santuit Pond,
then sat in a circle
and offered his pipe to Earth, Sky
and the Four Directions.

Welcome home to the coast
where your ancestors built wetuash
and gathered cranberries,
to the woods where they hunted
turkey, deer and bear,
and to the clearings clad
in goldenrod and asters
where they danced for 10,000 years.

Welcome home.
The elders have been waiting for you.
Listen to their drums, the beat
of your own heart.
Take this wampum necklace
made from the sacred shell
of the quahog clam.
When you wear it, walk through
redroot and wild lupine, hear
the quickening rhythm
of the field sparrow's song.

 Lucille Lang Day

Long Time Ago (for Lance Henson)

Long time ago invisible in the woods
wolves ran alongside us.

Long time ago unseen panthers purred along
night branches, gold eyes many grandmother moons
lighting our path.

Long ago before the wolves
were trapped in a gauntlet and clubbed.

Long ago before the great cats were shot
into extinction.

I have heard it said long time ago
our hearts greeted strangers like mountain roses
fully opened.

I have heard it told we really did know
Indian love medicine, touch

so tender it made us cry tears in shapes
of blue deer and brave eagles.

Brother in poetry, long time ago
we learned how to condole each other
when our hearts closed,

re-open our ears, eyes, throats.

Oh, my brother, I am so afraid.
The wolves. The panthers. Our moon flowered hearts.
Long time ago, long time ago.

~ Susan Deer Cloud ~

Souls don't scatter like the rest of the body. They latch on for as long as they can, their legs pulled to the sky, fingertips white in desperation. And that grip. Souls grasp for us, for the ones they left behind and for the truth that only they can see. They are the best witnesses to their last breath — as they float to the sky, to the aerial nothing, they hold onto whatever they can, so they can't go. So they can tell us the story. So I can stand in that bitter cold wind with that ghost and take its picture.

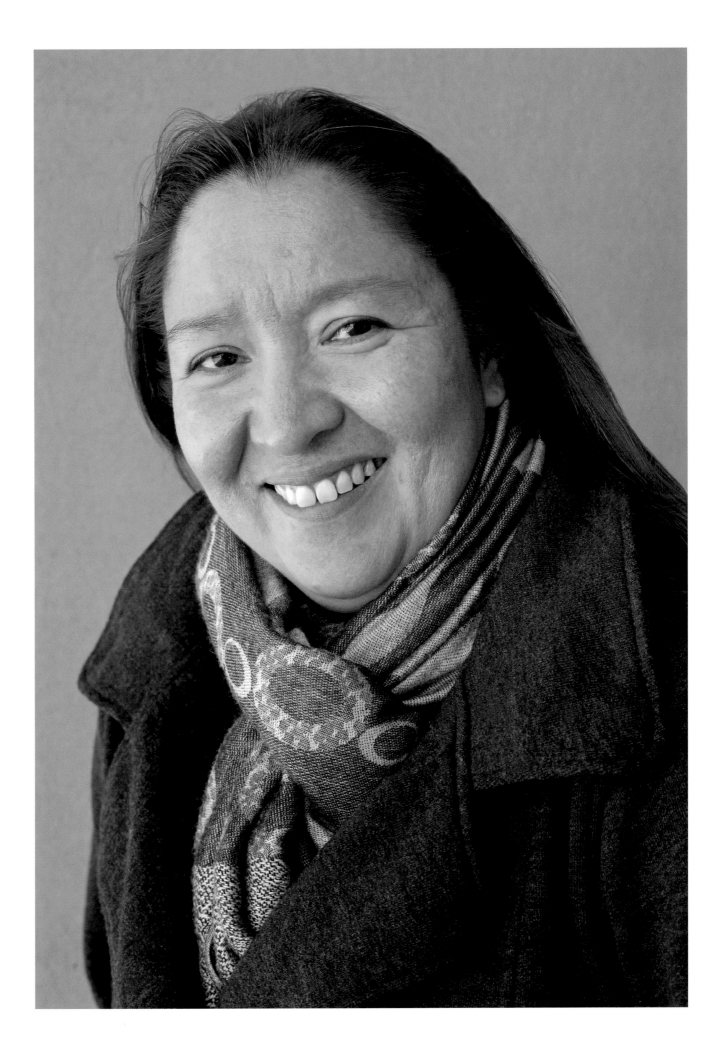

Sister Nations

We convene in long dusk, in lasting corona,
in twilight of our prairie homeland mid-summer.
We gather beneath our ancestor dancers:
vivid whirls, magnetically arrayed giants.
Or solar flares. However we knew those lights,
we are theirs.

Glass blue depth at our backs, we ease,
lean into lush summer skies and comfort.
Three Nations of sisters encamped in
camp chairs, in the dark beyond arena glare.
We thrill together when a bear
dances her way into the circle.
Her attitude commands us.
Her crouched inspection, once round, stares
at everyone in turn. Sometimes she rushes the
crowd.
She shakes a warning — claws the air

Crosses her paws, pauses — then
hunches into the darkness beyond us.

Sisters, as she passes and her fur
brushes us
dark, warm, soft as night —
her beast breath left like blessing.
We gasped it so we could hear
her roar a true bear roar
before she threw her dwindling robe
back
and she laughed — and we laughed —
our woman's laughs.

Heid E. Erdrich

August, 2015

— DRAFT —

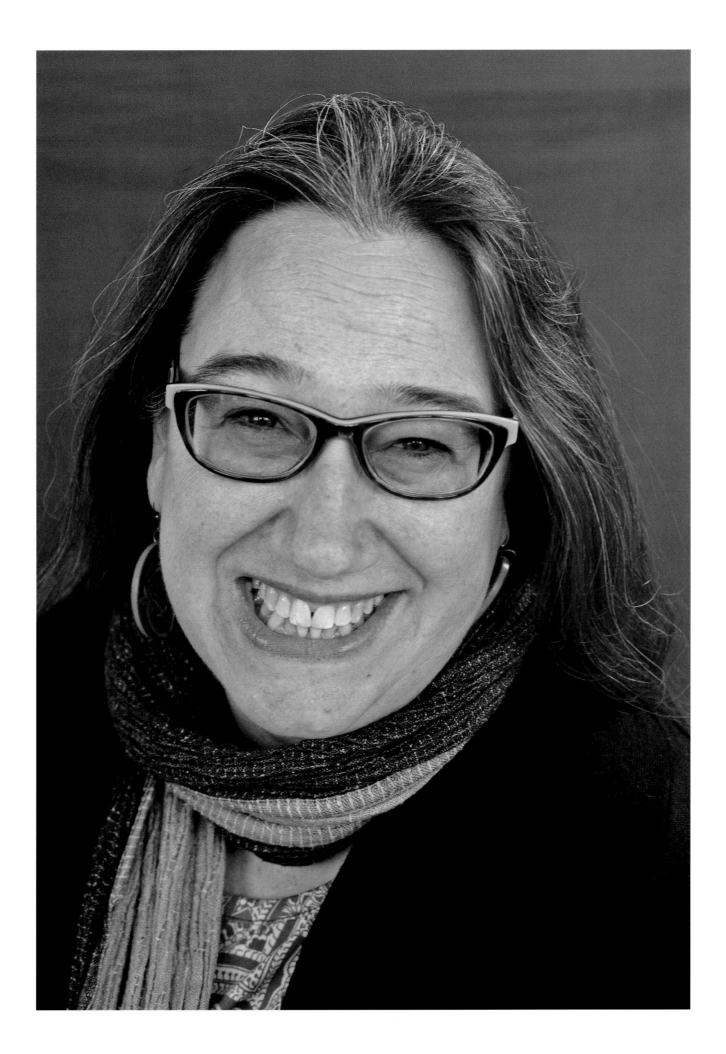

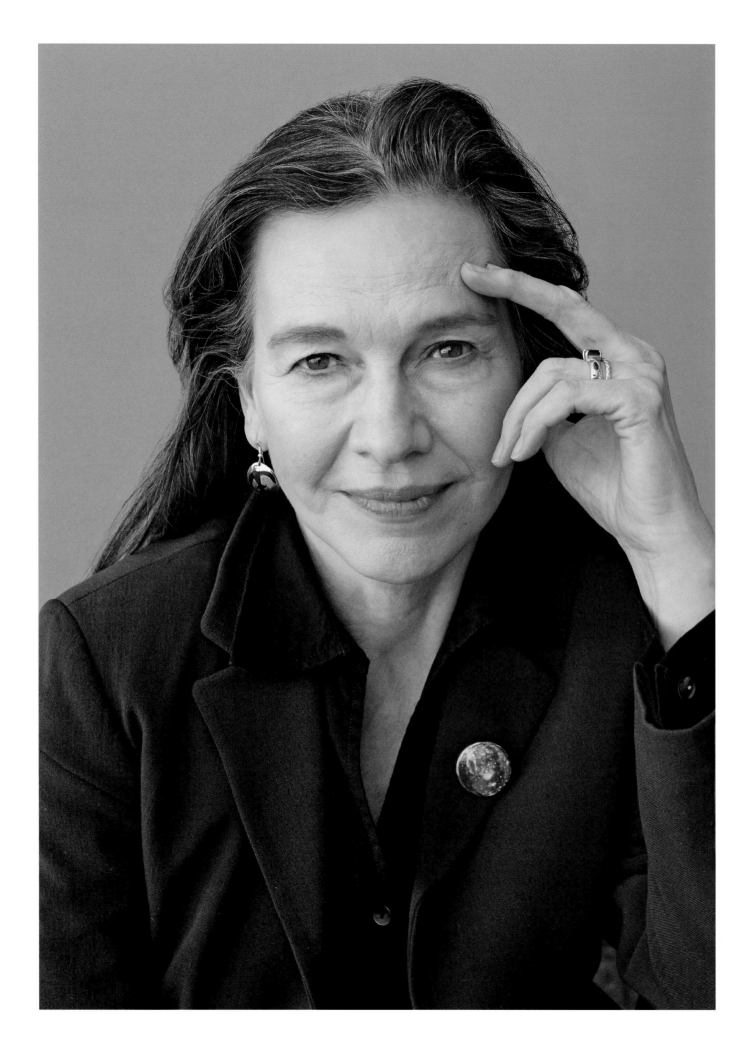

Regency Plaza

...a most gracious hotel in downtown minneapolis...

I wake in the blue hours once again,
my whole life spilling through me,
as loons pour
the cold green tea of their laughter
across the rose-slabbed lakes of Ontario.
I am one thing. I am nothing you can name.
I pray in the woods, begging to be taken,
the way leaves and stones are
whirled into your rushing mouth.
River of snow, river of tunnel carp,
sky of three holes, sky of white paper.
I praise you the way shadows
of deer move beyond the cut lawn
stripping everything into them, flowers, bark.
Shadow of my need, shadow of hunger,
shadow infinite and made of gesture,
my god, my leaf.

[signature]

41 NORTH TENTH STREET • MINNEAPOLIS, MINN. 55403 • 612-339-9311

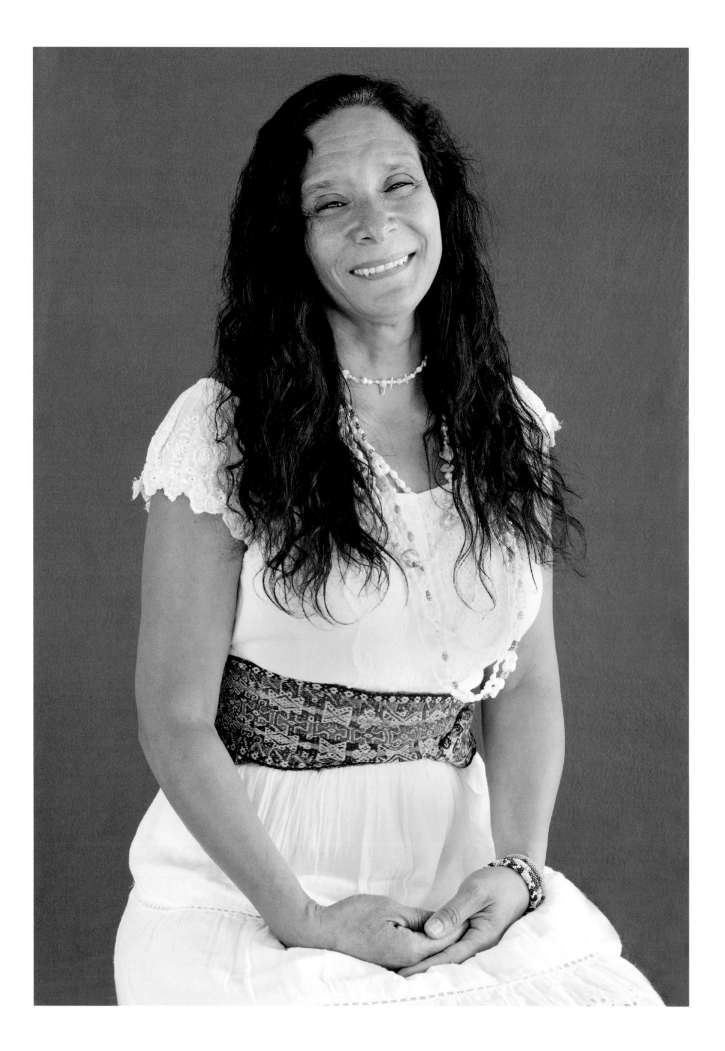

The Good News is from Northern Saskatchewan this Morning... RAIN for at least a week!!
Now that is what I call Sunshine on a Forest Fire ☺ Weather. There is conspiracy or not with the Fires & HAARP & stopping Home Grown fire fighters in their own territory from fighting the fires & evacuating & blocking peoples from coming in and out of their own home... BUT Allowing CAMECO trucks to haul through and military tanks ??

You cannot mess with the forces of nature.
This is Creators Thunder Rain... I pray it Rains Enough to put out the Deep Earth Heated Fire.
What a Beautiful Territory!! This was my first visit there during this time of the Fires (2015) What my Carolina people's would call "God's Country" Indeed it is a beautiful place full of life.
The Indiginous World & Mind...
What I love about "Indian" People is... no matter how much we adapt to technology... create it or use it... We Never loose our connection to the land and how it sustains EVERYTHING!! Indian People Know the real way... The Real Power and it is not in stealing power... or making it.
The Natural World is the Power. It will sustain you or swallow You...
 Respect... is teaching us all... aye?
 Pura Fé

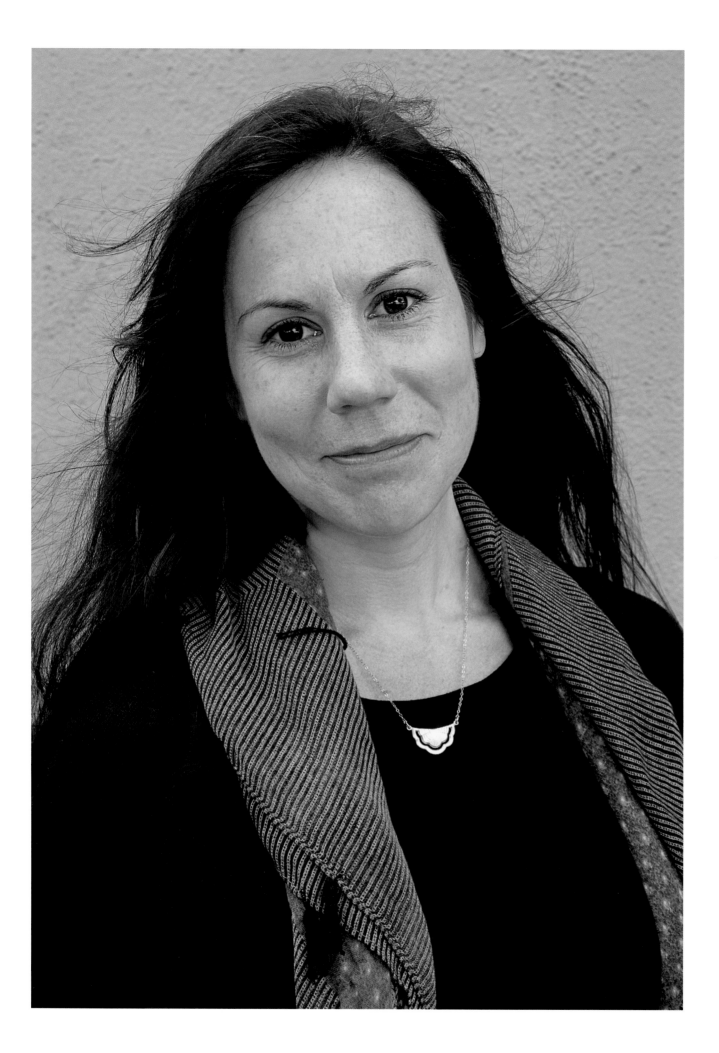

Before Waking

Empty highway.
Forest in the distance. —

cobwebs mapping
the clearing of the pines.

In a meadow of burning grass —
a book before you.

A tree drops its charred apples.
Crow comes to eat.

You will gather the seeds
and continue to travel.

Climb the bone-strewn mesas,
the mountains a doorway at your side.

This is the place of your birth —
pass by it.

There is nothing left here
to remember me by but webs

spun from cedar smoke —

where my footprints
disappear down your throat.

Jennifer Elise Foerster

Sacred Objects

Take
 some tobacco

Cedar chips
 snakes
 if you're ambitious

Dragonflies
Bee pollen
Eagle feathers,
 naturally

White dogs
Black cats
Trays of D-CON
Cast iron skillets
 seasoned like masks

Seed beads
Pony beads
Sweat beads
DNA beads, faintly dotting
 worn white briefs

And any other kind of bead
 you can imagine
 connecting one globe
 to another

But please note the verb
understand what it means
 and get back to me.

You'll know me, no matter
 how many years it takes.

I'll be the one with the empty hands.

Eric Gansworth

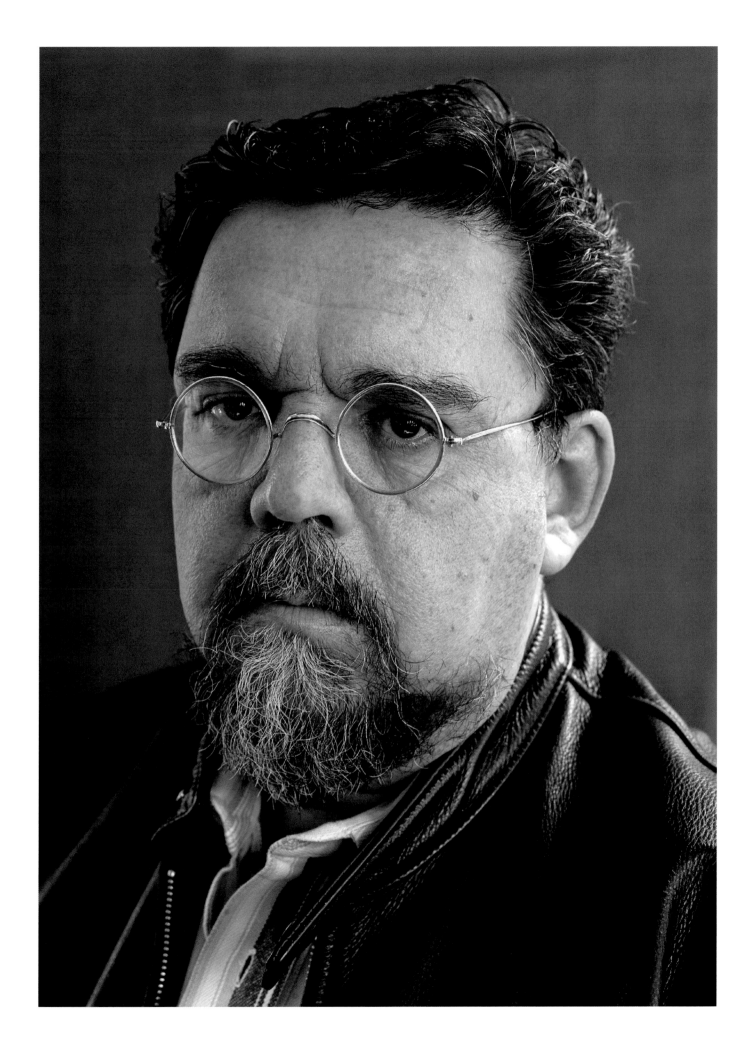

There was an old Indian
across the field I visited.
He went on with his stories
several days. There were
many translations and
versions, circling back
to the repetition of certain
images. I took my ideas
for writing from his versions.
The stories he dreamed
came to him in pieces or
fragments broken off from
the whole. He talked —
not worrying about
unification between the
parts. I could see the way
my writing would come,
one after the other. They
would find the trail
between them. They would be
linked. I only had to do
the work —

Diane Glancy

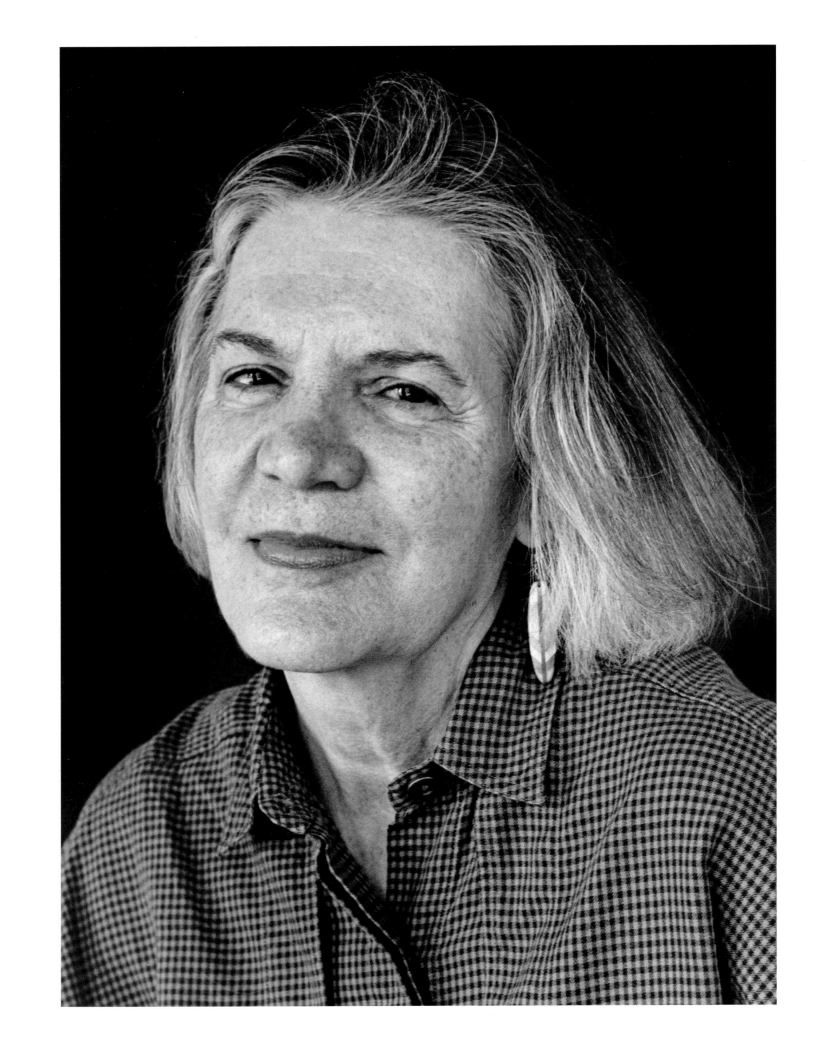

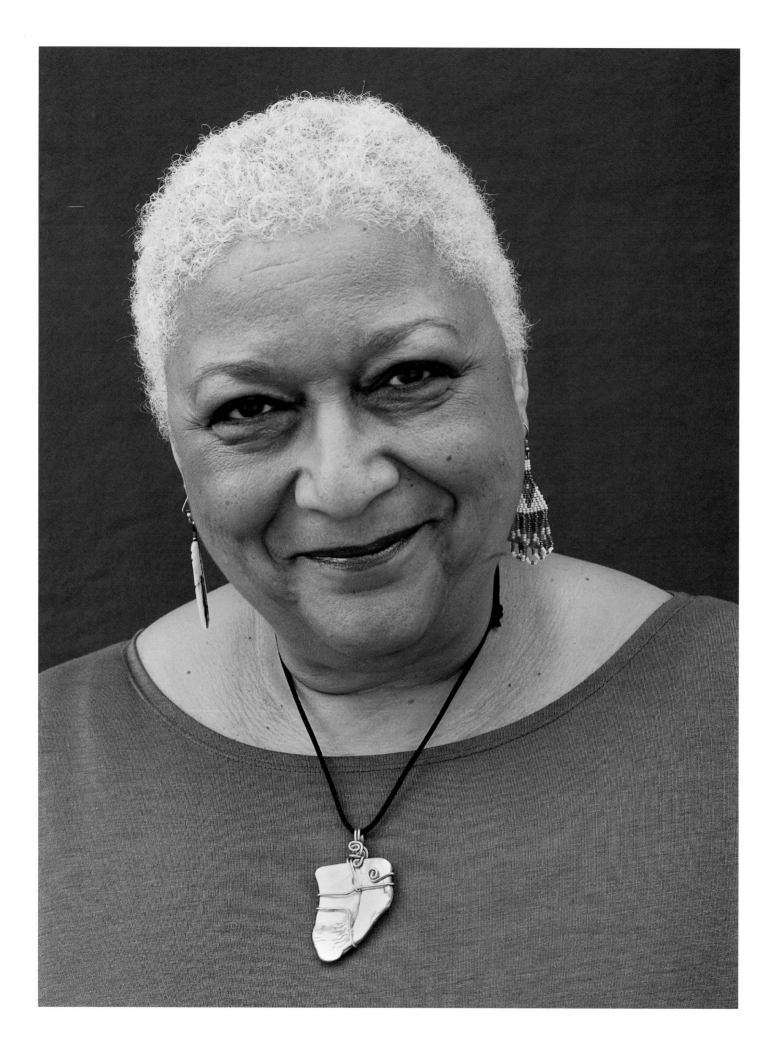

The Buckskin Dress
for my great-grandmother, Gracias

At 8 years old I wasn't sure
what a buck might be even as she told the story
But I longed to see her dress,
a gift from her Ioway father.
It was a mystery stolen before I was born,
taken from a trunk in a city basement.
Still I carried the image, cobbled together
from episodes of Gunsmoke + The Lone Ranger.
I imagined fringe swaying around her legs
as she walked through broken glass
blossoming in the park.
The fabric dances on her sturdy stride
like ancient luxury.
All eyes are drawn to the sparkle of
hard-worked beading alive at her neck.
The dress is inside my head
where I touch its butter-soft folds,
smell the wildness of Iowa before it fell
to those who unsettled our lives.
I hear the sound of women
dancing in a dust-filled circle
proud of the work they wear.

Jewelle 'Still Water' Gomez 3.15.15

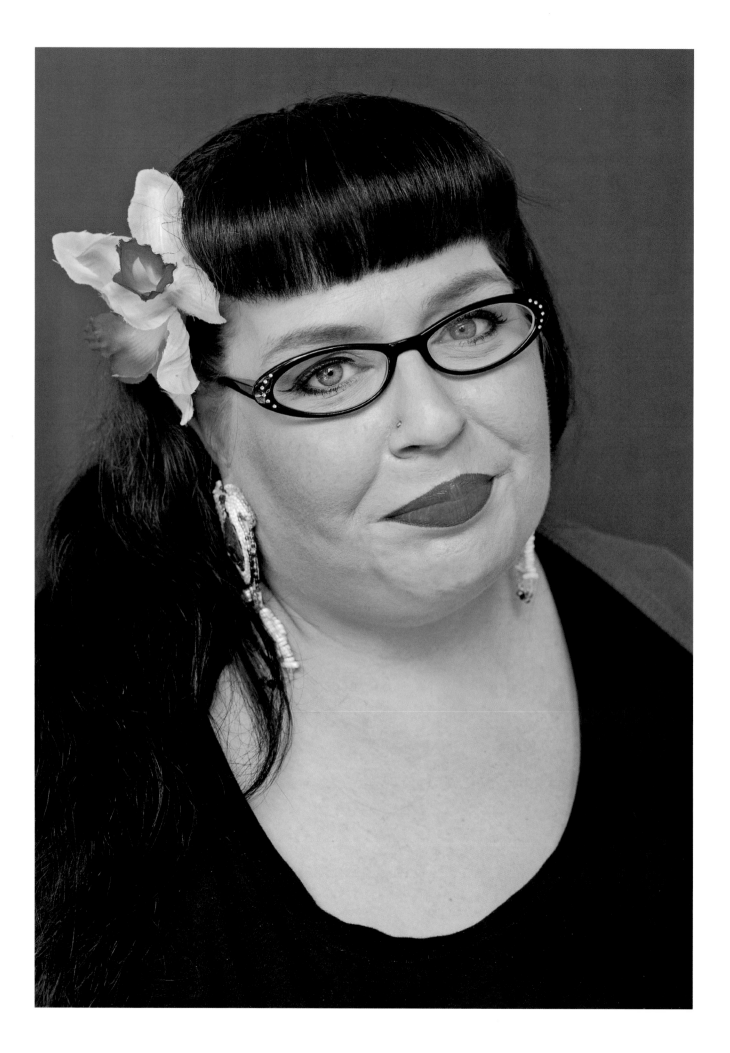

Sweeping Away

There's been a chipping off,
carving, and claiming from
waterways to inner deltas—
Second coming settlers
exploring bodies from fleshy
river banks to shaded pines.
"You've gotta mouth full of give me, a handful of much
 oblige" of much

Dwindling sands counted and stored
marked like inventory, numbered,
enrolled, verified, certified, organic—
cataloged carefully beside red clay
and white clay samples.—
Both entities whose bodies forget the
flexibility of coil pottery—
under browned silt worked hands.
"You've got a mouth full of give me, a handful of much
 oblige" of much

If the last bit of my home
Sits caked down— a deep red line
under crevices of my toenails—
You would come sightseeing
oney to dig it out —
Sweeping the dirt away.
" You've got a mouth full of give me, a handful of much
 oblige "

7-2-15

Fox & Crawdad 5?

A fox was running thru some woods one very hot day. He started getting thirsty. He saw a creek up ahead and he thought, "I bet that water is nice and cold." So he ran to the creek and started drinking.

As he was drinking, he heard a voice which said, "Who said you can drink my water?"

The fox looked around but didn't see anyone so he started drinking again.

Once more, the voice came.

"Who said you could drink my water?"

Then the fox noticed a hole in the mud right next to where he was drinking and a crawdad popped up from it. It was the crawdad that was talking.

"This ain't just your water," the fox said. "Anyone can drink."

"This is my home! My water!" Crawdad said.

"You know what?" fox said. "I'm hungry too!"

And he ate the crawdad, washing it down with a long, deep drink of the cool water.

Never pretend to be someone big cause there's always somebody bigger than you around.

Least that's what Gramma said.

-2015-

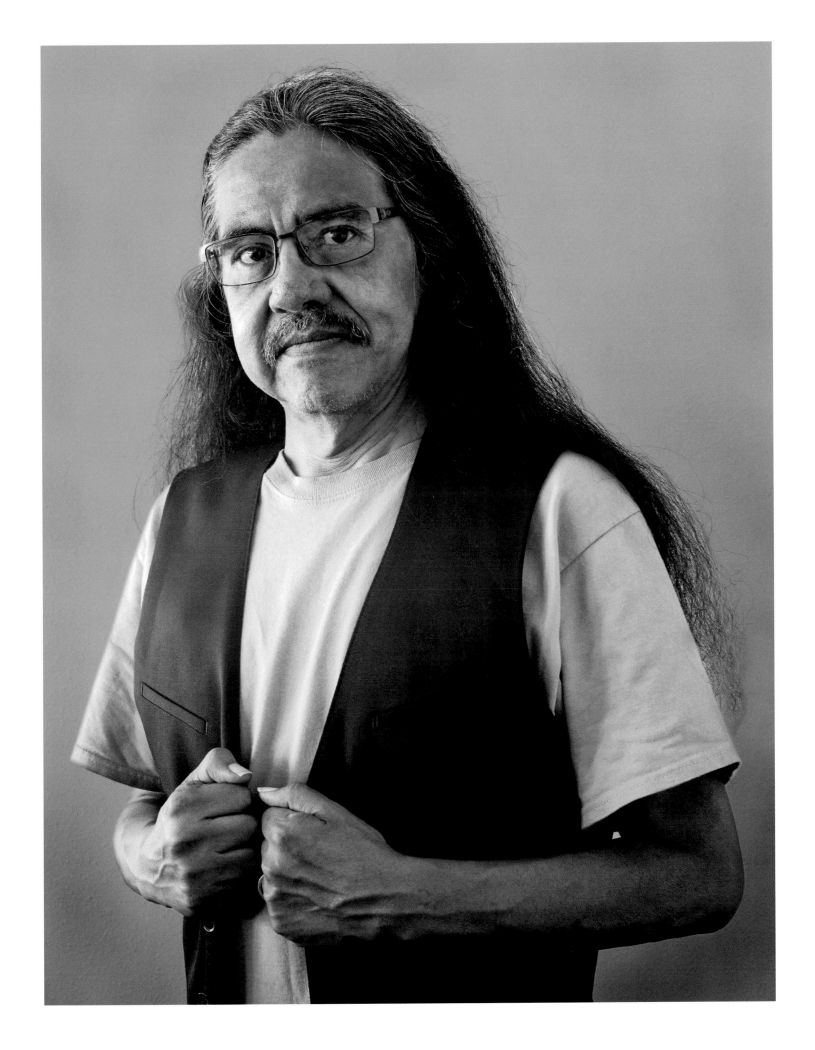

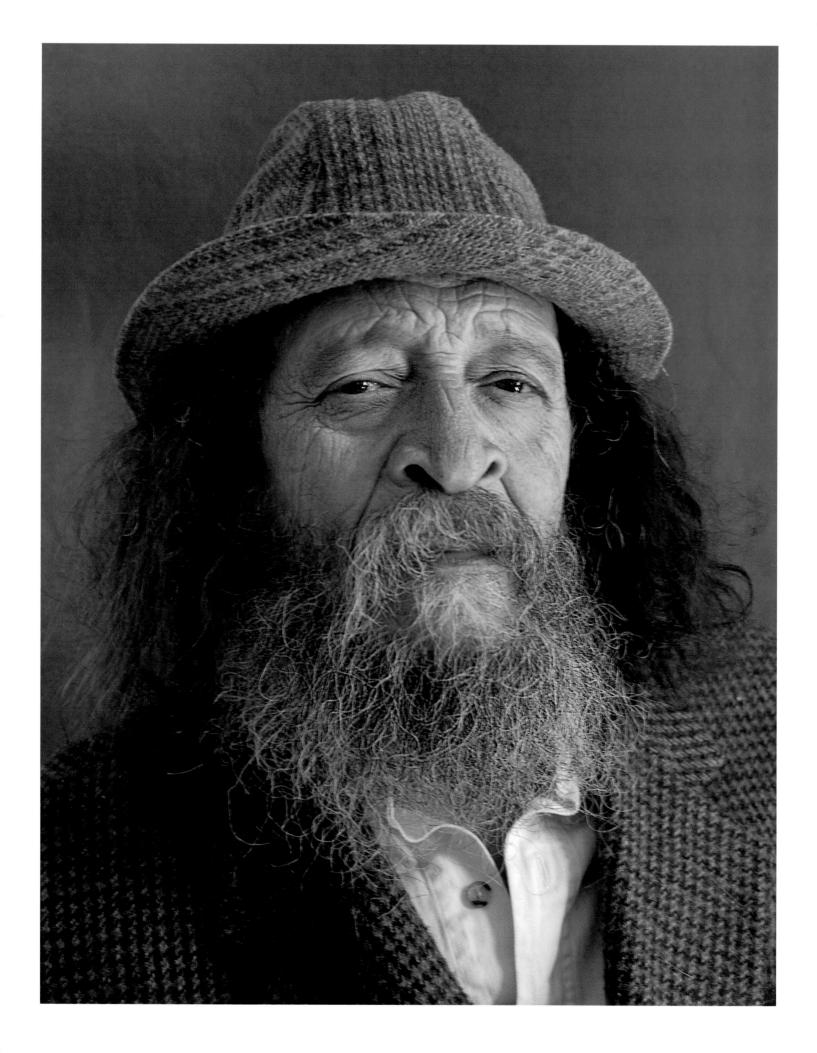

our hemisphere

afro carib latin hill billies
semitic hamitic semi dravidian natives
who might have come from india
and 'sho nuff be in the indies here

those carrying glyphics to the new world
whose old dwellers take to the hills still
and teach us to worship there

black and brown and golden and
peach pink urban populists
and left winged
anarchistic
universal
qua qua versal
color coded
god headed
new world peoples
of every shade there is
and we're makin more
every day

a class containing classes
the x's and y's of manifesting humanities be
the music of the coming world
containing all
excluding none

 let the Klan and the nazis go back
we home here now

 Q. R. Hand Jr.

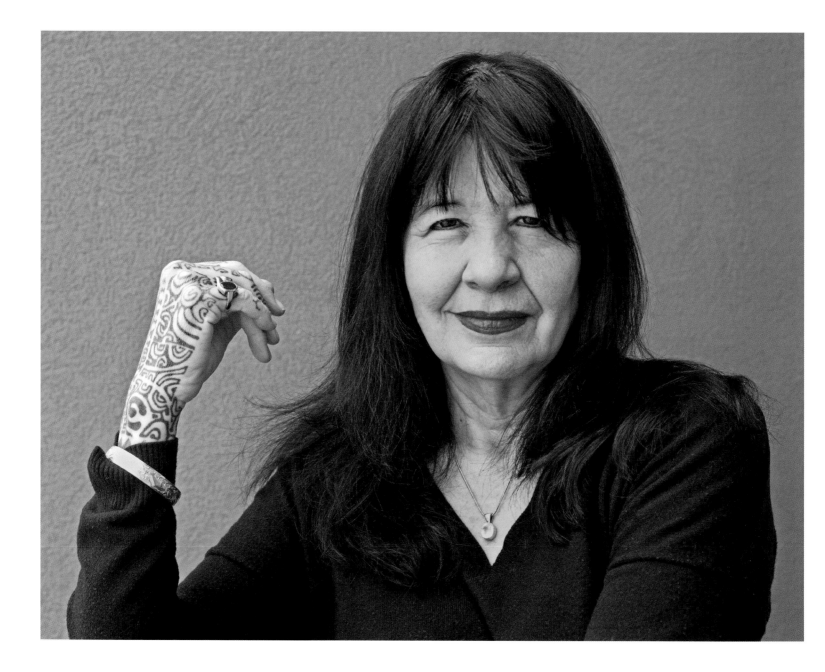

Midnight is a Horn Player

Midnight is a horn player warmed
up tight for the last set.
Two a.m. is a guitar player who is
down on his luck.
Three a.m. is a bass player
walking the floor crazy for you.
Four a.m. is a singer in silk
who will do anything for love.
Five a.m. is kept for the birds.
Six a.m. is the cleaning crew
smoking cigarettes while they wait
for the door to open.
Seven a.m. we were having breakfast
at the diner that never closes.
Eight a.m. and we shut it down,
though the clocks keep running
all through the town.

8/2015

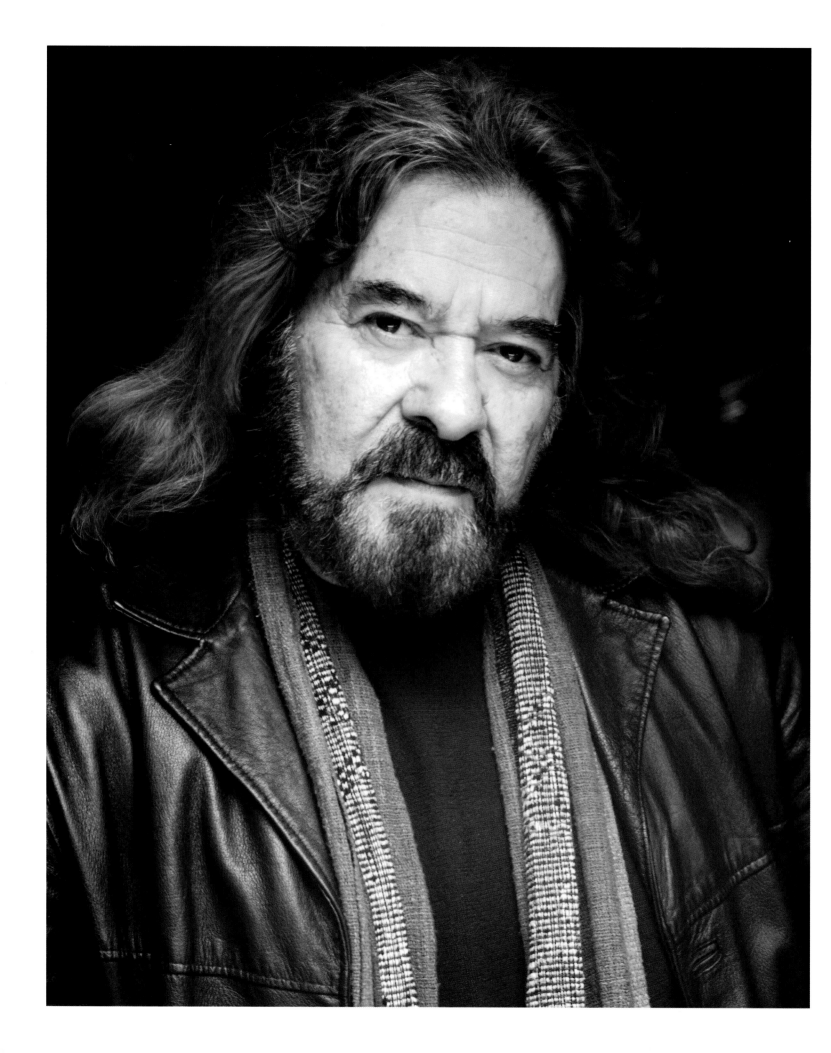

anniversary poem
for the Buffalo Wallow fight

at three am in a snowstorm
near Cowon Colorado
two years ago
the shrouded figures of warriors
crossed in front of the headlights

pulling to the side of the road
in a poignant sorrow i wept
placing tobacco upon their tracks

Ski oh hiu hotonifoneo
na me ho

our dog ropes are still in the ground...

The Suskao Manifesto

To our population
 We maintain the following:

We do not recognize labels, laws, divisions,
 fences, borders, countries, county, state,
 president, governor, police, paramilitary,
 Queen or King

We are neither citizens or immigrants
 pagan or Christian, wild or captive,
 sinner or saint, active or inactive,
 atheist or evangelical, democrat or republican,
 conservatives or liberals, American or Canadian,
 socialist or communist, right wing or left wing,
 red or blue, fettered or unfettered,
 safe or unsafe, foreign or local,
 sane or insane, balanced or imbalanced,
 pure or impure, insider or outsider
 modest or immodest, moral or immoral,
 inferior or superior

Humans fill their prisons with misfits, dangerous,
 labelled, judged, colonized, controlled, damned,
 condemned
Your Orders: Migrate. Fly.

Grace Hentz
Bird Clan

Washington Home
from Spokane to Grand Coulee
January 2009

we travel through the whiteness
quietly carrying faith
 wanting hope to shine forth
 the earth's blankets deep, & textured
 in places glistening
 in places the hands of The Mystery
 drawings of browns, sketches of trees
 line images in the snow of homes
 horses stand close to each other
 holding themselves against the cold
 traveling lightly we are filled with wonder
 waiting for a sign a promise to cherish
 in our hearts
 suddenly, standing alone on the top of a
 snow bank
 we see Coyote, sentinel of our path
 messenger from a beloved one
 poised, regal, head up, warrior that he is,
 from the old time, a long time ago
 we behold each other, keep driving,
 memory imprinted with his image,
 and ours on his
 we travel through the whiteness home,
 we travel home.

 for my son Tom

The Buffalo

This morning I woke to find the small bison
out behind the wild horses.
It was eating the long blades of grass.
Blades.
I worried about its tongue.
Then I thought it wanted to speak.
Old mother stood behind me.
She said it wanted to tell us
about the long great

absence.

Linda Hogan

Noble Savage Sees A Therapist *
By LeAnne Howe

Noble Savage: She's too intense for me.
 And I feel nothing. No emotion.
 In fact, I'm off all females,
 — even lost my lust for
 attacking white chicks.

(Pause)
Therapist: (He writes furiously on a yellow pad,
 but says nothing.)

Noble Savage: People expect me to be strong,
 Wise
 Stoic
 Without guilt.
 A man capable of a few symbolic
 Acts,
 Ugh — is that what I'm supposed
 to say?
Therapist: (He continues writing.)
Noble Savage I don't feel like
 Maiming,
 Scalping,
 Burning wagon trains
 I'm developing hemorrhoids
 From riding bareback.
 It's an impossible role.
 The truth is I'm confused,
 conflicted,

continued
Noble Savage: I don't know who I am.
 What should I do, Doc?

Therapist: I'm afraid we've run out
 of time.
 Let's take this up
 during our next visit.

* from Evidence of Red, 2005, Salt Publishing, UK

"WE REMAIN"

By Andrew Jolivétte

(Opelousa / Atakapa)

No TIME Shall PASS.
No Secret Shall ReMAIN.
No Night Shall pass.
No DAY Shall Begin.

Begin without the Sun pointed at your heart.
Begin without the meeting of soft white pebbles
 Motionless and solid... yet transformative still——

My Rock, my stone, my Ancient temple of Remembering
Open untold and shadowed Stories of Remembrance
 You were born at the intersection of revolution &
 defiance
 The lines in the arches of your back and in the
 CURVES of your feet

Speak lifetimes of triumph
Speak songs of Joy
 As you enter, I begin
 AS I begin, you continue

And in this lake of urban forgiving,
WE Renew once more that sacred hoop of sustenance

Where hearts cross, where paths intertwine, and where
 our journeys
 Continue...

"Objective" Data

There is a reason all the old aunties whisper, and pay attention
to who is speaking. *Truth* has more definitions than can fit
in a dictionary, especially yours, which is owned by companies
of sleeping people who keep company with the drowsy edge
of history that tells its own solipsisms and lets the rest slide off
into dusk. Take me out to a field of yarrow at sunset and catalogue
all the colors of grandmothers' memories, tell me about gathering
what they have known for ages. I will tell you how the rocks
you believe lack agency are intending to survive, actively
plotting a form of nonviolent resistance. Listen.
Si no habla español, you will never understand, not because
these stones speak Spanish but because you need to know
more than one tongue in order to learn how to hear. When
Derrida lectured in five languages he didn't want to make a point,
he was trying to sound like flowers blossoming in rich soil who sing
in sounds not heard by human ears for centuries. The sand
covers information, though the wind does not lie as it ripples
the dunes open. Everything lost comes back
in its howling caresses. Split the stories into percentages;
test them with a one way ANOVA analysis. They are still stories.
What do we know?
If by now you don't see why those old aunties whisper
in fits of raspy laughter,
you never will.

— em jollie

The drag hook

of the mind asthenic. Green not yet gone

though scrolled in

absent a horizon banked with clouds
turning forth, driven by wind. A black coat: nostalgia

in a harness. Pathogen of sweet brook water drawn
upstream from metal culvert buckled underroad again:
dust risen into light into rain. Our spring runs dry

beneath snow on an island now arid, now seam
of admonition: do not solve. Adapt.

— *Joan Naviyuk Kane*

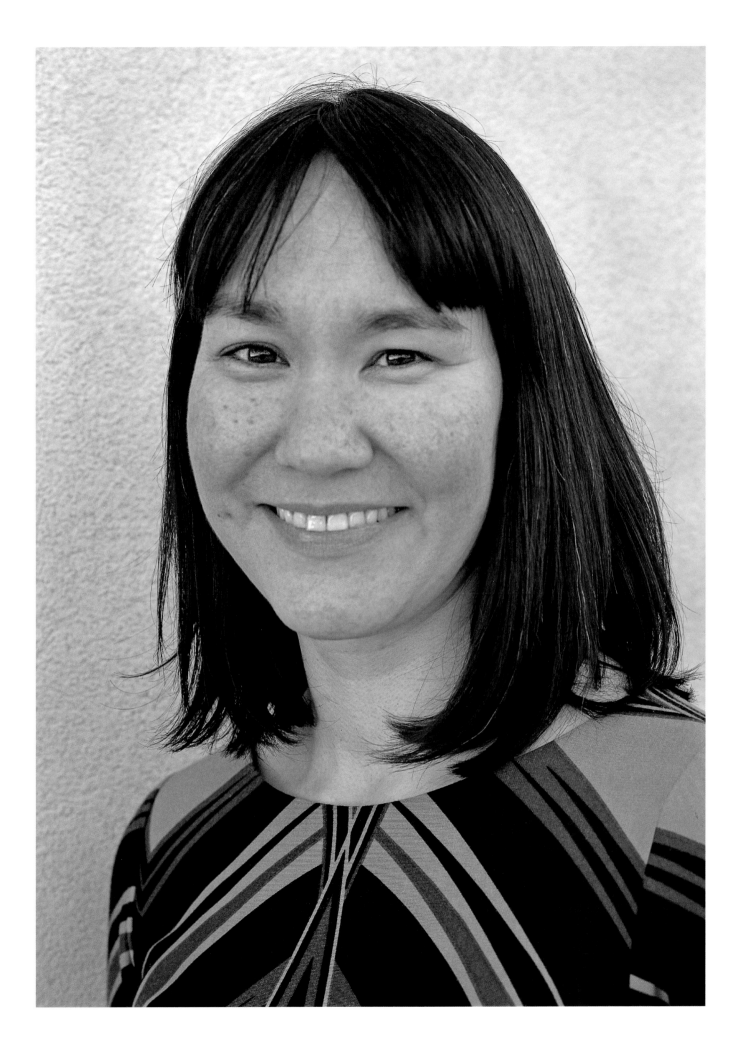

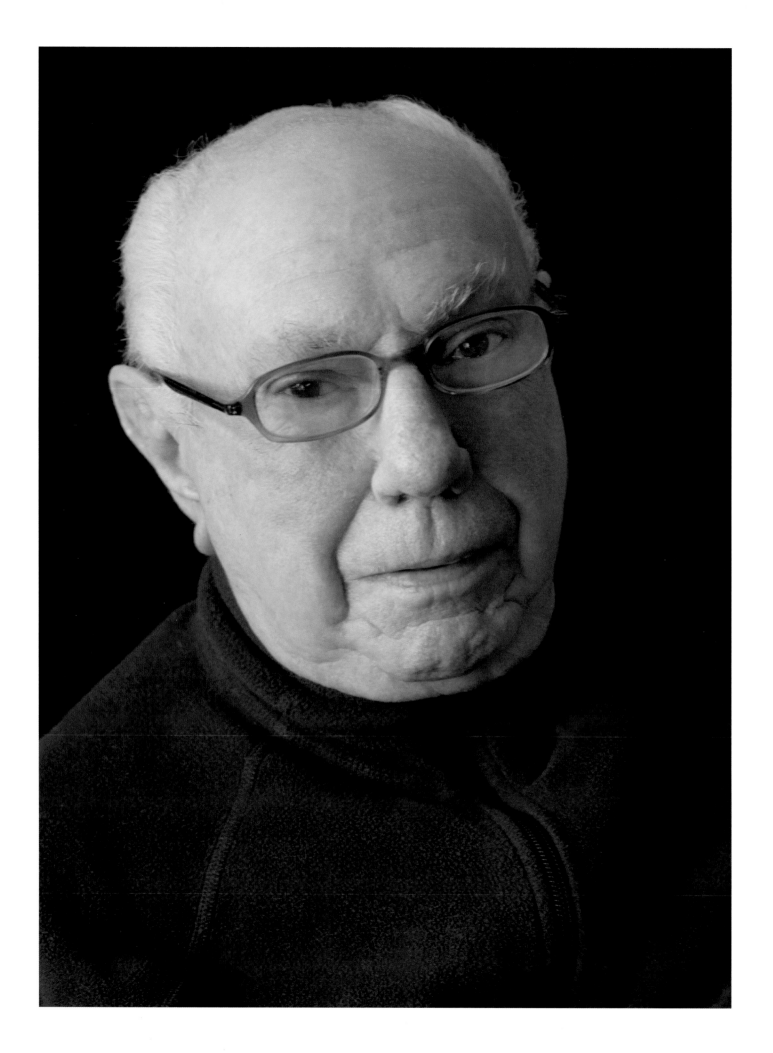

Lines

WOLF TRACKS
DEEP IN SNOW
NEVER TO TRAVEL
BEHIND ANOTHER TRAVOIS
.

BRIGHT FEATHER
ON THE PATH
(CUT DEEP)
INTO EARTH
ON ON A MOUNTAIN CREST
.

SPIRIT
ECHO VOICES
ON A LONG JOURNEY
IN PRAIRIE WINDS

Maurice Kenny

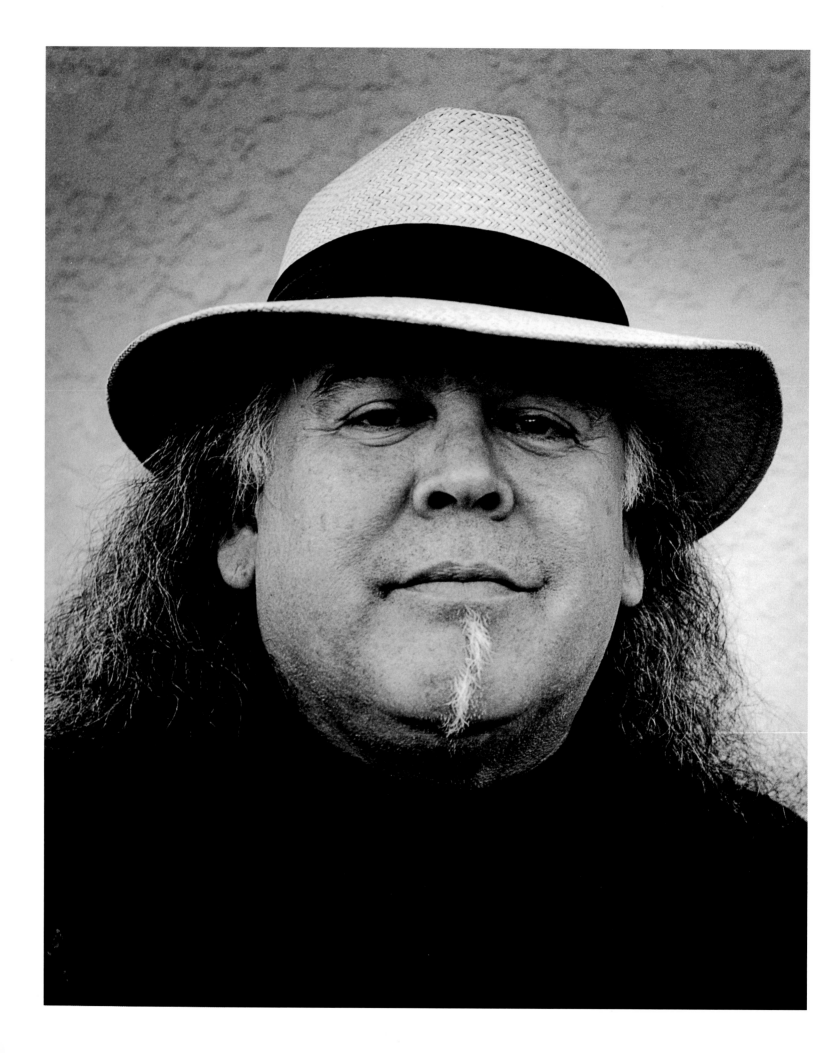

Talisman – Sing a New Set of Blues

Physical touch - the embodiment of prayer
Touchstone of protection
Sentiment of reachable wishes
an old guitar laments
my woman done, done me wrong
treated that guitar better than we
treated that woman
Talisman – sing a new set of blues

Spirit presence noted in ghost stories
Planted on the rez this hall of nobility
Designated to the living in honor of the dead
Serving the present ignoring the moment
Reference for the future
Talisman – sing a new set of blues

We miss the grace of enlightenment
Ignoring the divinity of existence
Can't see the forest for the ivory towers
Pay tribute with an actor's commitment
while the heart remains imprisoned
an inverted Stockholm syndrome
Identifying with the illusion
Talisman – sing a new set of blues

Zephyr

I hold the wind to
keep her from crying)

She misses the moon
like the memory of a lost love

Worn throughout eternity

the sea cannot calm her

She needs my gentle arms
my breath whispering

soft morning love songs

as darkness edges onto the river

once again we prepare
to meet the moonless night

XOX LᚷᛌF

Sharmagne Leland-St. John

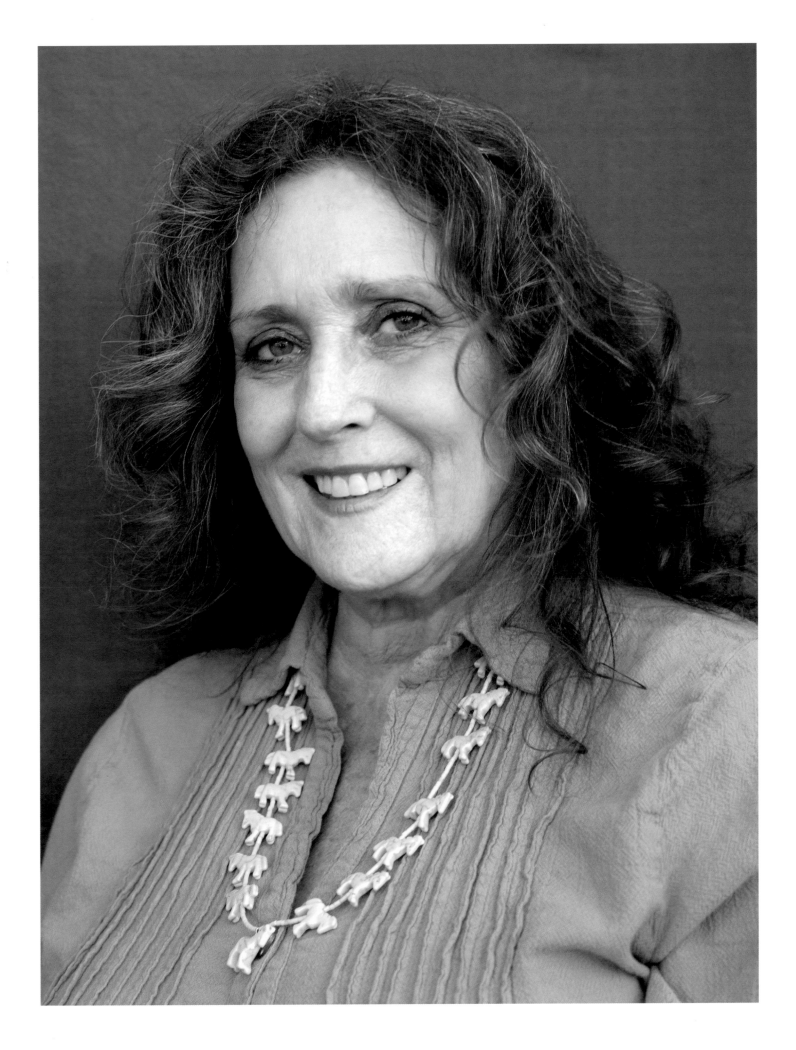

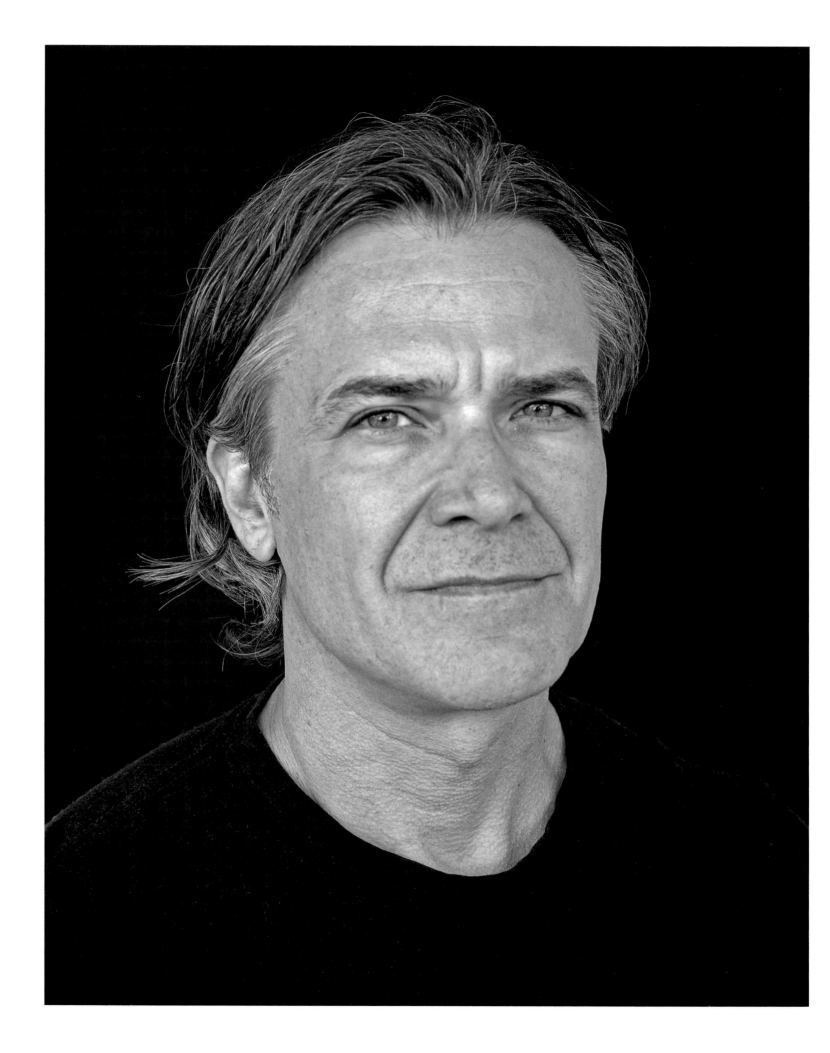

A PROPOSAL

I am a young man, fire.
you are a young man, Wood. Listen
I will go with you. In the air
I enter, ancient. You in the smoke.

Kingfisher just kissed you.
the green frog, he just kissed you.
The dragonfly, wood, water, stone.
Choices are frequently made through inspiration.

A cloth, a chair, a walking stick.
Various symbols to elevate you.
The little white dog made footprints.
you and I just hold up the stars.

Chip Livingston

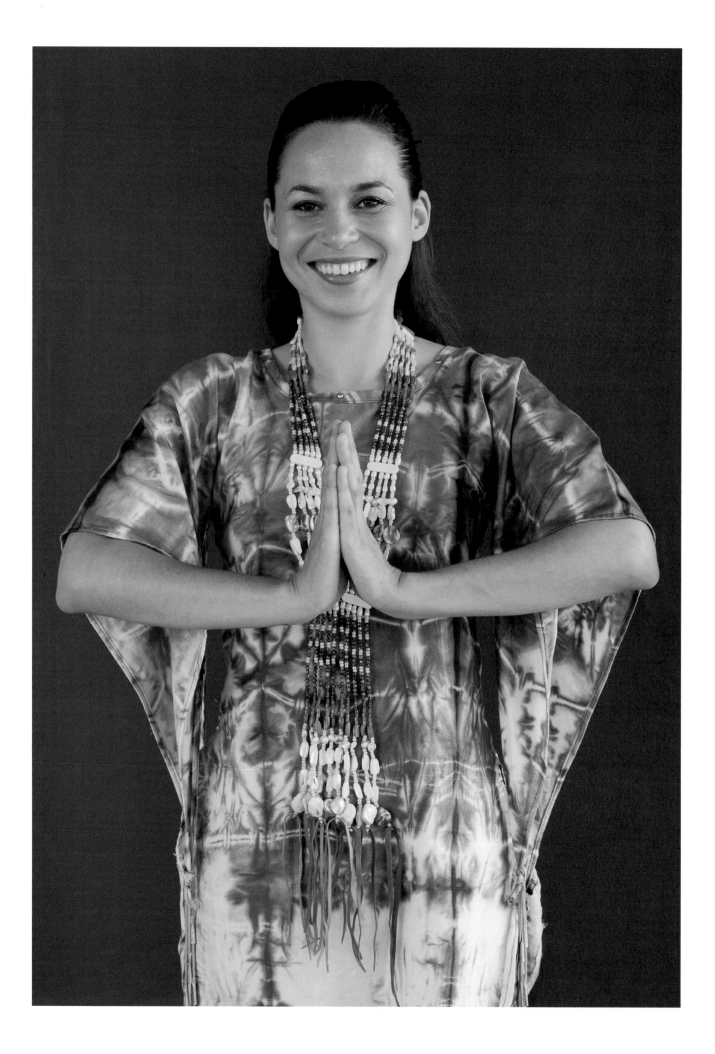

Brownskin

An existence so beautiful, so colorful, deep-rooted in originality,
Eye candy of shallow minds, that was her reality, Still —
 She walks around with a smile, for the whole wide world to see
while her insides are screaming, "free yourself from strains of society."

Brownskin, why do you hide the pain within?
Brownskin, Brownskin....

Day in, day out, it's the same
Living by the standards of a male domain
She can't help but recognize the stares
Because of who she's talking to and the clothes she wears—
Still — she holds her head up high, for the whole wide world
 to see — while her insides are screaming, "free yourself
from strains of society."

Brownskin, why do you hide the pain within?
 Brownskin, Brownskin...

Brownskin, how long will you continue to pretend?
That who you know, where you go, won't phase the life you live—
That what you do, where you be, will catch up with you in the
 end?

Live your own life, don't worry about the need to please

Be the queen of your own society!
 Brownskin, Brownskin — Brownskin, Brownskin.
 — Charly

My Manifesto!
"Why I Never Again will I
Stay in a Bed & Breakfast"

No matter what the owners says,
"I feel like an intruder

I don't want to talk in the
morning, first thing — Leave me
alone!

I don't want your help so
stop asking me

Stop asking me Questions —
especll. bout Indians

It's either too Hot or
cold in this place!

I can't Fart out loud

I can't Run around in
my shorts

Get that Dog or cat away
from me!

I fully understand and
Enjoy Motels & Hotels are
made for people that travel
and are not a slave owner."

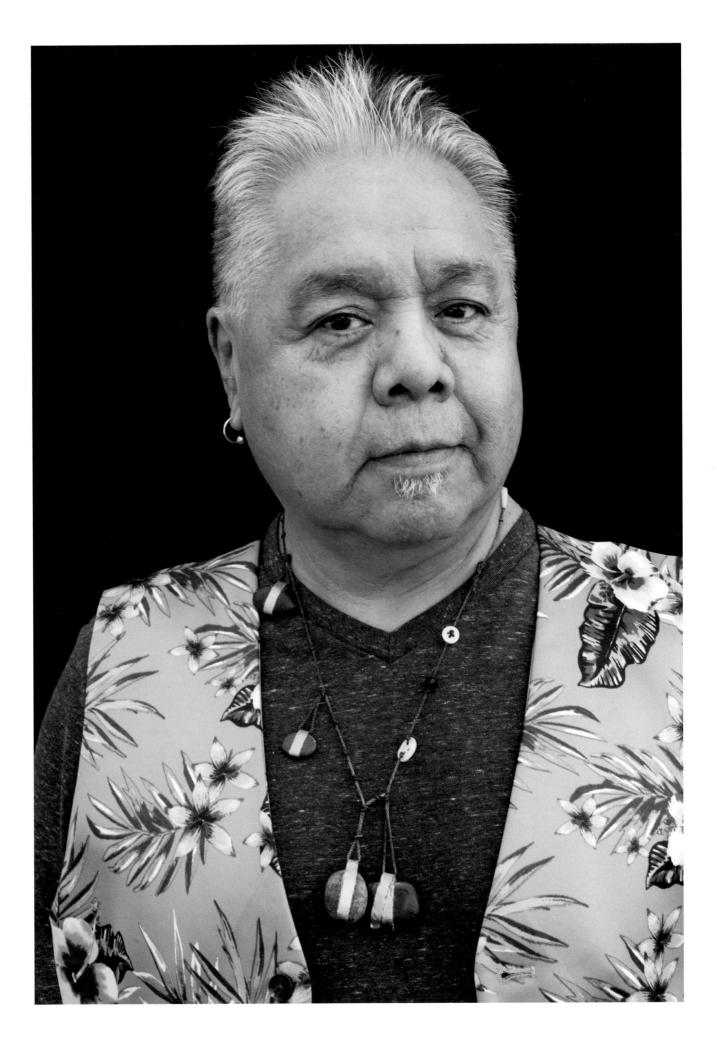

The Laguna Scouts and Geronimo, A Close Encounter
By Lee Marmon

In 1928, the remainder of the scouts from Troop f, Company I, 3rd Battalion, 1st Regiment of the New Mexico Volunteer Cavalry gathered for the last time. A photographer took their group photo for an Albuquerque newspaper, and they reminisced about their exploits together during the Apache Campaign of 1881–1886.

The Marmon brothers, Robert Gunn and Walter Gunn, had been surveyors working for the government when they moved to New Mexico, after the Civil War. Robert G. was assigned as the Captain of Company I during the Apache Campaign and served under his brother's command. Walter G. Marmon was the Colonel of the Company and their cousin, John M. Gunn, was 1st Sargent. Of the company's four troops, Troop F consisting of Laguna scouts, was the Colonel's favorite since those men were his neighbors and friends.

Indians had a long history of assisting government troops, but they were not permitted to join the military officially. That ruling changed in 1880, and Pueblo volunteers became highly active in protecting their homes and livestock, and in campaigns against the Apache that soon followed.

In the spring of 1885 Geronimo and Chihuahua were especially active, conducting many raids in western New Mexico and eastern Arizona. On June 9 the troops, numbering about 100, were camped at Luna, New Mexico, near the Arizona border during

their regular patrol of the territory. Residents of the area had suffered violent raids by the Apache the week before. After surveying the Luna Valley area, Capt. Marmon with his troops crossed into Arizona near Alpine. They conducted a surveillance of the area there and north of Nutrioso, and on June 20th Capt. Marmon returned to Laguna "with a

detail of 10 men and escorting two women and a child who were fleeing the Apache" (Schroeder 18).

Years later, Angus Perry, a Laguna scout in Capt. Mormon's Troop F recounted a meeting he'd had with an Apache friend of his who had been with Geronimo. The two visited and compared their accounts of those days of the Apache Campaign, and the Apache friend then told Perry about the incident near the Arizona border. The Apache knew of their presence, and without attacking the troops, Geronimo alone orbited the camp. The Apache warrior's attempt to get a clear shot at Captain Marmon was unsuccessful, possibly because 100 soldiers surrounded the Captain. After two unsuccessful efforts, he gave up.

The Captain and his scouts continued their surveillances of the area, never knowing how near they had been to their prey, or to danger.

Source:

Lee Marmon
Schroeder, M. A., Albert H. ed. *The Changing Ways of Southwestern Indians; A Historic Perspective.* Glorietta: the Rio Grande Press, Inc. 1973. Print.

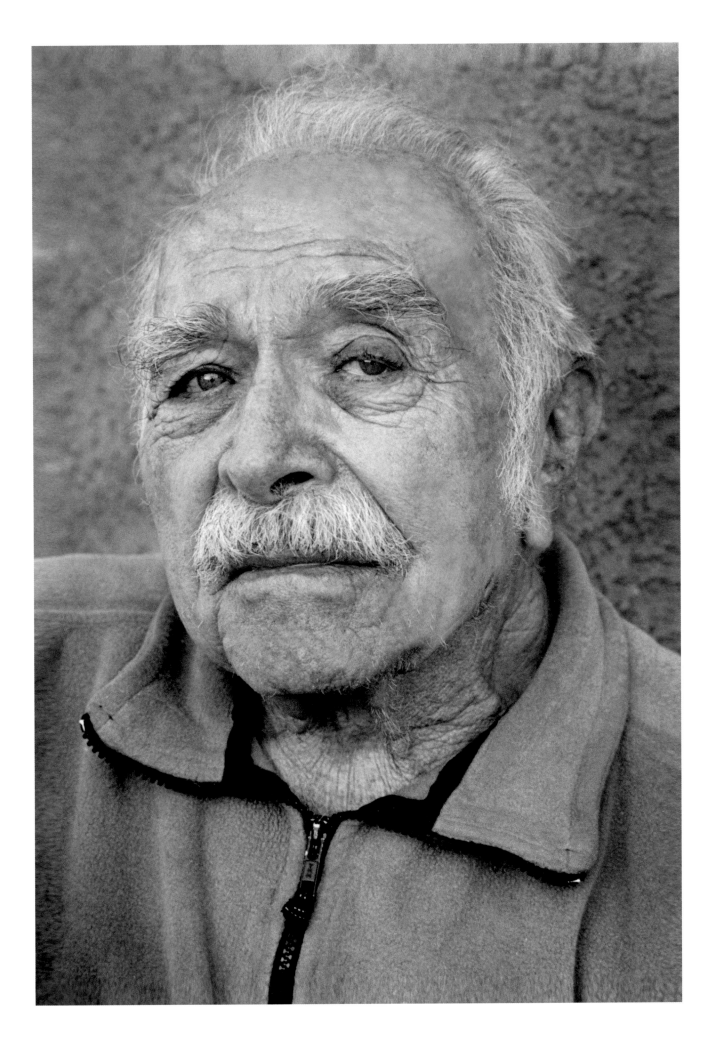

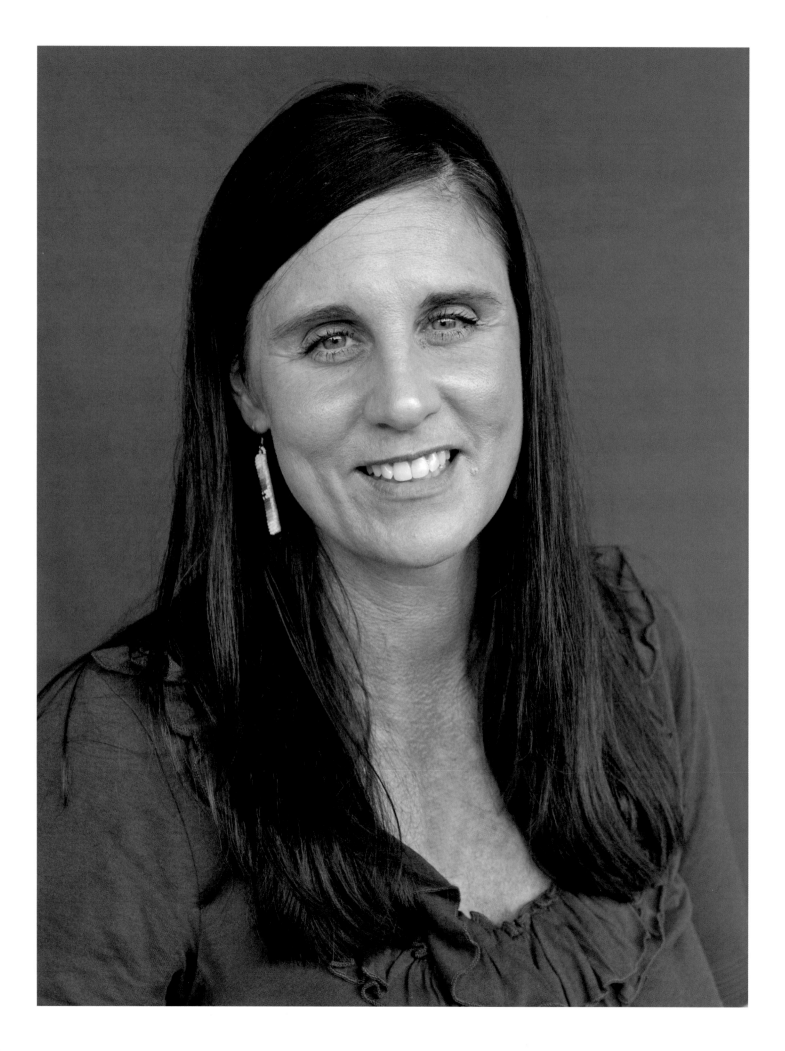

Composition

I assemble with the hands of a poet
who does not know the end
of her poem, ink is an afterthought.
Piecing myself together I use all
the material I can gather:
Potter's clay and her acrylic paints,
thick and thin camel-hair brushes;
a chinese jump rope that looped my ankles,
twine we used to hold the tomato plants.
If I use food, it's mostly
what I can recall: wild rice and walleye,
peeled oranges left for me in the morning.
The crescent-moon cashews she loves.
If I need markers, I locate northern lakes,
lilac bushes that guarded our back yard
overgrown and drooping with fragrance.
The cotton-blue bed sheets she draped on the line.
I must sit patiently to do this, to place
it all in order,
from memory. But will it matter
if I can't quite get the smell—
her hands as they tied ribbon round
ends of my braids?

"In their arrogance, science addicts who call themselves environmentalists blather about those who are destroying the earth. They miss the point. They are destroying themselves, not the earth. No matter what industrialized societies do to themselves and the human race, the earth has eons to heal itself. Indigenous people feel that time is only the white man's linear mathematical construct. We understand immortality. Time is not a line stretching from one point to another, but a cycle of eternal renewal. Compared with how long it takes the wind and water to turn rock into sand, our lifetimes on earth amount to less than the blink of an eye. In eternity, there is no death. Your body is returned to Grandmother Earth, but your spirit survives. Your blood survives in your children — procreation is immortality."

— Russell Means, *Where White Men Fear to Tread*

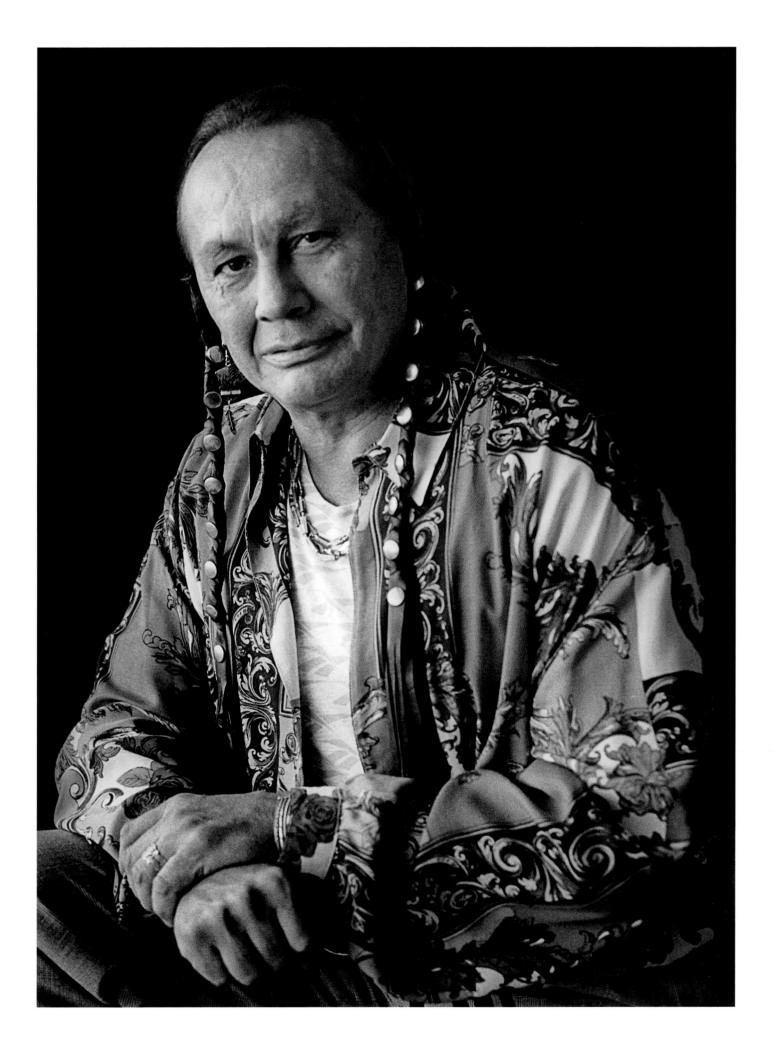

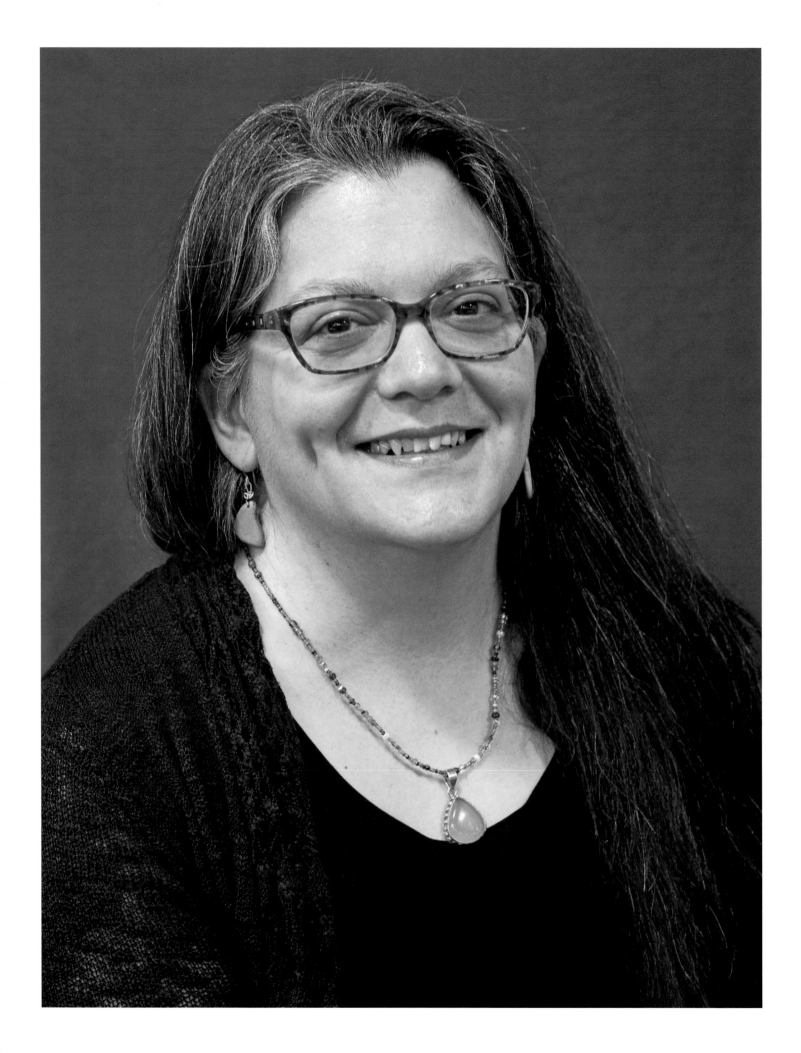

What Whales Want

What if we could swim oceans?
What if home meant water, darkness,
depth? What if air were precious scarce
and our hearts beat sleepy slow

in time with each blessed breach?
What if we circled continents
like currents, our bodies indifferent
to land, property, gold; what if

what mattered were only the taste
of one sea or the next, the pull of moon,
a song made up between the birthing
and weaning of babes? What if

that were our world,
and all we needed to know
was how to do it well?

Deborah A. Miranda

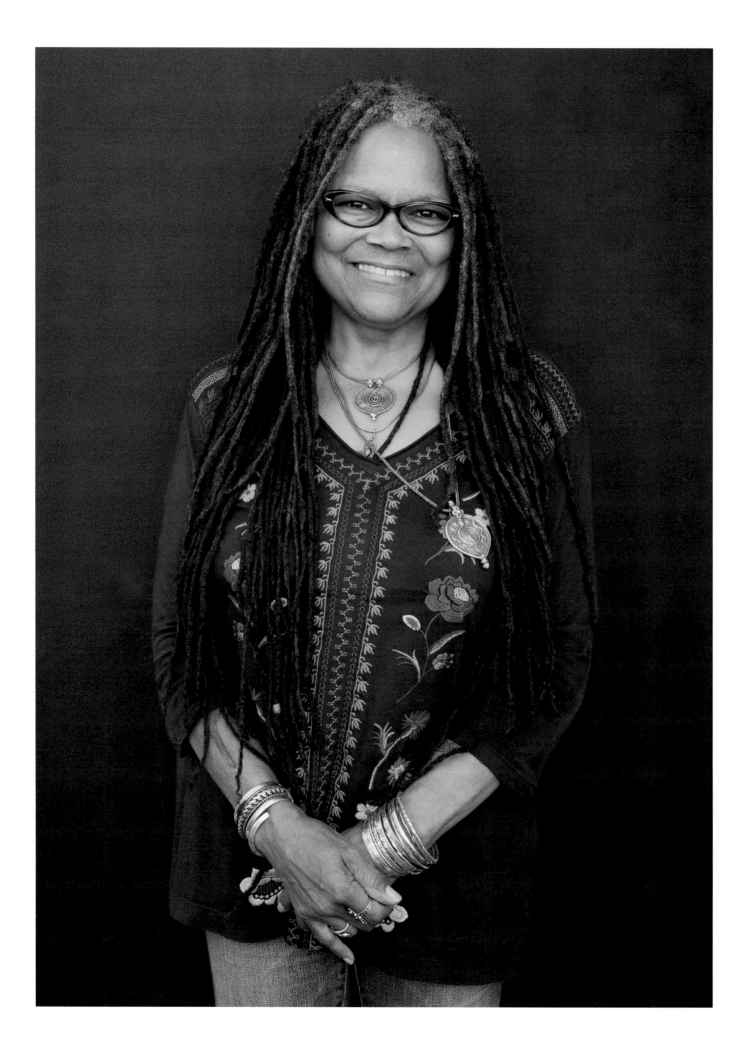

Double Nickles
for Eugene Curley

Fragments remain cutting up the pieces to make the whole
the white space around the border
a broken arrow someone's great-great-great grandfather held onto
The skins taken off a dead woman hang in a museum to remind us of Manifest destiny
tell tale signs old shields moccasins a baby's cradle board a headdress
and a shirt someone danced in to bring back a dream
distributed like the spoils of war numbered and catalogued
blood stains in the snow are only memories
Wounded Knee a tale told twice
Smoke and ash of long gone cook fires something else passed into history's memory
Where are you tonight where is your head pillowed are you shadow dancing

In my heart there is a red hand print and the bitter taste of history's lies
90 proof won't bring back the warriors won't change the way some women bleed
When I say I'll see you in the morning that is a prayer that you will survive
My heart is singing to you can you hear it
It is the drum calling you to warm yourself wake from your haze
It will take more than a fast horse more than beads and ribbons
There are so many stories to be told
I don't want you to become one more urban Indian statistic
Don't want to hear th earth shattering news that someone found you . . .
off 18th and Mission
with your head split open and sunshine pouring into dead eyes
Remember that photograph you keep telling me about
of the young mothers with their children
We are no different than the ancestors We are what they left behind
to continue
fire water poisoner of spirit teller of lies broken glass
broken hearts broken lives
the cutting of the pieces to destroy the whole
How do I talk about blood wine and sacrifice
I have not seen you in 10 or 15 days
and that tape loop is playing in my head again
When I say I'll see you in the morning it is a prayer for your survival

Gail Mitchell

Mind, mind, oh blessed mind,
Survive the body Be so kind.

N Scott Momaday

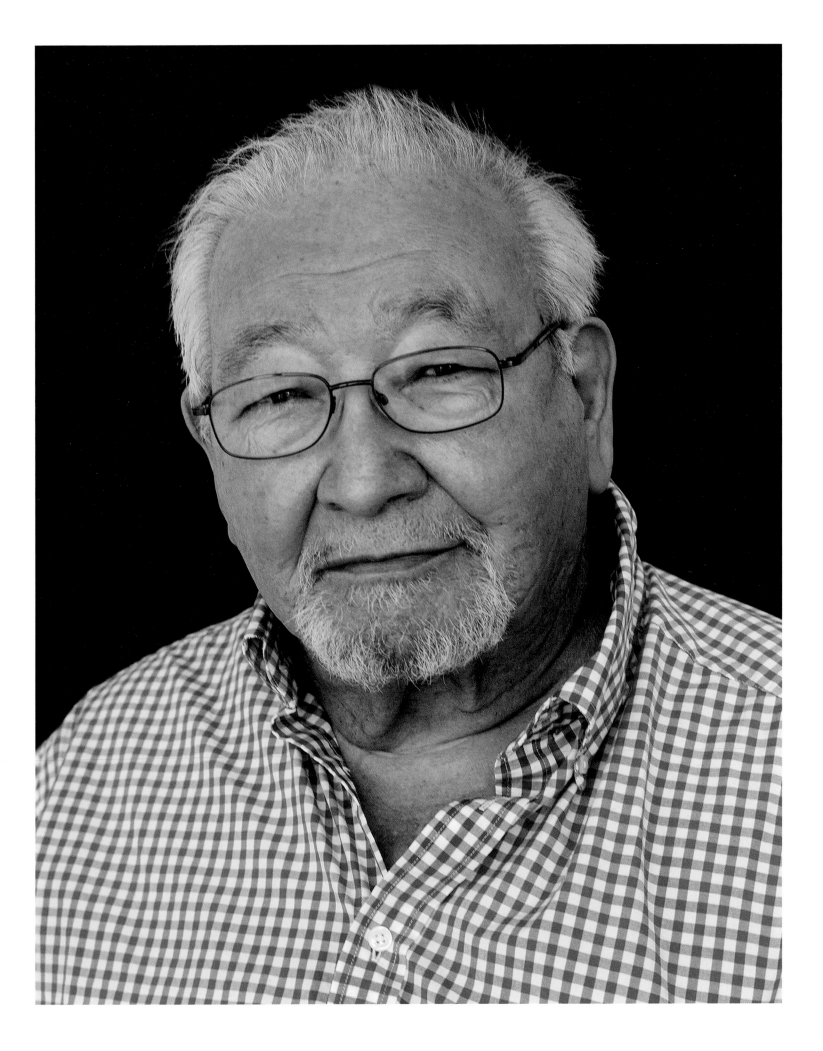

Twins

We are as close now as we were in our Mothers womb. When we are separated for any length of time we become depressed and irritable. Our disagreements dont really matter. We are one and have been since our Conception. My twin was once asked what it was like to be a twin; her reply, "Its like having your best friend spend the night every night.

C. L. Nelson
Catherine L. Nelson-Rodriguez

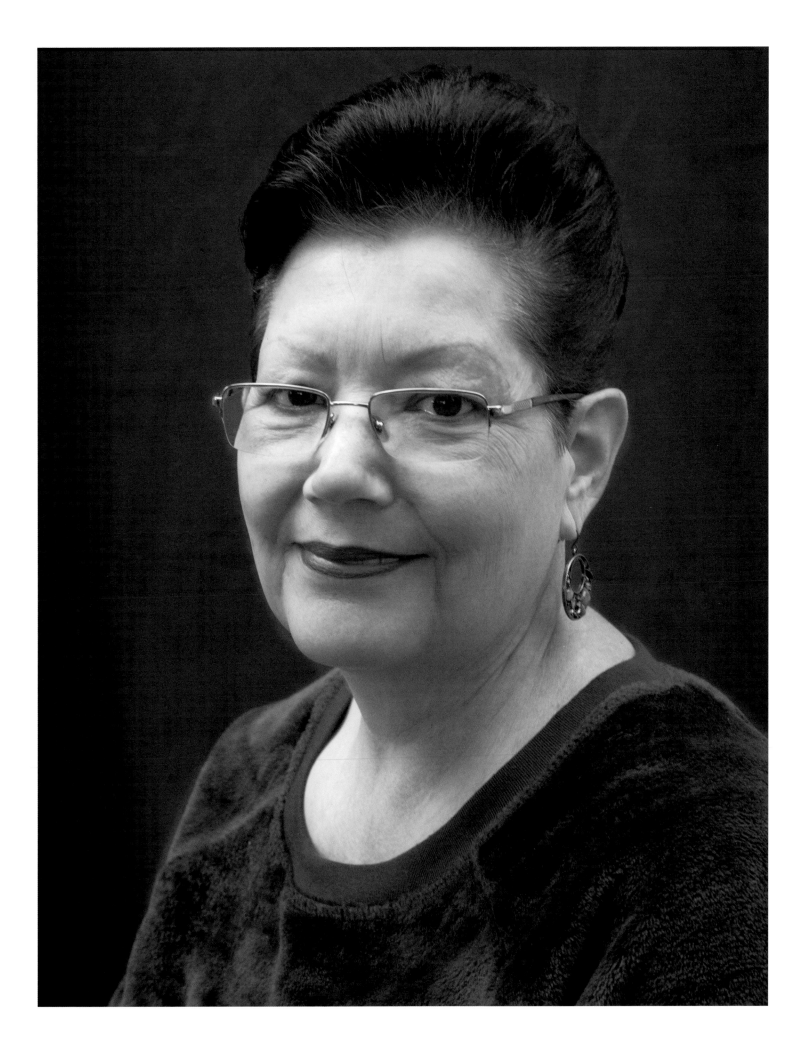

WHERE SHADOWS STRETH
TO THE PACIFIC

WHERE REDWOOD IS A HEART
SUCKING UP HEAVY RAIN

WHERE MOUNTAIN LIONS
KNOW THE ORIGIN OF JAW AND BONE

WHERE THE MIRROR OF RAIN
HOLDS HISTORY

WHERE REDBUD DESIGN
IS MEMORY OF ORIGIN

WHERE THE HAND OF GRAMMA
BENT WILLOW SHAVED AGAINST STONE

WHERE MEMORY CLINGS TO THINK PINK PETALS
TAKING FLIGHT

WHERE I LET LOOSE THE RED LACE
OF MY HEART
TO LET YOU IN

Linda Noel

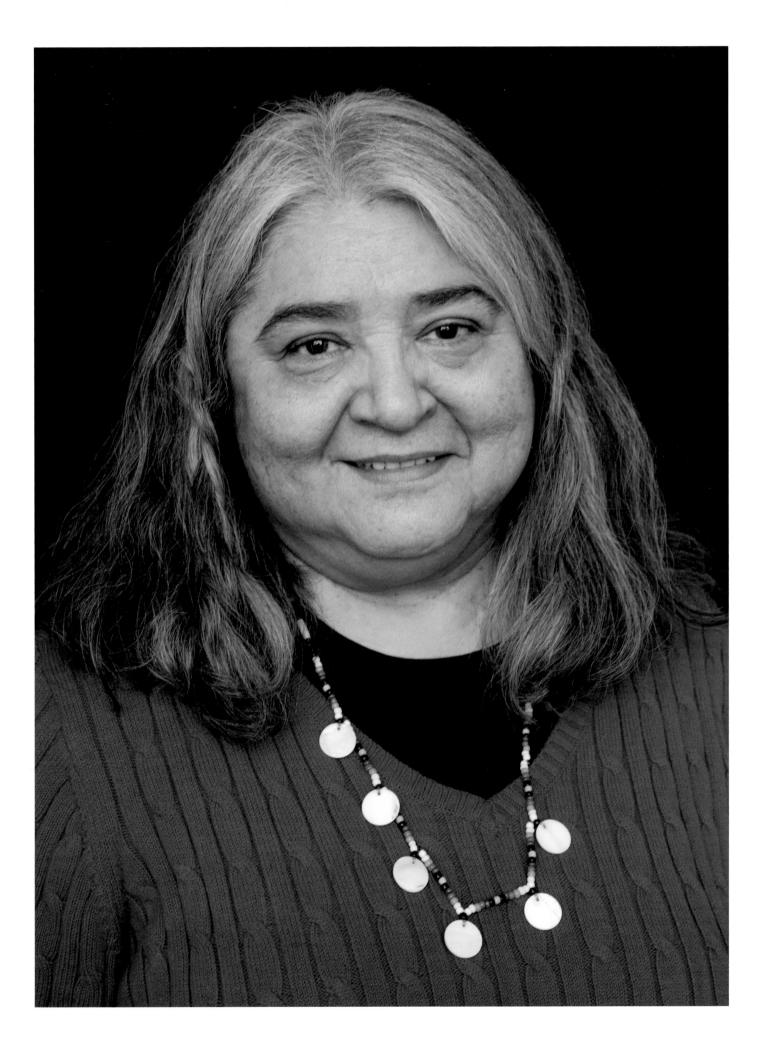

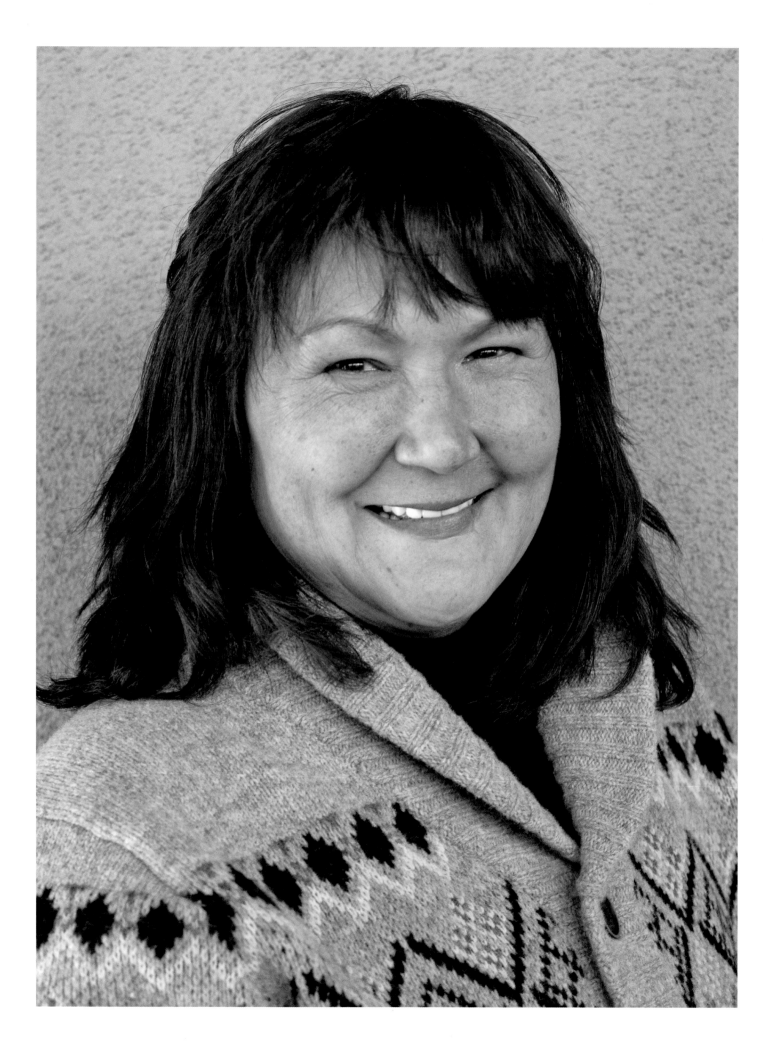

(the end stanza of Little Gidding)

corpse whale

We shall not cease from exploration
And the end of all our exploring
Will be to arrive where we started
And know the place for the first time.
Through the unknown, remembered gate
When the last of earth left to discover
Is that which was the beginning;
At the source of the longest river
The voice of the hidden waterfall
And the children in the apple-tree
Not known, because not looked for
But heard, half-heard, in the stillness
Between two waves of the sea.
Quick now, here, now, always—
A condition of complete simplicity
 (costing not less than everything)
And all shall be well
When the tongues off lame are in-folded
Into the crowded knot of fire
And the fire and the rose are one.

 t.s. eliot
 ~from Four Quartets

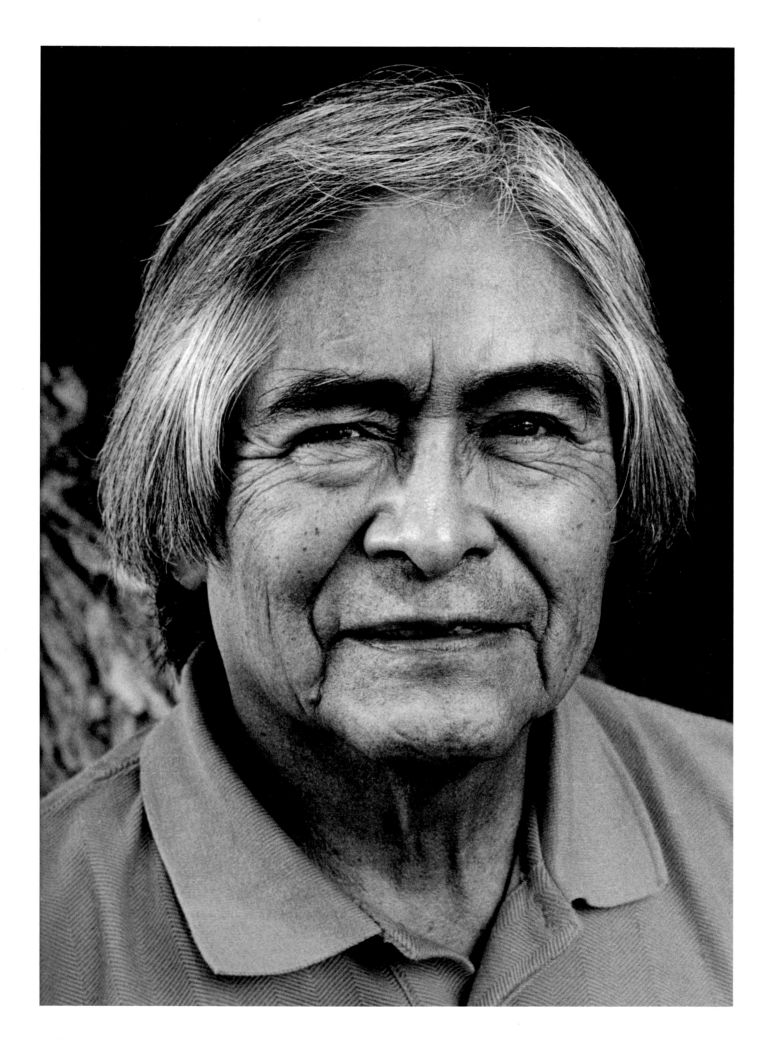

Stories and poems. Poems and stories.
That's what my life is everywhere I go.
No matter what I'm doing. — no matter what
 thinking. Or feeling.
I'm ~~doing~~. They are there: stories and poems.

In a way, I have no choice but to acknowledge
them. Because they are there. Before me.
All around me. And I am part of ~~them~~.

All people are — poems and stories, stories
and poems — part of ~~them~~, and we become
part of them and part of each other.
 Simon J. Ortiz
 Tempe, AZ

On this night i GRASPED
my hand
 HAND it to them
FUELED
 But what's it FOR???

STUN the WINGMANS
 OWN desire
Deep-FRIED
 UNTELEPATHIC
 WIRE
my JAW shut tilt the
 FLOOR
Focus that Hocus right
out that CRAZY door!

Wishful thinking
 ALL times BEFORE
THE BRAVE HEARTS
pumped You UP
 ADORED

 TURN up
 TURNED ON
 THE ENERGIZED

 AM READY
 FOR A BIG
 SURPRISE!

leaura ortman

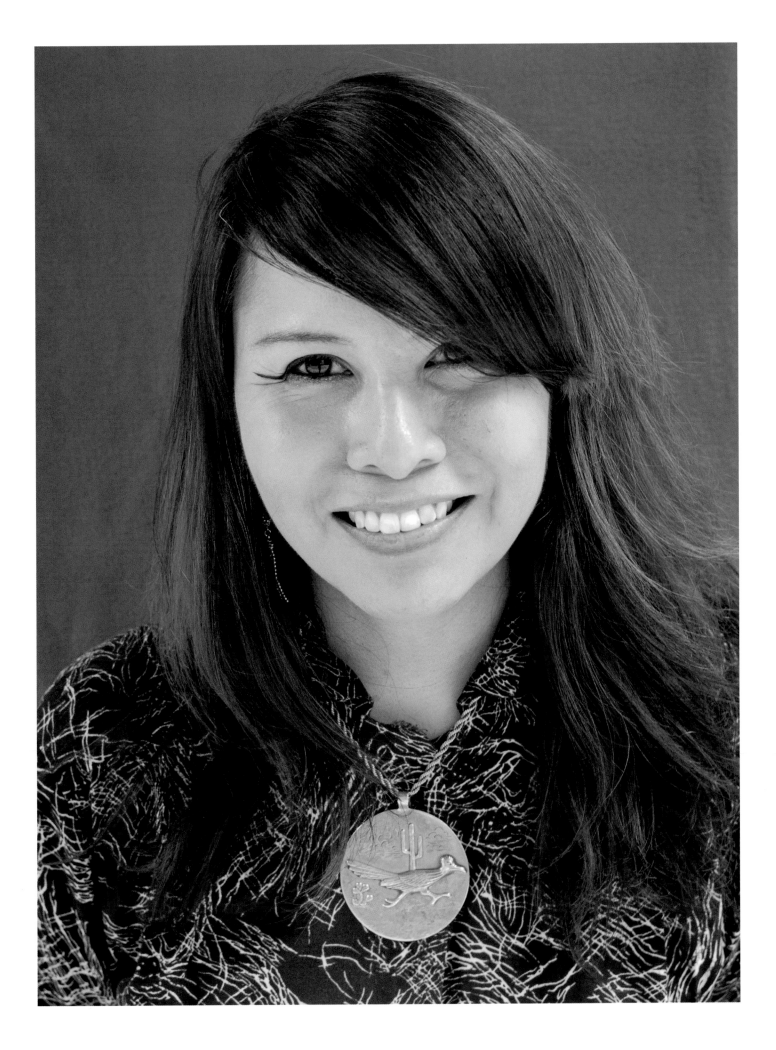

I moved home in the Spring
But didn't know what that would bring
The journey, truth be told
Has been worth it's weight in gold
And each day I want to sing.

I am a proud member of the Haliwa-Saponi
That's Halifax and Warren - then Saponi.
I'm a single mom—
my kids are da bomb
And there's nothing about me that's phony.

A few years back, my son grew ill.
Everything I knew, my life, grew still.
All my focus was on him
And I tried to satisfy his every whim.
Because I didn't know exactly what was
God's will.

But little man over came the hump—
Realizing it was just a "bump"
In this beautiful life of ours
That is filled with sun, moon & stars.
Now he is not afraid of any leap or jump.

We only have on life to live
It is up to us what we give
I choose to live to the max.
Cuz you never know when God's ax
will come to complete your life.

A. Kay Oxendine

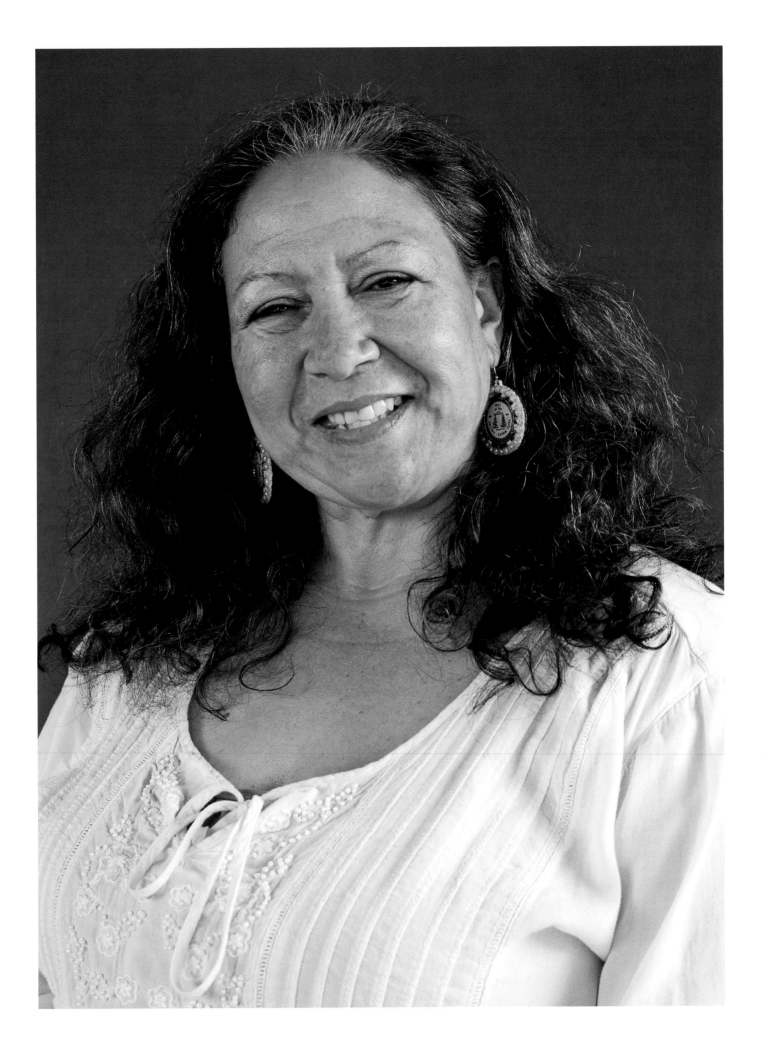

Kwasinaboo (Snake Medicine)

Earth smells slowly emanate upwards
Sweet grass, cedar, sage and
Ghost medicine
Interweaving inside the sweat lodge

My companion steps aside
I enter the dark space below me
"Don't say it," he pleads — yet
Your powerful name escapes my
Lips once again!

Hidden in a snag
Hibernating in wintertime
Secreted in sweat lodge rafters
Coiled in crooks or
Sliding through dried prairie grasses
Moving like Spring lightning
Rising up or
Flattening out
Fitting through horizontal vents
Slim magnificence and
Terrible summer wonder

The Comanche name you
"Tail with a design," a magical being
With it's repetitive pattern and
Unspeakable, unblinking eyes

Like a strange puzzle in a great mystery
I say your name and you appear like magic
Somehow this terrible pleasure
Outweighs the fear as we
Conjure you together
The quest — an uninvited gift.

Juanita Pahdopony

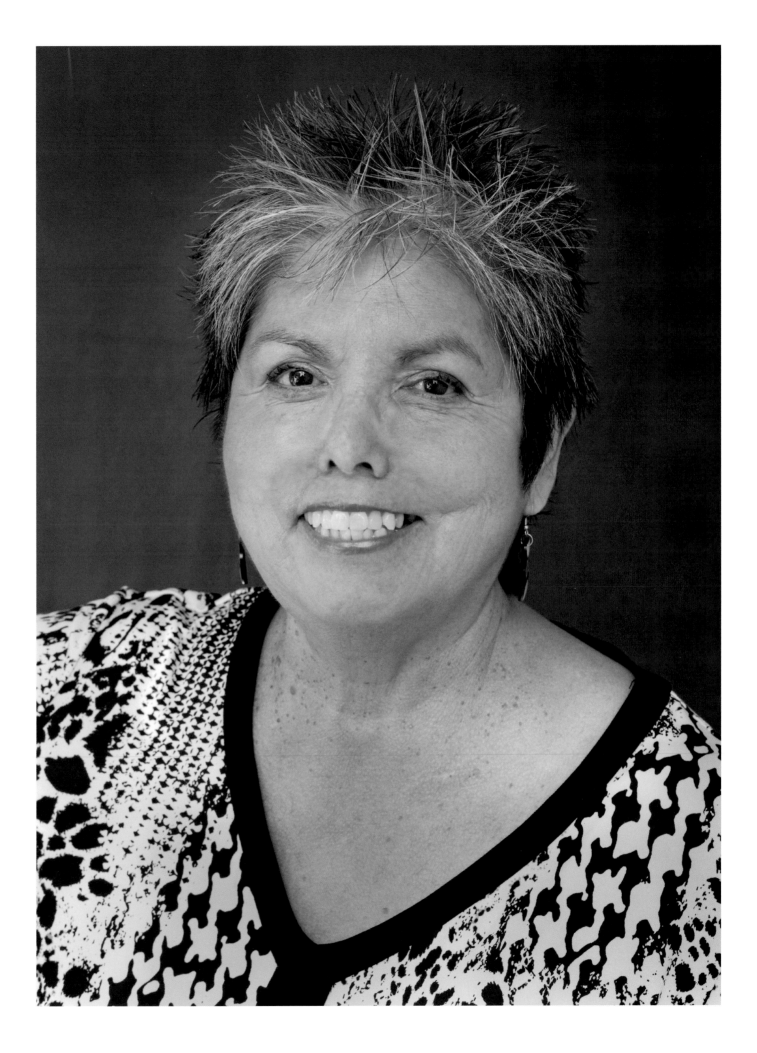

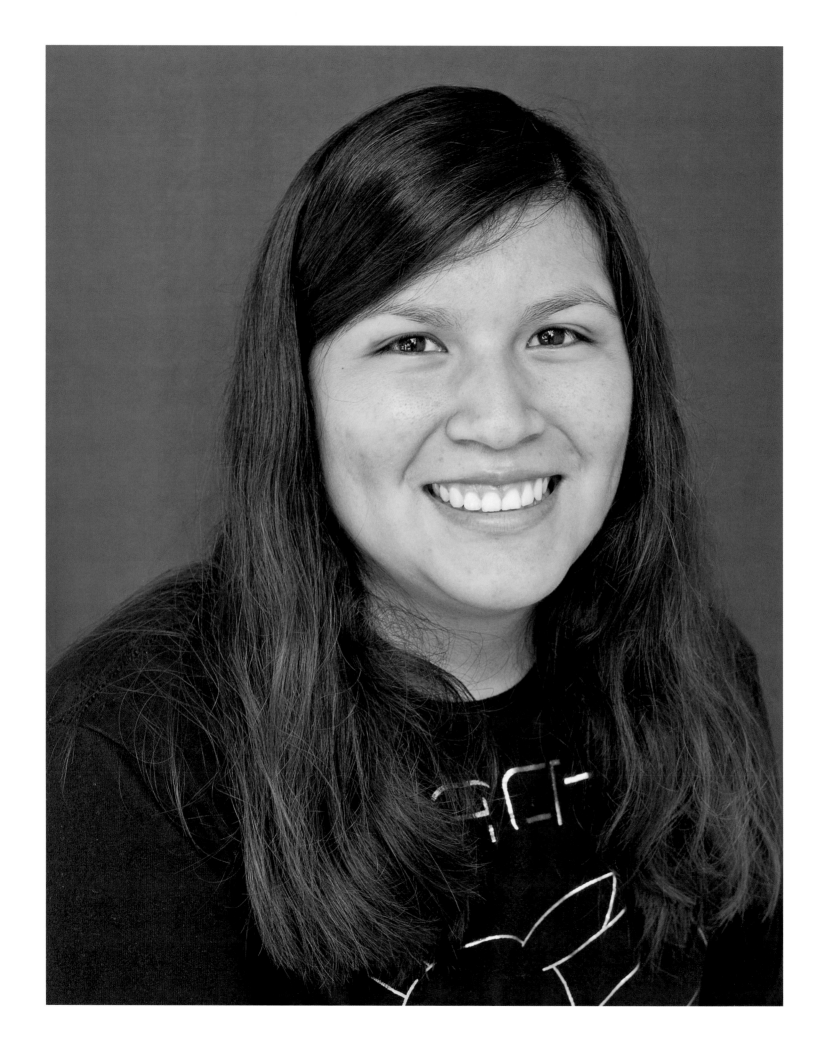

"Do you want to die?" The angel asked. Her eyes lifted to look at the teen's. The teen shook her head. "Why? What have you contributed to the world other than cold remarks? What kind of life have you lived to benefit others?" The sweet angel suddenly turned on attack mode. The teen felt herself shiver from fear. For the first time in her life, she felt fear. She was worried about her fate. She had never believed in fate until she was on the verge of death. "When angels save," The angelic being sat on the bed, never breaking eye contact, "it's for those who have much to contribute. It's those who deserve a second chance at life." The angel flashed a confident smile at the teen.

"Wait! You mean you can't save me?" The teen asked in a panic. "If you give me another chance, I'll right all the people I've wronged."

"That's dandy and all, but you hardly dented anyone's future by your harsh remarks. Only one life has changed—your soulmate's." by your perked the interest of the angel. The girl was willing to sacrifice her "My soulmate? What if I help him." The teen suggested. This soulmate to live again—to stop the mourning of her parents. This was the first time the teen showed interest in others.

"You must help him reach any goal he desires. Any goals. No matter what happens, you aren't real. You aren't truly alive. Remember that. You must help him regardless of how you feel. Only then will you be given another chance at life." The angel gave a cute smile. The girl had agreed, not knowing how painful her objective would be.

Black Tinkerbell

Mary Grace Pewewardy

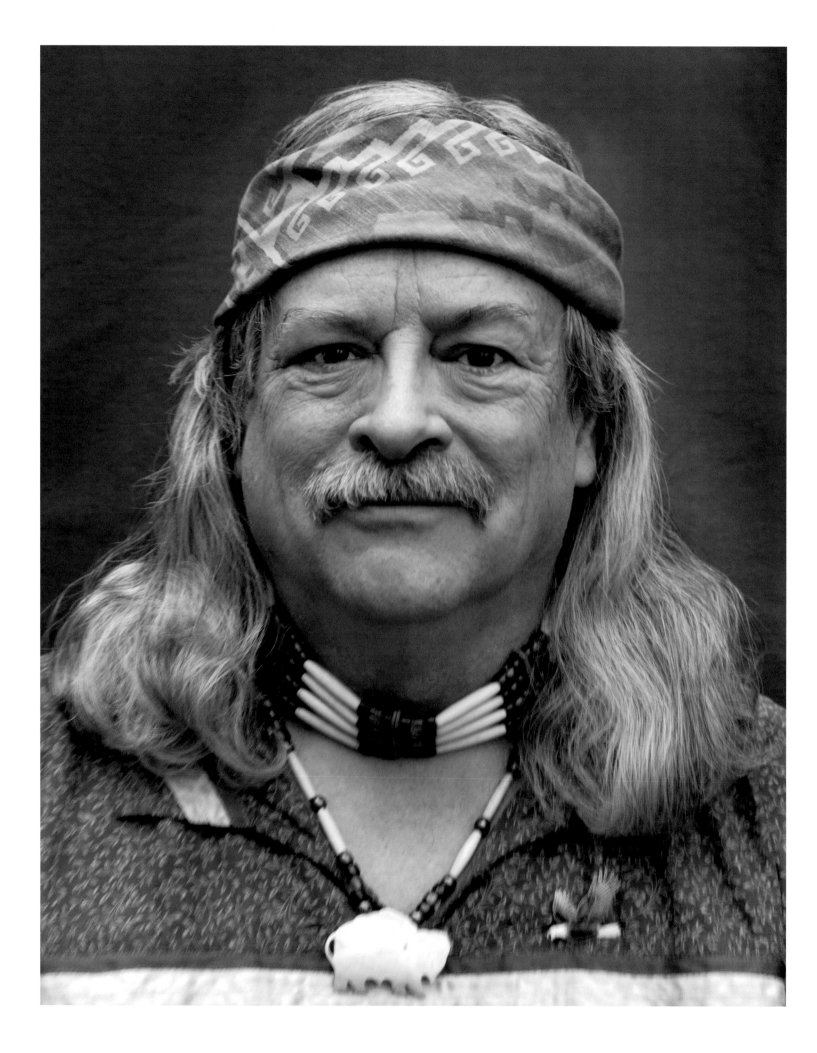

The Aunt Who Haunts Me Now

My Great Aunt Helen once said to me
A boy of just Thirteen
"You gotta know your ancestors!
I'm a Micmac," she said
 in a voice so Downeast Maine and true
"and that makes you one too!
There's really nothing you can do about it
The spirit that runs through me
 will go through you.
So here's some sweet grass
 and here's some sage
And don't... don't...don't... ever be afraid
There are lots of changes
 in the socio-political system
 That need to be made
And if your great-grandpa were here
He'd say the same
This is not a game.
You need to learn the ancient ways
You need to be independent, fearless
You need to be strong
Cause some day no one else might be singing that old song
The one that keeps the sun coming up at dawn
But someone has to sing it
Or Creation won't continue very long!"

Evan T Pritchard

Underdog

Ain't it funny how the world can get to you?
Even fools get lucky sometimes
Every cloud has got that silver lining round it,
Mine just needs a little dusting off...

We are the underdog
We're the fighters getting ready for the next round
We are the underdog
It's never easy
But our odds keep tumbling down.

— Martha Redbone

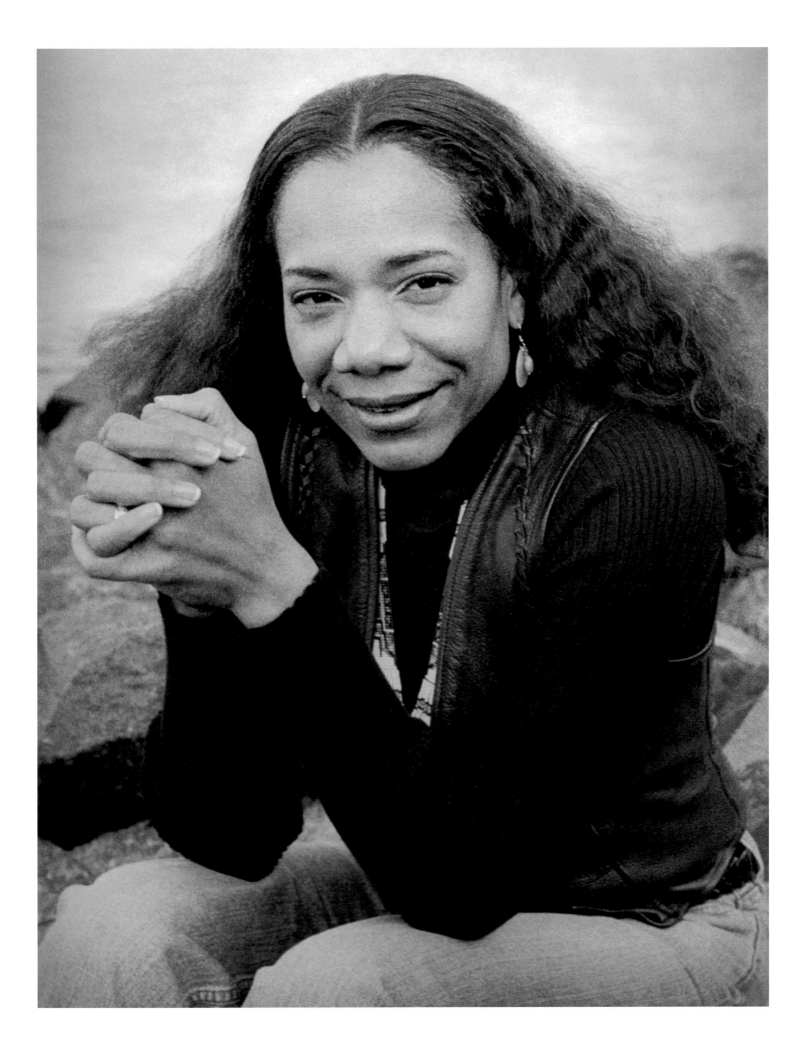

Untitled

Today, I feel Bearish
I've just stepped out
of a stream
with a jerking Trout
In my paw

Anyone who messes
with me today
Will be hugged
and dispatched.
Ishmael Reed (Afro-Cherokee)

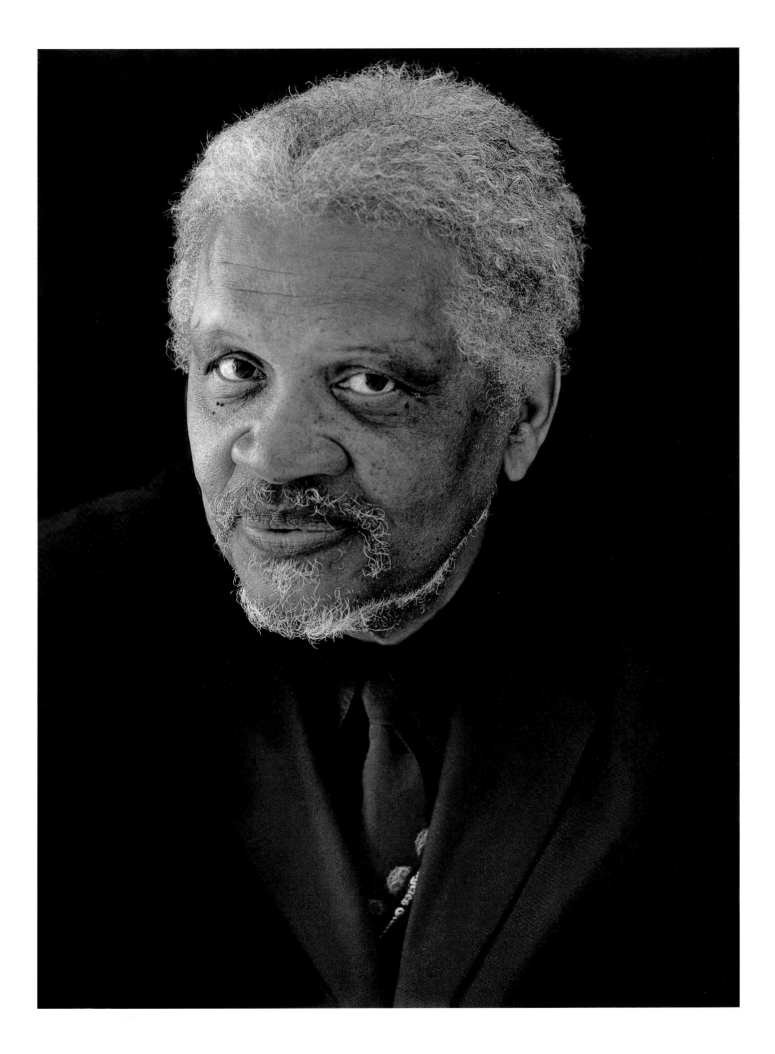

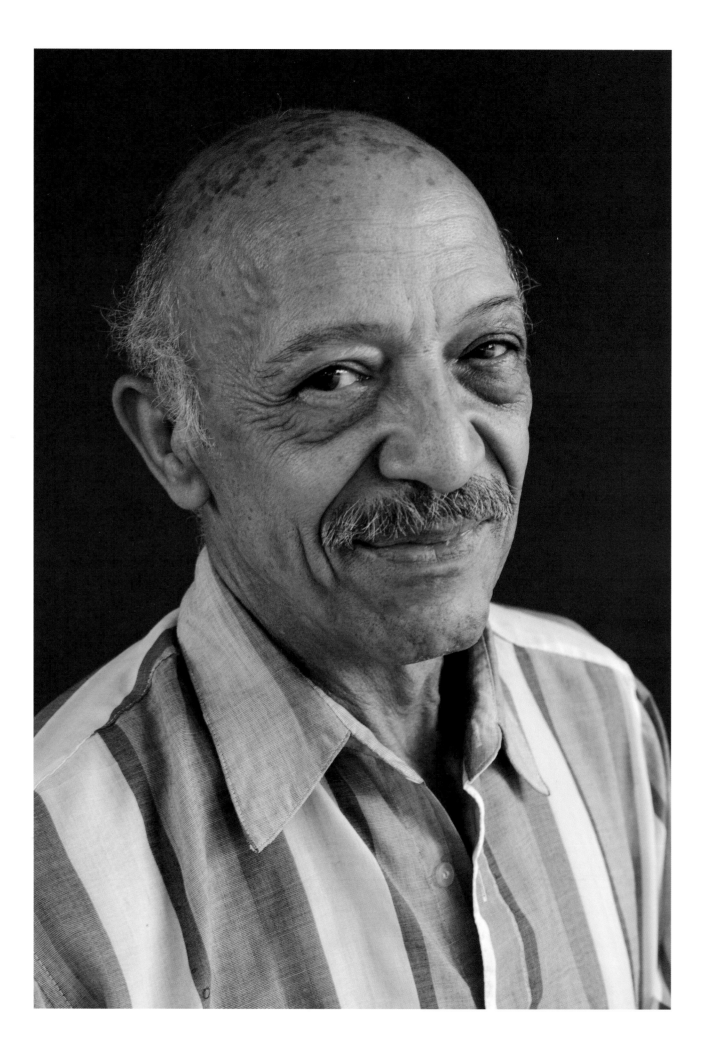

Corporate Securities

The on-shore breeze carries the sound
out across the water. The moon floats above,
silent. How will this one end?

"Thanks for meeting me on such short notice."
"I'd already done my hair..."
"Please come with me."
"I can't. This is my home. Besides, you don't
really want me."
"Of course I do! I've offered to pay for you to
move."
"Yeah, right."
"What's that supposed to mean? Don't you trust me?"
"What about your part? You never talk about
your scar."
"That's over. Leave it in the past."
 (I CAN'T TELL YOU ABOUT THE ADJANI. THEY THINK
 I'M DEAD.)
"If I don't know where you've been, how can I
trust where you're going?"
"I don't know what else I can say."
"Well, I don't either."

As the separate taillights fade into the
distance a tiny crater is formed, invisible
to the naked eye, as the moon sheds
a burning tear.

Bobby J. Richardson
17 July 2015

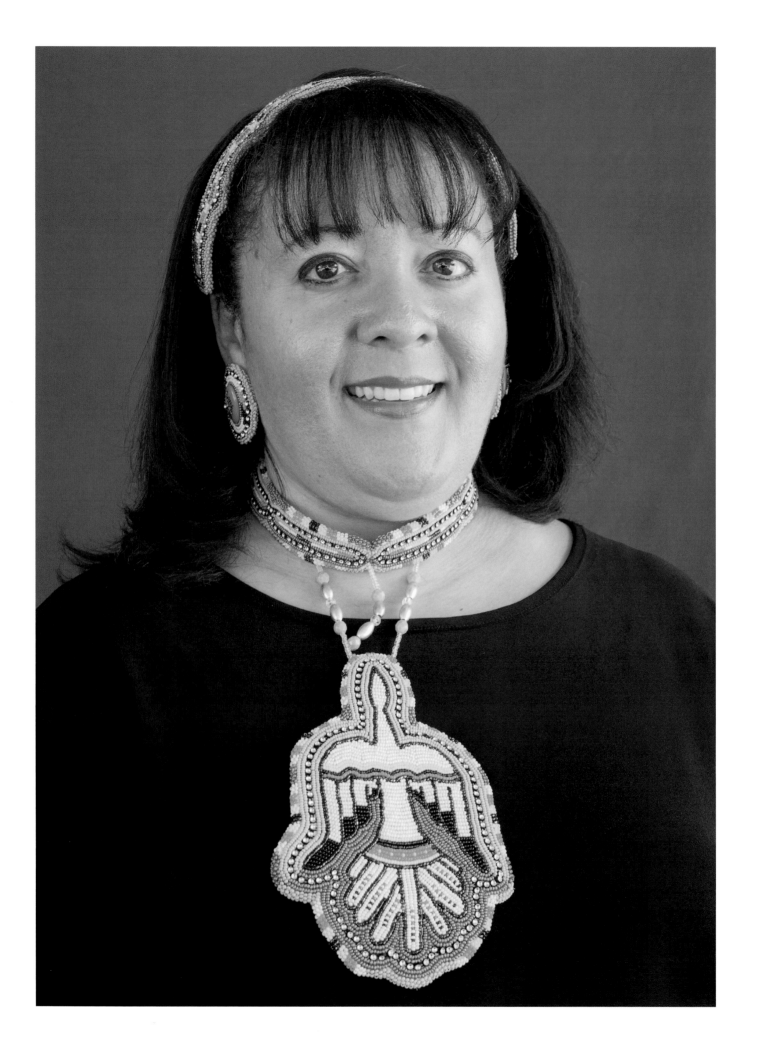

The Cycle Continues

You don't know what its like
Always being on display
People staring at you
People mocking you
All because you're an Indian

They say "Are you Hispanic or Italian?"
"You can't be white. Well... you must be black"
"What exactly are you anyway - mixed?"

They're always denying who you are
And make you carry a card around to prove it

"Woo Woo Wo!" "Can you make it rain?"
"Where's your feathers 'injun'?" They taunt.
So you stand there like a freak at a side show.
They'll never stop the stares, the gawking, the mockery
The ignorance has been passed down from generation to generation
Their ancestors tried to kill us all
They try to deny us all by making us something else
But the fact remains we're not going anywhere
And so the cycle continues
And I stand here once again on display
and I try to educate them a little while I have the spotlight
And a few change their minds about us
And a few could care less
But I've done my best to make the world a little less ignorant
Why can't you just accept me for who I am?

a human being!

Ladonna
Richardson

MIGRATION

The bottle nose dolphins circle the harbor off Nantucket Island. It is a cold December day and they should be out to sea on winter migration south. No one knows why they have come into the harbor.

An old woman stands alone on the shore. She watches and listens. "They have come for me," she tells no one.

3/20/2015 © Barbara Robidoux

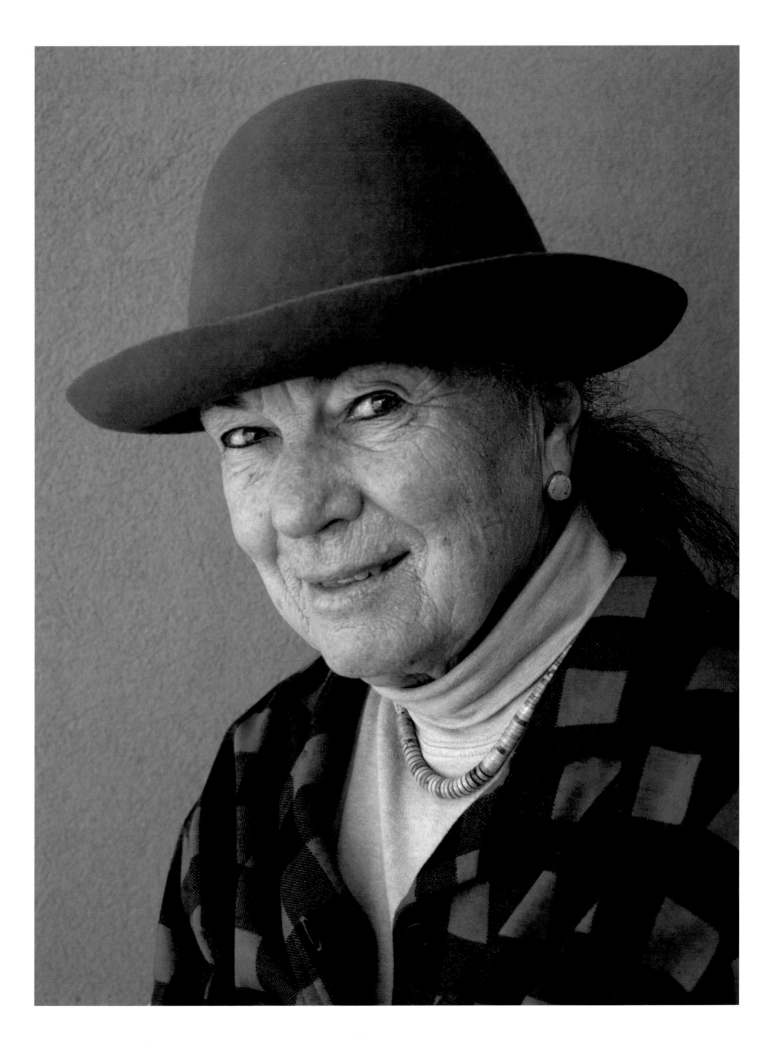

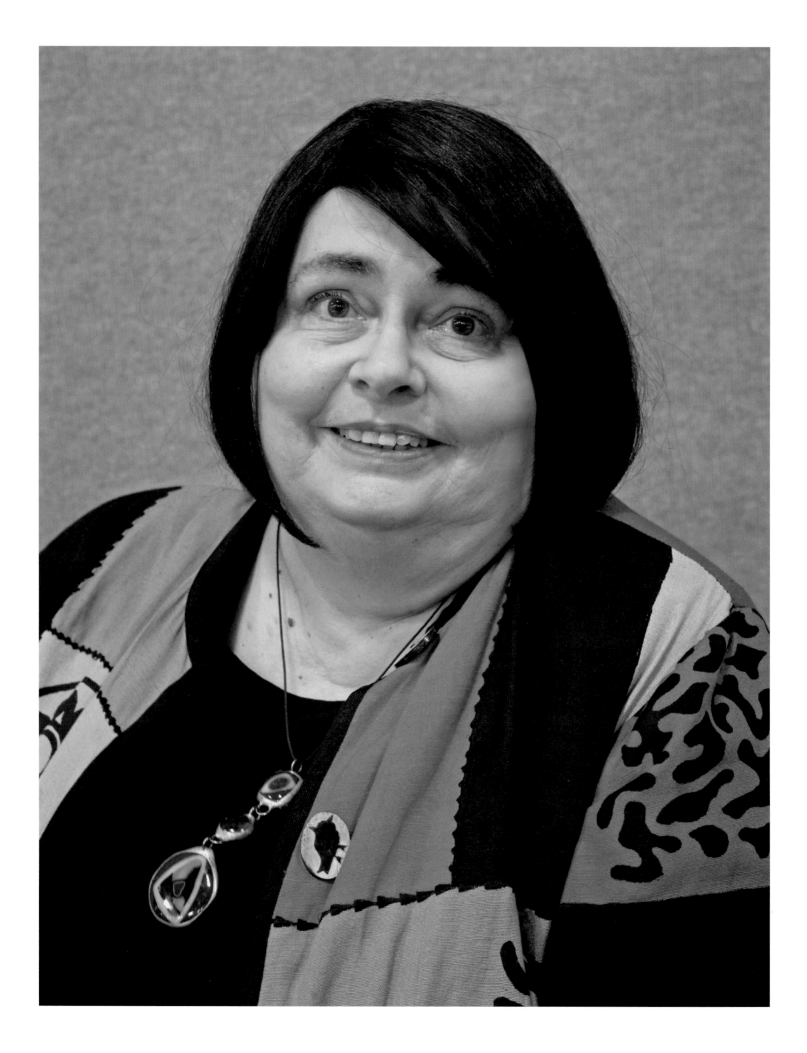

Something To Do With Respect

It was summer in a younger time.
We sat out on the flat roof of the garage,
slicing lemons and limes into our drinks
watching stars showered on the night's velvet.
I looked for The Boys
that Grandma told me about,
sons of seven medicine families
levitated to the stars to judge
whether we should be allowed to go on
every 52 years.
You waved the knife at me,
splattering citrus juice on my face.
"You got to forget all that old shit."
I've never forgotten,
and you, my old love, never made
your full cycle of years.
Something to do with respect

— Linda Rodriguez

So dance the mission revolts,
let ambush blossom in your lungs,
claim the enemy's finest night,
sing, oh sing him to death,
for when he sees how strong
is spine tied to spine,
woman holding woman,
Coyote will creep most quietly beneath
the ancient gallows that creak and creak...
... must lure the soldiers

into the trap,
must feed them
 dried mushrooms,
old meat...

 Wendy Rose

excerpted from "One of Those Days When I See Columbus"
Itch Like Crazy

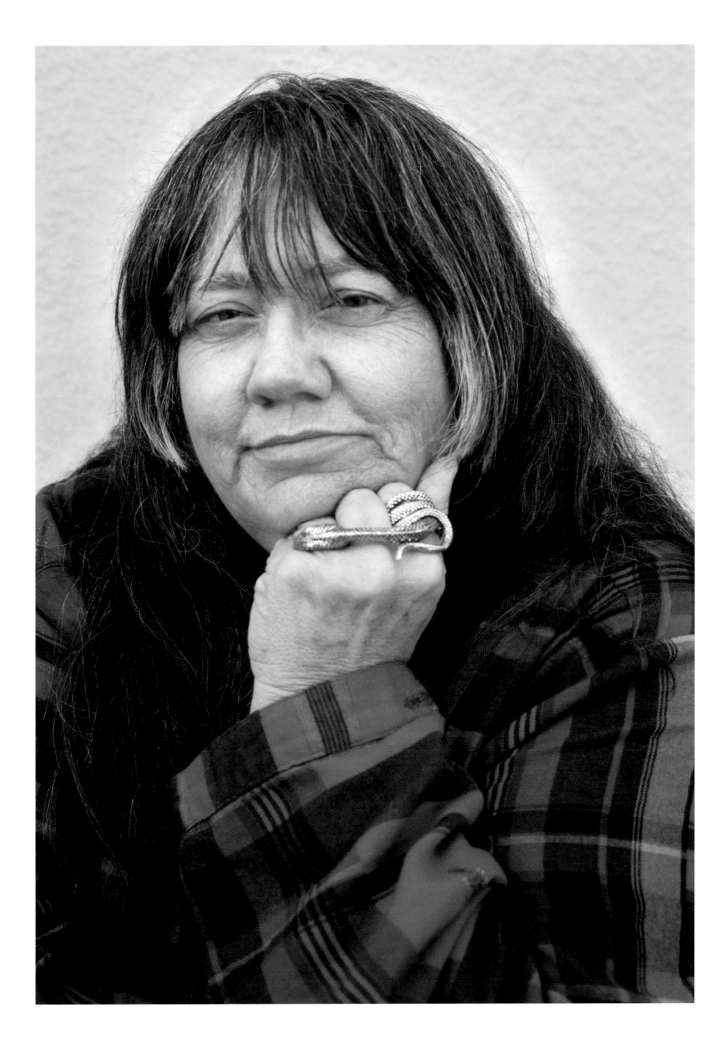

Beadwork

I dreamt of my grandmother
the way she sat in her easy chair
looking very old, yet hair dark
parted in the middle with two braids
rocking in her chair
arms resting on her apron lap
over a long dark floral dress
the way she would twiddle her thumbs
her other fingers intertwined
a representation of her beadwork
gifted for creating the traditional patterns
sought after for beauty and detail
even loaned pieces to my auntie
for her contemporary Indian fashion shows
that adorned her models wearing
ribbon shirts and Lakota pattern dresses

I see her there rocking, twiddling her thumbs
grandmother says nothing with no expression
perhaps in deep thought
on the intent of a next design
her beadwork is currently in
the Sioux Indian Museum
are on a national historical registry
4 pair of earrings and a bolo tie
sit wrapped in a small cardboard box
in dark storage of the museum
waiting for someday their bright bead color
spirit to escape
from their own dream

Kurt Schweigman

8/3/15

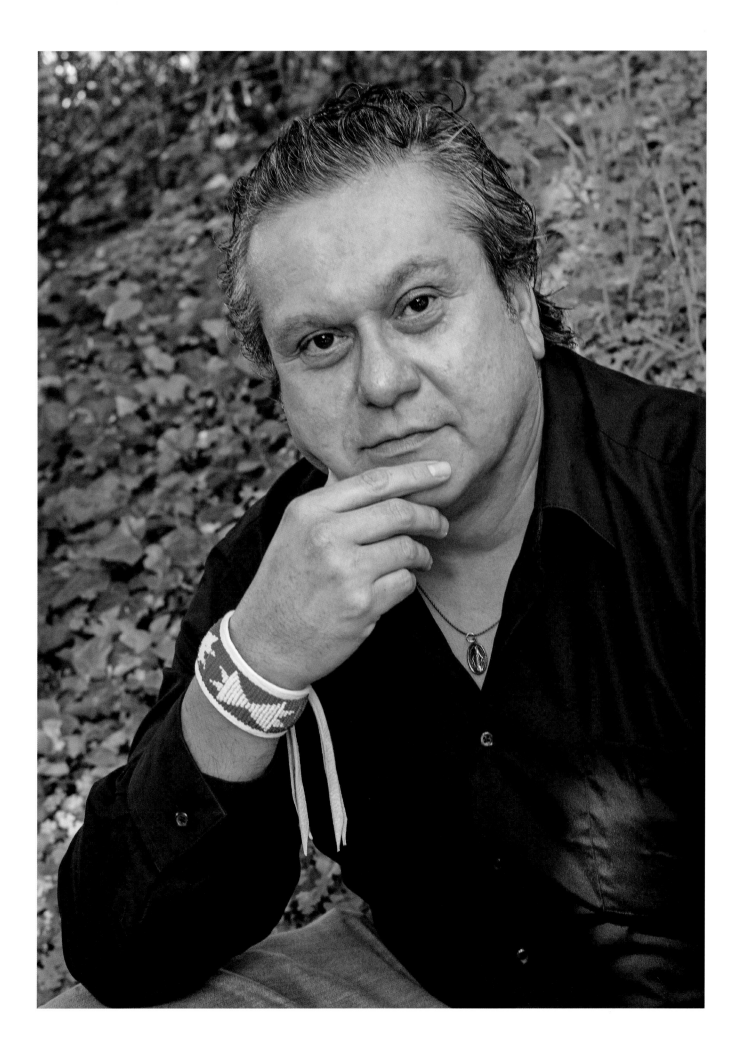

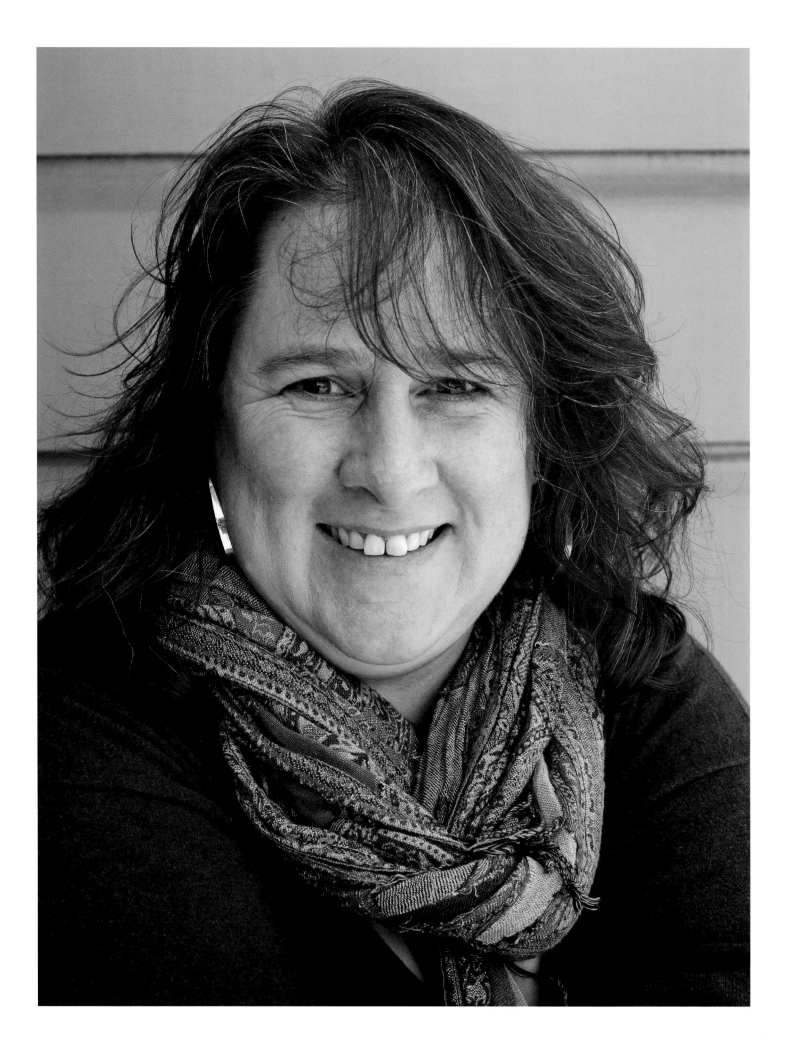

The Butterfly War

Never ended this
Tension and the
Sierras keep burning
Flame pressing tips into each
Hidden place that Tenaya
Knew and as the
Fires pass the people
Scatter grass seed to
Hold the earth down hold it
Down in the Valley in
Mariposa grove there is this
Fire and it reads the
Stories of these hills in a voice too
Terrible too airless for
Understanding takes the
Trees by the throat and
Reads them ring by ring
Into Every fingerhold that
Water has and the
Beating of indefinable
Wings of flame these
Winds of burning take
Non-human prayers to
Other gods on that
Smoke and every bit of
Hope and history is
Told and retold in
Cracked rock and
Charcoal stands of trees

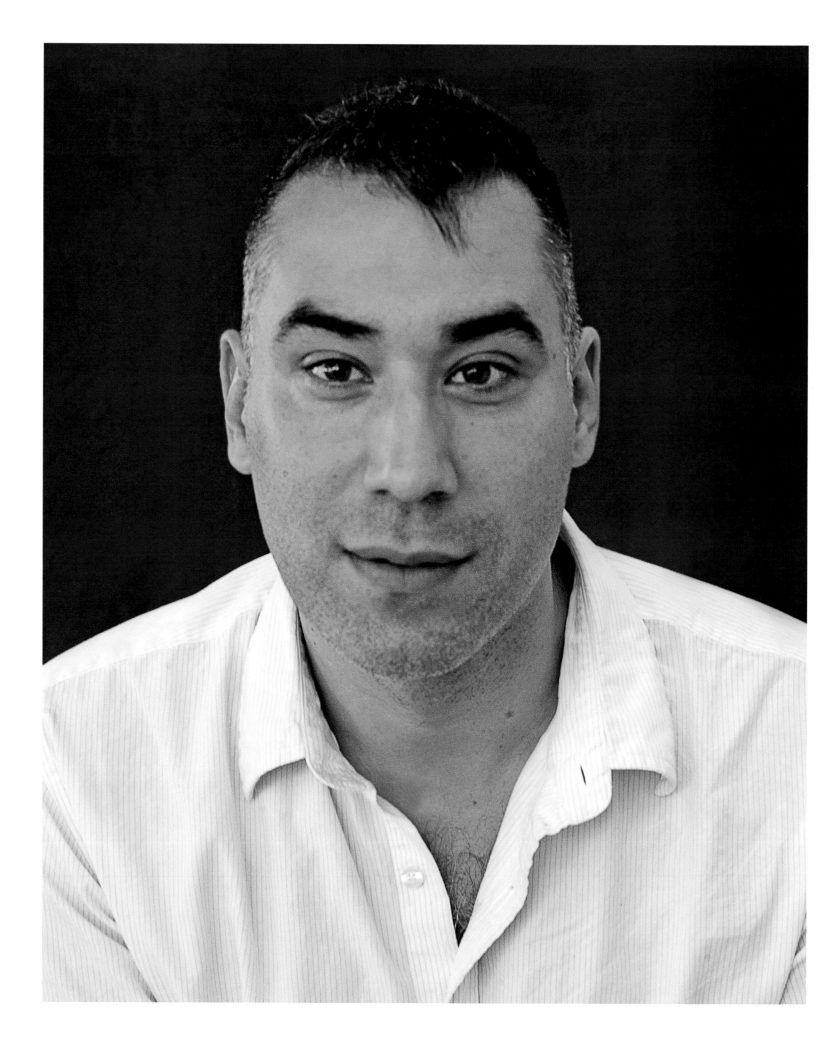

A Small Secluded Valley

Your portraits are all stick indians
Half their faces edging out the fog
Where sparks rain onto our temple, where I enter
to write the names of my poems for the night
Day Break Star and The Sun, both of which

 I never got around to

For want of love and allegiance in every second
My regrets you interrupted. Offset in the kind light
as a crown. (Evans walking around sounds behind
a closed door) Nice to see you, to walk a bit
and stop as on a river. Its lava shut under
in a tunnel of love, regardless the visions
hike up overnight and flames trail off like
the finest spiders thread slipping my mind. Cedar 8-23-13

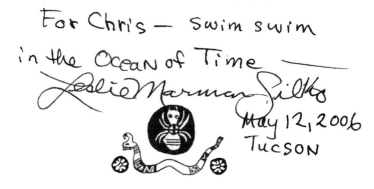

For Chris — swim swim
in the Ocean of Time —
Leslie Marmon Silko
May 12, 2006
Tucson

From The Golden Book

And once when we lay, an impossibly bright moonlight through the blinds,
we looked at our striped legs, torsos, and feet.

The Jumanos, the striped ones of the southern Pueblos.
Their clay ollas painted with painted peoples. Tompiro.

Gone now. But you're here next to me. Stripped and striped and
smelling of rivers.

James Thomas Stevens

A Mindful Invitation
Una invitación consciente

Inés M. Talamantez K.

It is the sun with its litole, raya that bring us new life
It is the moon's radiance that watches over us during the night
It is the female rain that gently washes away our fears
It is the breeze that caresses our skin making us strong
as we walk on the land
On this sun day I offer my thoughts for all of our
journey to succeed.
This is hard labor
The ancestors knew we were coming
They left work for us
Now we carry their wisdom forward.
Know who you are, sabe quién eres
Know your land, conoce tu tierra
Learn your language, aprende tu idioma
Follow the beliefs of your people, your spiritual culture
Do not let spells affect you.
Like every other achievement of human thought
We have emerged culturally and religiously
We are still exploring the possibilities for future growth
Seeking and testing, so take time to measure our generations
and know that through working together we
continue to build decent conditions for our people
This is our obligation
Never give up.

They Lived Here

The Holy People lived here in the beginning.
They built the first hooghan, made the first weapons,
sang the first songs and the first prayers.
Diné language, ceremonies,
history and beliefs began here.
This is where we began.

The Round Roof Hooghan

The round-roof hooghan is like a woman's tiered skirt.
It is said that the mother, amá, is the heart of the home.
It is said that there is beauty within
when a home is as it should be.
Beauty extends from the hooghan.
Beauty extends from the woman.
Beauty extends from the woman.
Beauty extends from the woman.
Beauty extends from the woman.

—Luci Tapahonso

~ Luci Tapahonso
1/20/15
Santa Fe

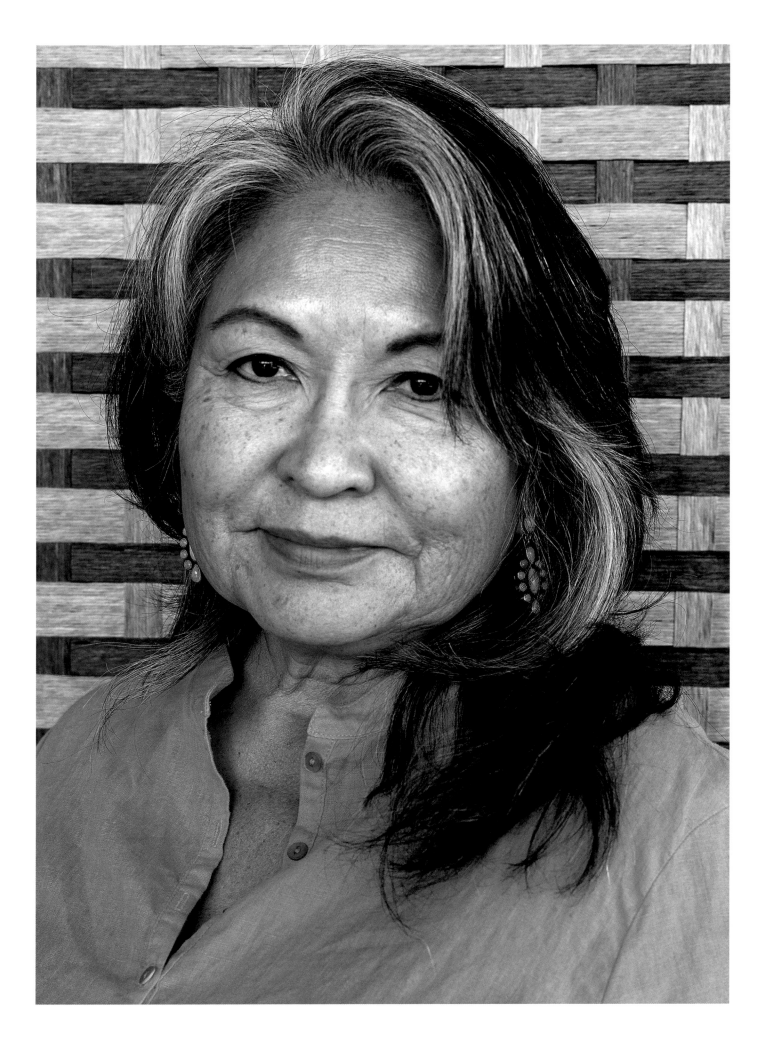

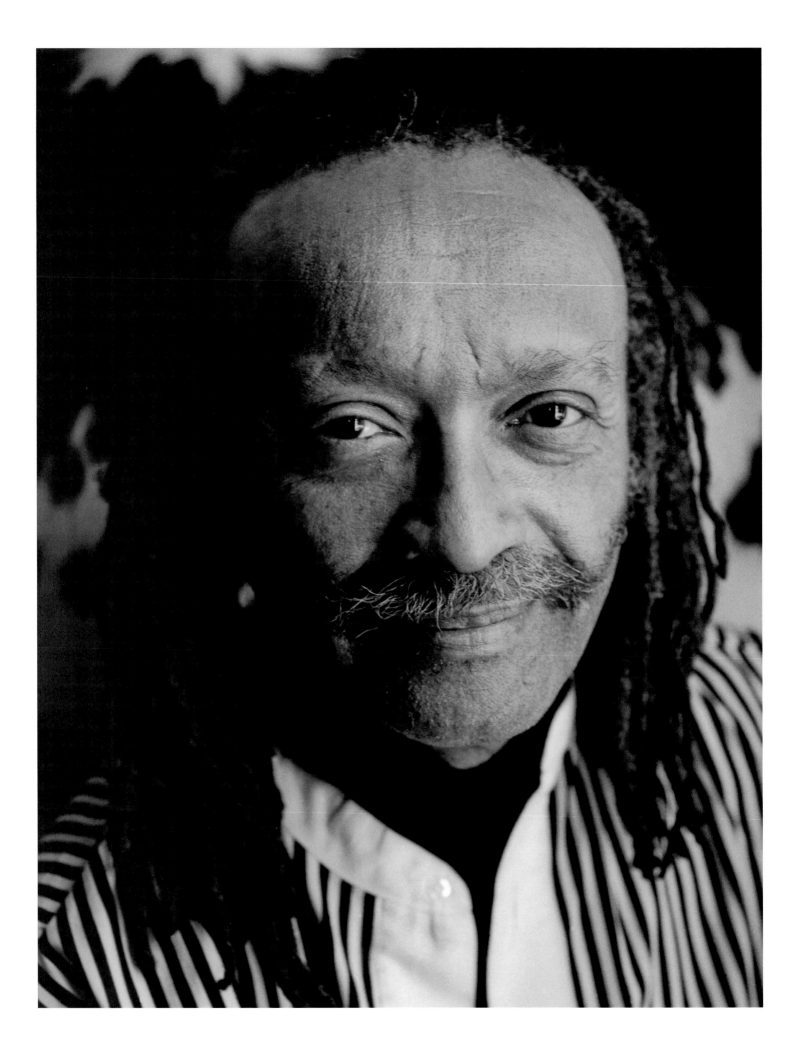

Soul of Man is of circular form.
circle is symbol of period (masculine)
Symbolizes the seed of man circular in form.
Soul was seed of man determiner of time
and period in creation
Ba is soul, circle, metal ring
Seed corn

Egy. Seru is seed, Seru is the same as Soul

Pet - foundation Pauti type form image
 └ to figure forth
 or
 └── embody

the Lofty was the tree
 the aak or Oak
 and Al child
 or Soso
 of

Damara tribes of Afri
divided into Eundas

Clans
 or
Ongs

Sun Children
Moon "
Rain "

mistletoe
was at
time
born
of
oak

Each Eunda
has sprig of
some tree as
Emblem

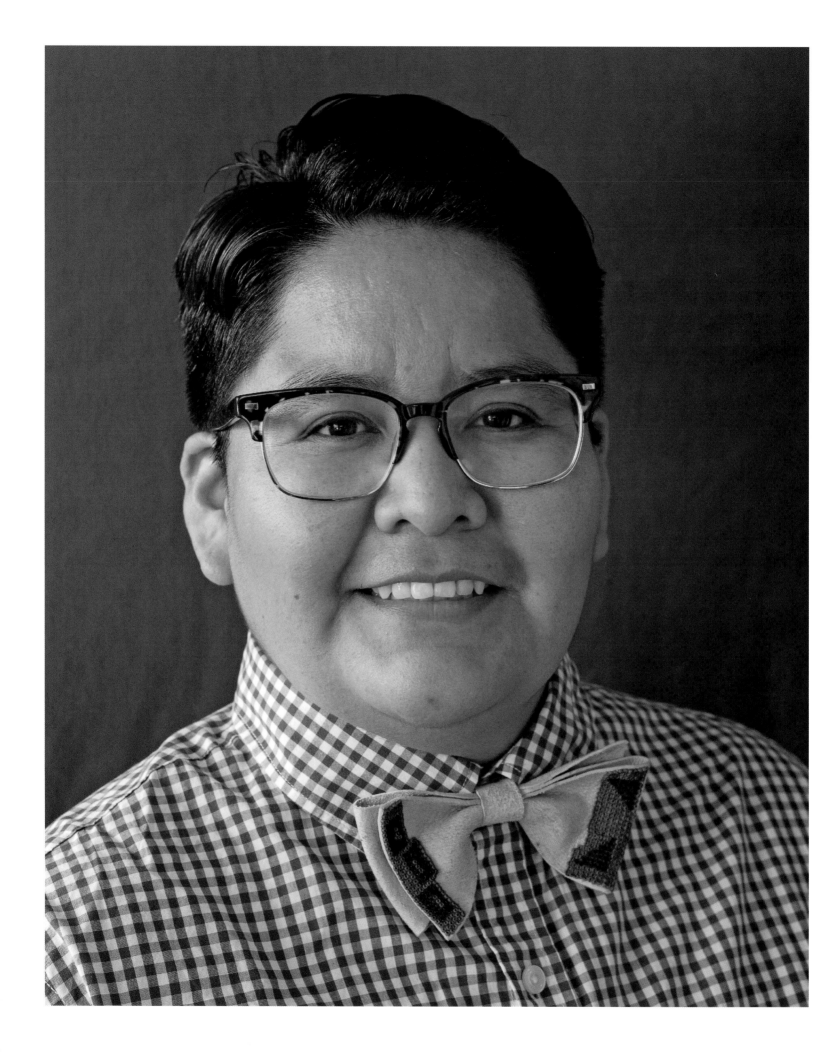

"you can't stop stirring it"
my mother says
as she hands over the duty of making corn mush to me
in our small trailer kitchen
nestled in to the belly of the valley

i take the bundle of sticks in to my hands
i imagine my hands are sand twisters
dancing across the valley
i am blue sky and sandstone
stirring the season of monsoons
when our faces carried the thunder of laughing floods
ádístiin has a long vision of stories
that tie together the other season of
dry spells

when we witnessed the vulnerability
of the parched valley floor

this pot has been stirred by many hands
shilá' bee – by my hands
shimá bílá bee – by my mother's hands
shimá sání bílá bee – by my grandmother's hands
shimá sáni'sáni bílá bee – by my great grandmother's hands
shimá sáni'sáni'sáni bílábee – by my great-great grandmother's hands
and so on

it's the stories
that have kept us alive
stirring deep inside
the center of our juniper ash bellies

 ádístiin

these fingers, almost effortlessly
have lovingly carried stories
in to our bellies
feeding a memory of
laughter that lives in our braun skin
where off the river dust storms
dance uninvited

 Nazbah Tom ©2015

Indian Land

in the blink of an eye
lightening flashes low
over north Texas hills

wind whips up a dust devil
sweeping a low mesa clean
throwing pebbles and arrowheads alike

this is Indian land
we have known these trails well
since the oldest of days

two horned toads dash
under a heavy outcrop of sandstone
to wait out the fast moving storm

they understand spring arrives
around here every year like this
with savage rains and fierce hungry winds

Rebecca Hatcher Travis, 2015

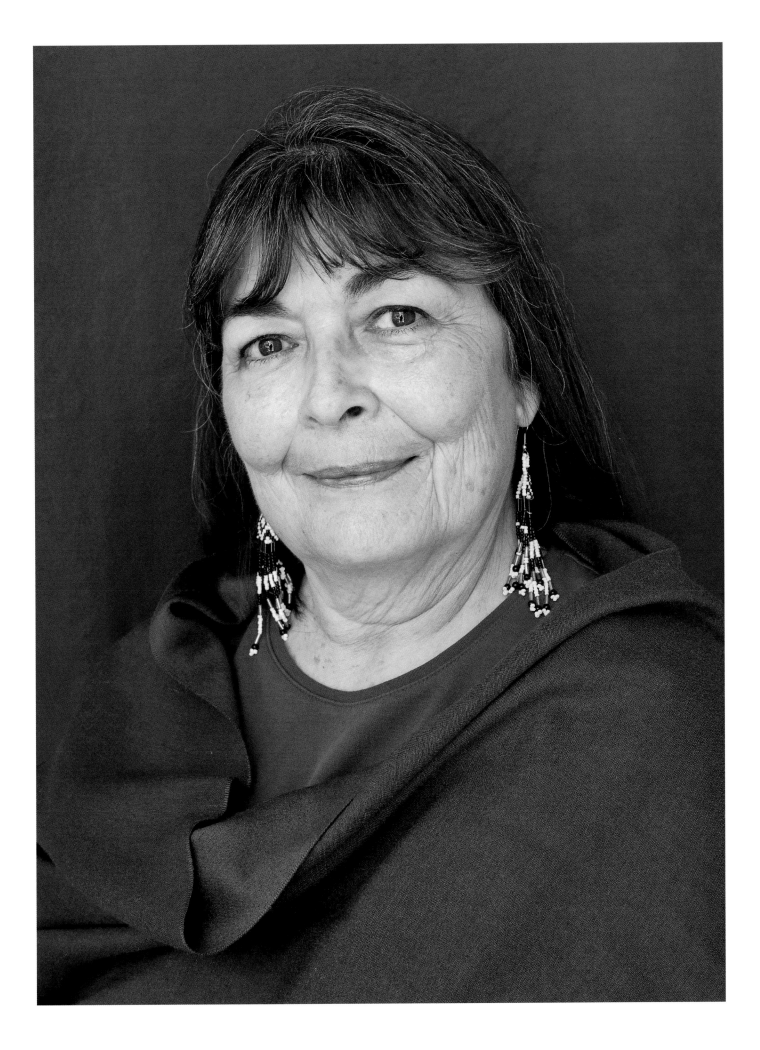

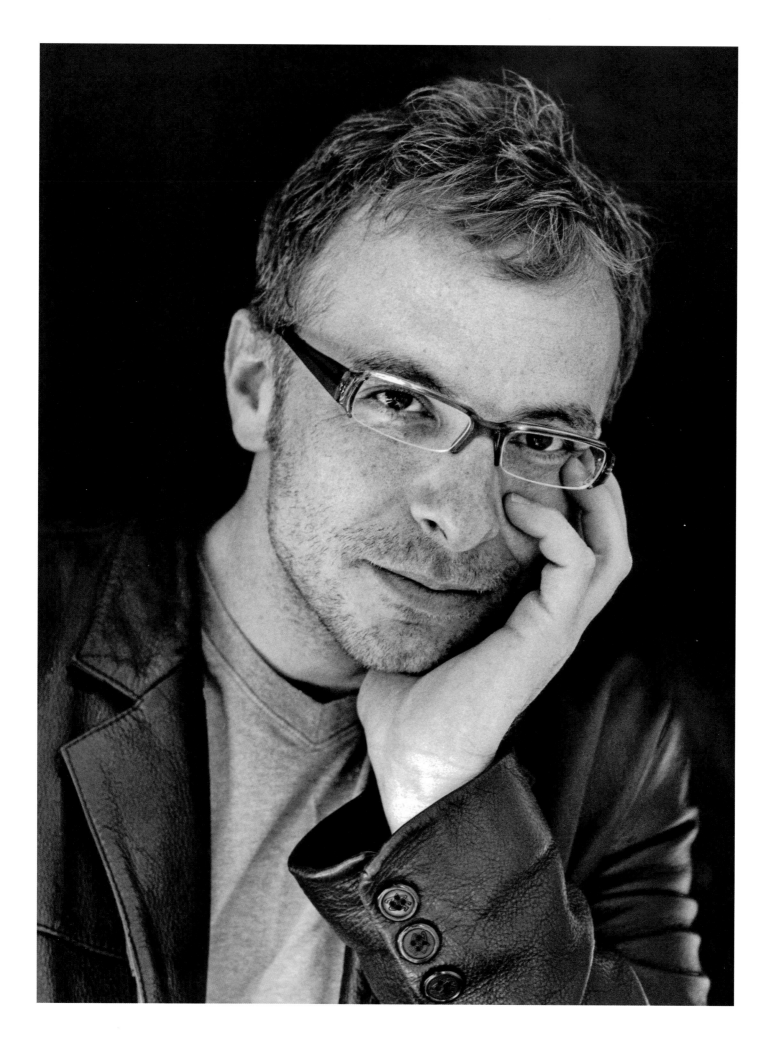

Everyone remembers the day in 1952 when the [first] arrived on the reservation. In later years the Indians would sometimes mark [on] the actual fact of his arrival and his departure on the first train to Minneapolis the next morning. But the [two] was forgotten that day until then a day like any other because an hour or a later they found Prudence's body above the Wigwam Bar, her [frozen body frozen] in the August <u>heat</u>.

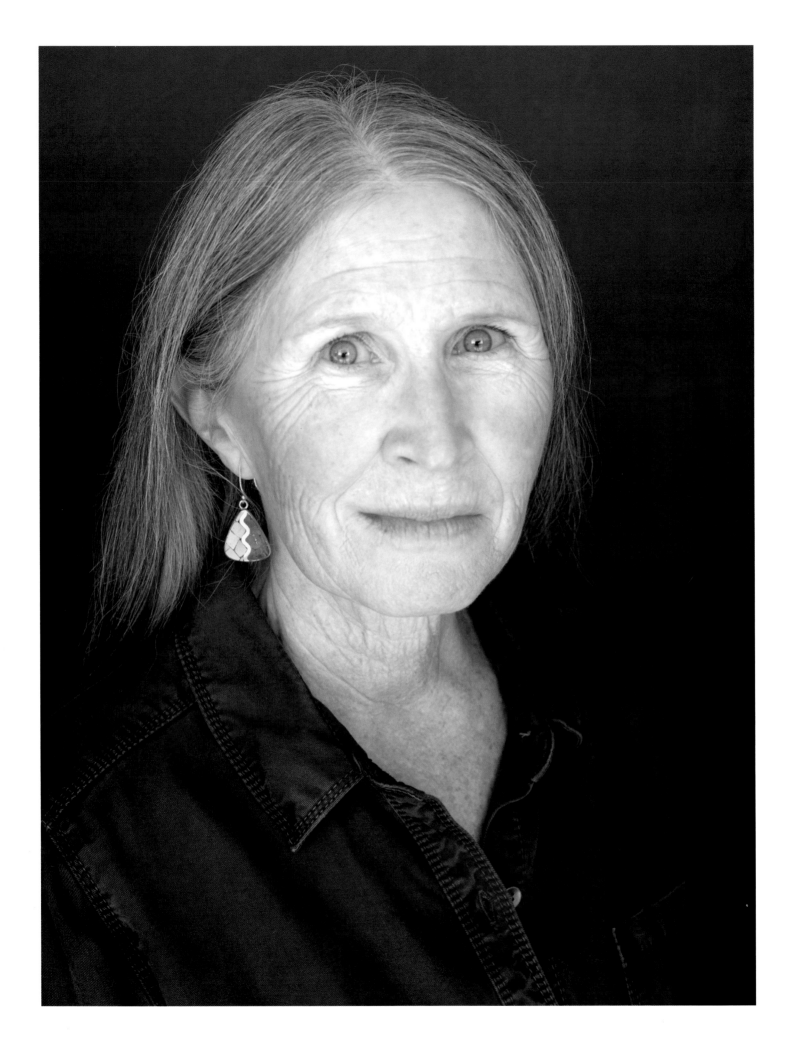

All night Jay's breathing stopped and then started again. I kissed his forehead. "It's Okay." I whispered. "Don't wait for anything. It's time for you to go."

I wished my son a good journey as he crossed over to the other side. At that moment he smiled the sweetest smile, a peaceful feeling settled over me. Something warm and cozy fell across my heart, And then he was gone.

Rain began to fall. I felt as though a million years had past. As if I traveled with my son to the faraway place beyond this life. In that moment I was certain he was headed home. Then I was plunged back into a stark awareness that no longer held a living breathing Jay Trevor. Jay's body lay still and small. I sat with his body in the hush before dawn when darkness gives way to light. I stroked his hands, tracing the creases in his palm, looking at each finger that had been separated with each syndactyly release surgery. As I held his hand I thought about my great grandmother who had given birth to eleven babies. The first died at four months, the second at age eight. It went on like that for years, grandma giving birth and grandpa making baby boards, digging holes and lowering those dead babies into the ground. It was a time of measles and small pox epidemic.

My mind glimpsed my great grandma, and I felt a distant memory pulling me back. I could hear her wailing like wind coming up, crying, swaying. I thought about how her cries must have drifted into the cabins of nearby white settlers, and I wondered if they knew the high shrill sounds pressing against the night were from an Indian mother mourning her dead child.

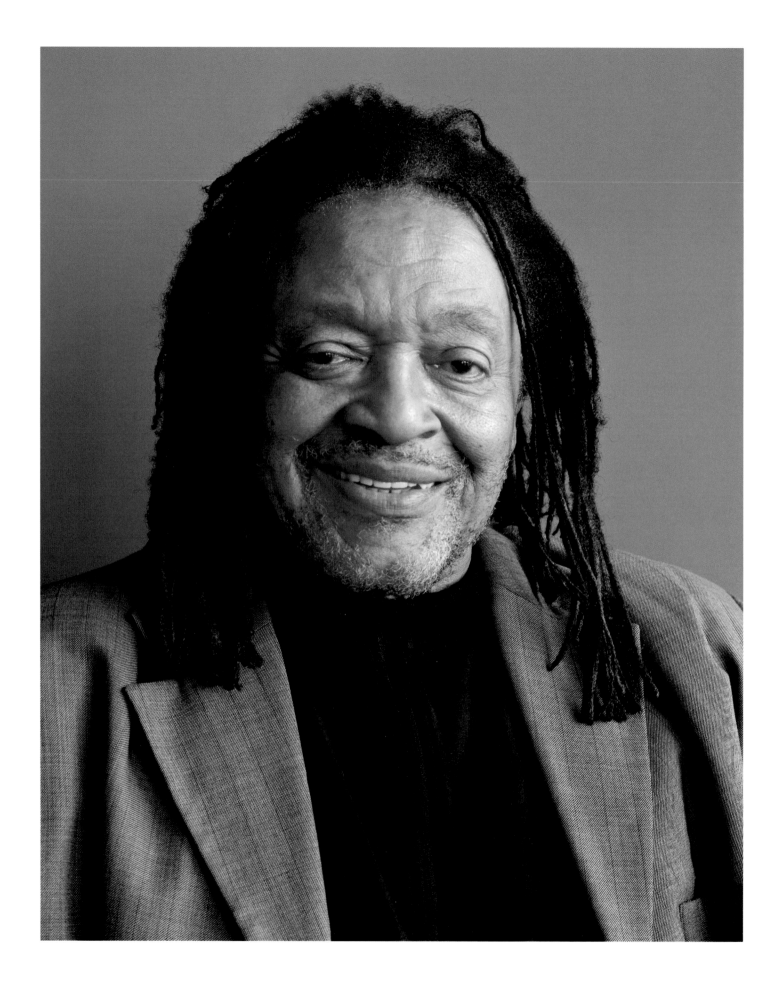

Ghost Voices Whispering from the Near Past

they call from the Near past whispering
through ether, call fragmented

disembodied, their meaning climbing from silence,
shapes emerge transparent, seek a form to enter
this bloody world, look like amoebas

they float into space blooming flowers,
voices whispering at the edge of our ears

by Quincy Troupe

I use to remember nothing
now
nothing remembers me
and
I wore the stars like a cape
until
the stars made a cape out of me
then
I fell through my own mortality
on
my way to immortality
where
endings are beginning beginning
as
part of ending ending

John Trudell

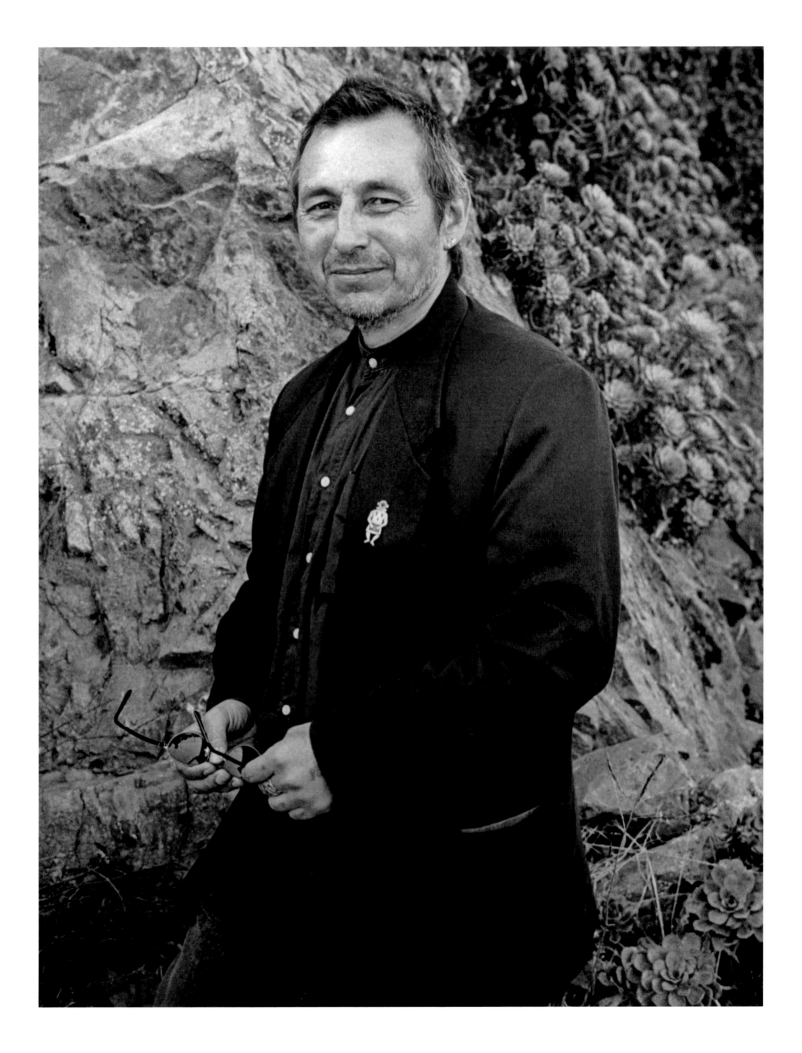

fat green flies
square dance across
the grapefruit
honor your partner

Winter sea
over my shoes
shadows
round stones
at san gregorio

Gerald Vizenor

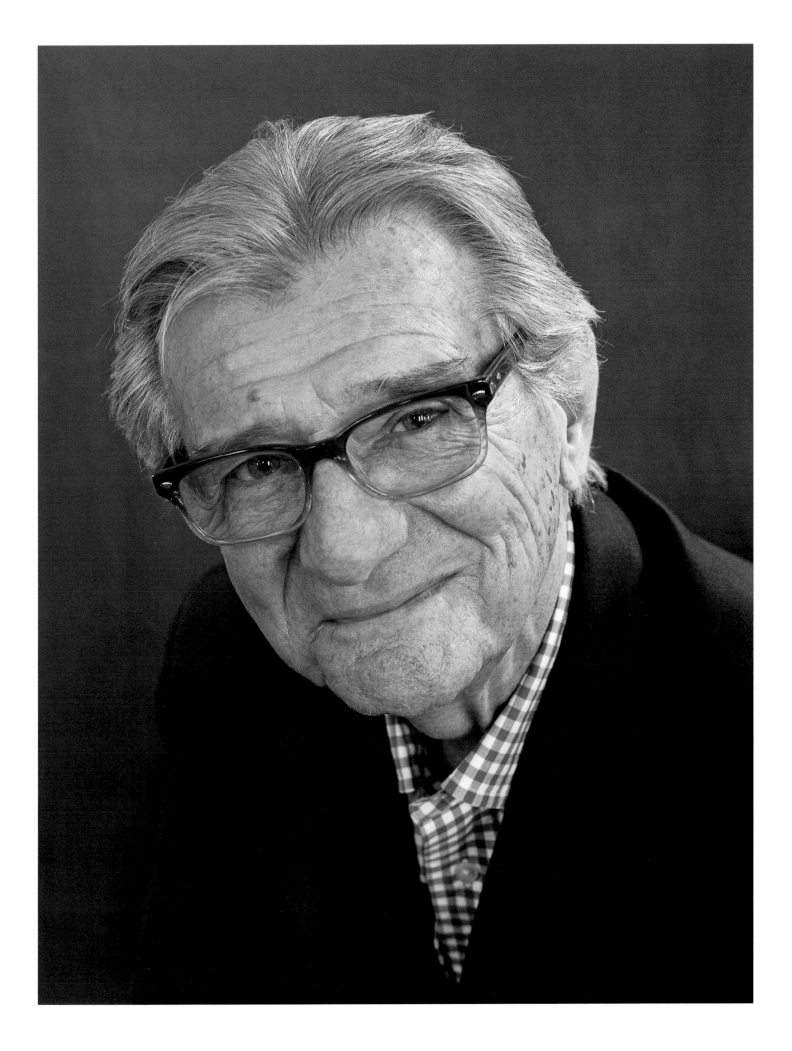

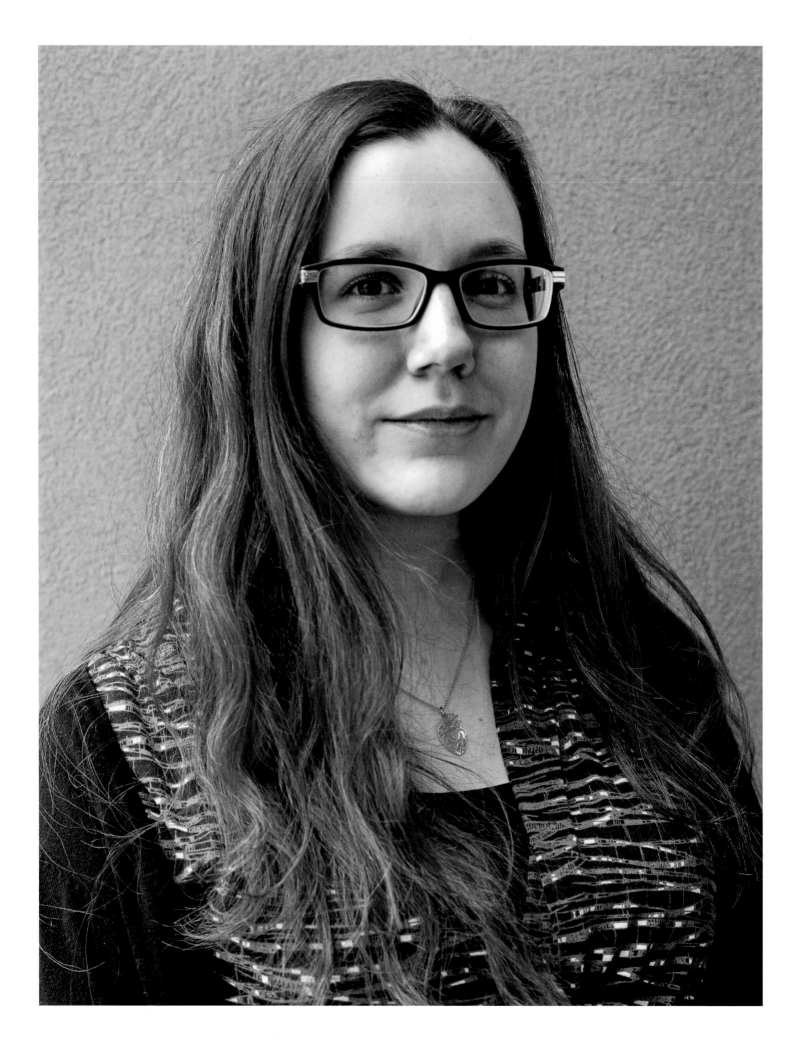

I have not wrapped my body in the hairshirt, have never bound my bones within the iron girdle, but I may as well have.

Elissa Washuta

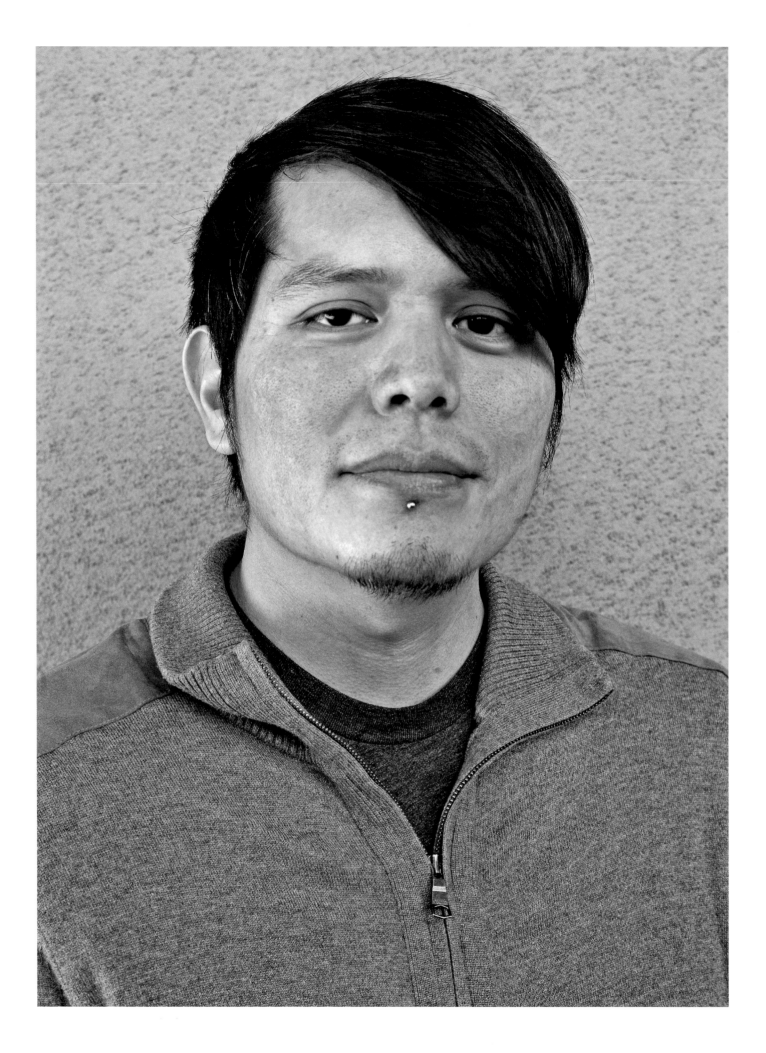

"grab the letter j next to him, hold it like a ting black scythe,
behead the i, and watch its dot head roll to the back of a sentence."

– Orlando White

excerpt from
the poem "Cephalic"

Paper Milk

Newborn alphabet cries its vowels and the page
nourishes them: a opens into a u, it becomes a ting
cup, fills with paper milk; the c, too, unfurls to an o
and nurses on the colostrum of pulp —— thought
attaches sound from motherese to thin sheet of
white. Form, a structure of feeling, an instrument
of print means to foster —— verso and recto will
be caretakers of our infant text, as writing develops
calcium to bring life to ink, letters become collagen
of thoughts.

– Orlando White

Putting Down Her Bundle

I have no time for weaklings subject to the whims
of wild woman medicine,
those distracted by the footloose and fancy free.
Grown women carry burdens and need feet
stronger than those of men.
I have no patience for fools putting hurt girls on pedestals,
expecting them to conduct themselves as queens.
I have no time for weaklings subject to the whims
of wild woman medicine.
Blind worship is a prison, not a castle for the feminine.
A swift running prisoner makes her get away clean.
Grown women carry burdens and need feet
stronger than those of men.
Women warriors in life's battles need hearts that are garrisons.
Wise men look past those who pout and preen.
I have no time for weaklings subject to the whims
of wild woman medicine
Men who are veterans see the impediment
of a woman not grounded, pretty, but weak.
Grown women carry burdens and need feet
stronger than those of men.
So don't be confused by the bait of estrogen.
Bright baubles can lead to traps unforeseen.
I have no time for weaklings subject to the whims
of wild woman medicine.
Grown women carry burdens and need feet
stronger than those of men

Kimberly G. Wieser
aka "La Kimi W" & "Meona hanehe

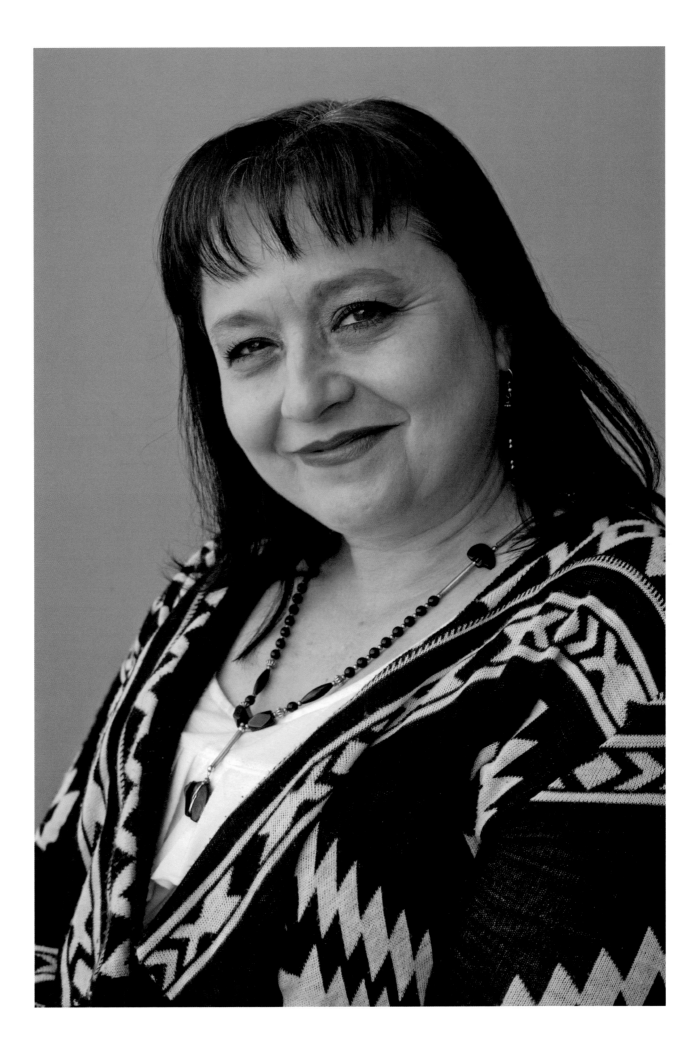

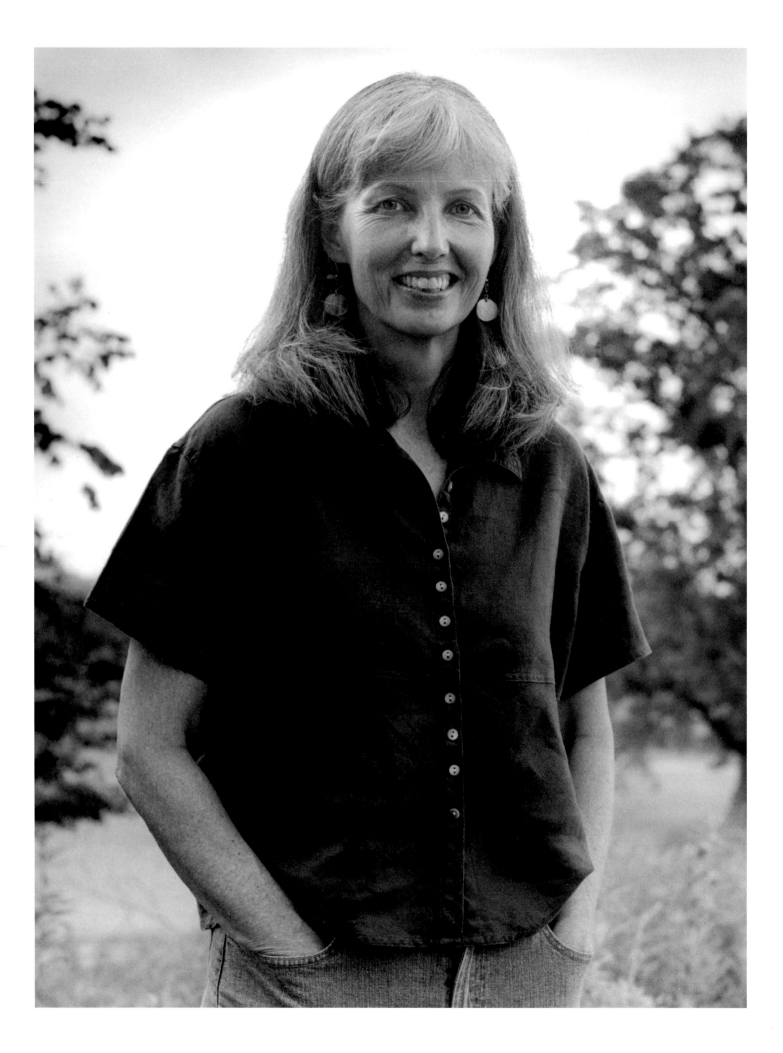

Excerpt from "Beloved Child: A Dakota Way of Life"

When I was a teenager, my mother told me a story of being left at Holy Rosary Mission School [Pine Ridge Reservation] for two years when she was fourteen. When she came home to Rapid City, South Dakota for a surprise visit, she found her house empty, her family gone — they had moved in search of work. In the few words she used to tell me this story, I felt something shift from her life to mine. I drew it in like a breath, felt it attach to my heart in a way that would shape the direction of my life. This one story was the culmination of experience from generations in my family, just as a single seed contains the history of what has happened on the land.

Throughout our lives, we are taught, shaped, scarred and strengthened by the stories we are told, the stories that we live, and the invisible legacies that help shape who we become. When these stories are silenced, as has happened to many generations of Dakota people, when the history is ignored, then we are unconscious witnesses to the past. When a generation cannot reconcile their experience, it becomes a legacy for their children and grandchildren, who inherit the raw, unfinished work of their ancestors.

Diane Wilson

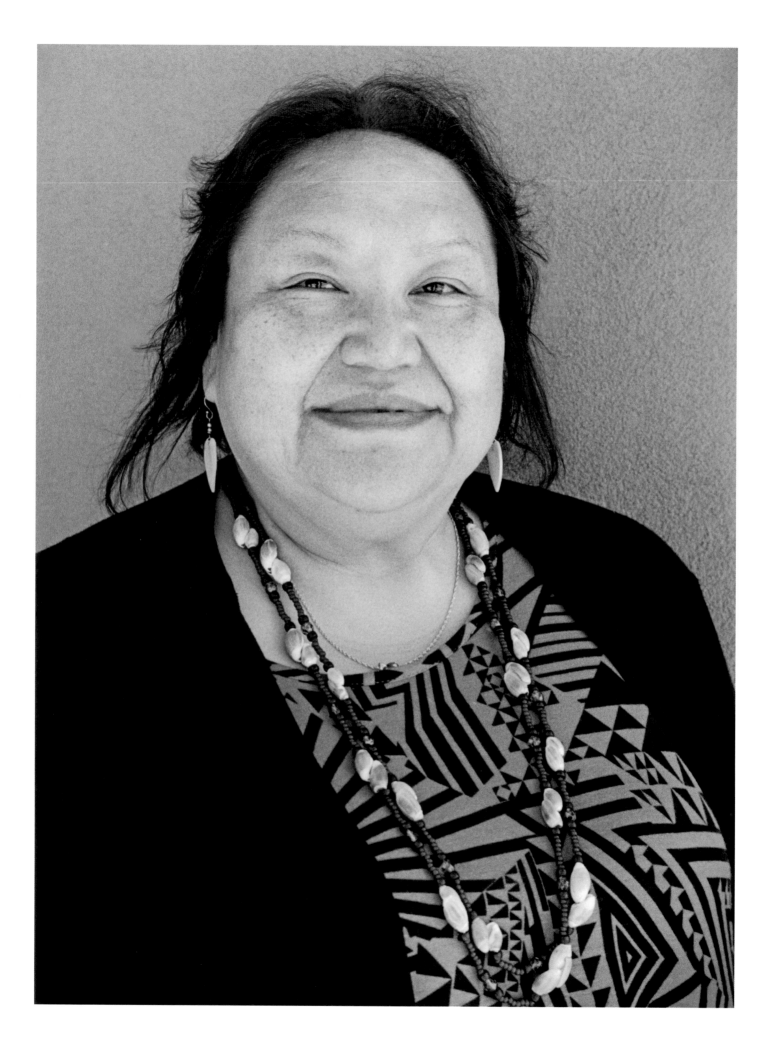

Excerpt from "Beloved Child: A Dakota Way of Life"

When I was a teenager, my mother told me a story of being left at Holy Rosary Mission School [Pine Ridge Reservation] for two years when she was fourteen. When she came home to Rapid City, South Dakota for a surprise visit, she found her house empty, her family gone — They had moved in search of work. In The few words she used to tell me This story, I felt something shift from her life to mine. I drew it in like a breath, felt it attach to my heart in a way That would shape The direction of my life. This one story was The culmination of experience from generations in my family, just as a single seed contains The history of what has happened on The land.

Throughout our lives, we are taught, shaped, scarred and strengthened by The stories we are told, The stories That we live, and The invisible legacies That help shape who we become. When These stories are silenced, as has happened to many generations of Dakota people, when the history is ignored, Then we are unconscious witnesses to The past. When a generation cannot reconcile Their experience, it becomes a legacy for Their children and grandchildren, who inherit The raw, unfinished work of their ancestors.

Diane Wilson

She left us growling at
the sky. Her power
 translucent with embers
of glowing glass. Synchronous
breathing with her daughter
pulsed, then stopped.
The volcano of feminine
 heat never cease breath.

The aromatic bark
 mixes with evergreen sheaths
of cedar, fir boughs as rain
 permeates the pungent earth.
The fire's dark charcoal
deepens on the high desert
plateau.

It is still peace
 in the afternoon
with grandmother's breath
between story of her
 love of the deer,
the grandfather who laughed
fully walking in the brilliant light.

Somewhere in the dusk
are promises of new people
 from old stars.

ξ

EPILOGUE: *Learning to "Tend the Fire"*

Christopher Felver

Stone Pipe

Together, we bend this stone
to roundness
and our oiled fingers
with its marrow . . .

The heat of this mountain
we sit upon
will taste the sacred
tobacco in this pipe.

—Peter Blue Cloud, from *Sketches in Winter, with Crows*

Looking back on the making of *Tending the Fire*, much of this work came into existence through a spontaneous and unstructured process—a living journey. One writer put me in touch with another writer, over a meal or the phone. The most rewarding and nourishing aspect of this experience has been the interconnectedness of Native communities, which continually opened to me.

We owe the image that the general public has of Native Americans at the turn of the century to Edward Curtis. In his famed photographs and ethnographic narrative, Curtis saw the genocidal impulse that was moving west and assumed it would be successful. His goal was to create a visual record of this vanishing race being systematically removed from their homelands. Today, in spite of massacres, theft, and legislation, Native peoples remain, individuals in an evolving experience. Now Edward Curtis is a controversial figure, in spite of his intentions. Some think his work has mired Native culture in stereotypes that have been difficult to overcome. Nevertheless, it was Curtis's images, rather than Hollywood's, that made a lasting impression on me.

The quietude of the Shoshone-Paiute Reservation was my point of departure into Native culture. In 1980, the director of Sun Valley Center's Institute of the American West invited me to work on the documentary *Duck Valley Water Rights*. We interviewed many citizens of this farming community about the ongoing struggle with the Bureau of Indian Affairs and other government agencies to

secure water needed to farm in the high desert of northern Nevada and southern Utah. Mark Klett and Ellen Manchester of the Rephotographic Survey Project were on-site, making copies of photographs from community members' family albums. What I learned while working on the film and seeing bygone pictures of life on this reservation became the bedrock for my understanding of this timeless culture.

The government gave half the tribal members a $6,000 check while we were there. To cash those checks, everyone went to the closest city, Elko, Nevada. A few returned home the next day with new trucks. However, many who paid $300 to get their checks cashed arrived home penniless, having gambled it all away. Witnessing this, I saw firsthand an example of the ongoing exploitation Native people have endured.

When our entourage departed the reservation's pastoral lands and headed back to Sun Valley, we were imbued with the peaceful feeling found in that ranching/farming community. The film *Duck Valley Water Rights* screened to Idaho legislators, hopefully raising awareness to the persistent water dilemma facing the community.

When the Whitney Museum's 1995 exhibition *Beat Culture and the New America, 1950–1965* came to San Francisco, composer David Amram introduced me to actor-musician Floyd "Red Crow" Westerman. Floyd's stalwart friend and legendary comedian Charlie Hill was there and it was amid the music, poetry readings, and symposiums that were part of the celebration that we began our

wonderful friendships. David and Floyd were rehearsing the Lakota social song "Mastinchele Wachipi Olowan" to play the following day on the radio show *West Coast Live*. All the while, Charlie charmed me with his brand of revolutionary humor. Across town, Russell Means was celebrating the publication of his autobiography, *Where White Men Fear to Tread*, with a book party at City Lights Books. After his reading I made a few pictures. We discussed his support of the Miskito indigenous people in Nicaragua and the courageous stand taken by the American Indian Movement (AIM) at Wounded Knee on the Pine Ridge Reservation. The standoff with federal agents drew national attention and widespread public sympathy for the goals of the occupation, as Americans became aware of long-standing issues of injustice related to Native people.

The synchronicity of these meetings piqued my curiosity and led me to seek out other activists. AIM cofounder Dennis Banks was discussing his just completed "walk for justice" from San Francisco to Washington, DC, when I crossed paths with him in my local café in Sausalito. Through Dennis, I met his fellow AIM activist John Trudell. John was the spokesperson for the Indians of All Tribes occupation of Alcatraz in 1969, broadcasting as Radio Free Alcatraz. We met in Jackson Browne's Hollywood studio just after John's release of his album *Johnny Damas & Me*. I thought it incredible that these remarkable men, with so many extraordinary accomplishments, were so accessible. AIM members realized they

had to take political action to get the public's attention for the wrongs committed against their people for the last five hundred years. They felt an urgency to speak out and go public, to alter the political landscape and be a catalyst for change.

For many years I've worked as the photographer for the literary magazine *Poetry Flash*. In 1996, I was introduced to Joy Harjo's music and poetry at the first Watershed Environmental Poetry Festival in Golden Gate Park, presented by *Poetry Flash*. Her deeply moving performance proved to be the impetus for me to learn more about the contributions of Native women.

A few years later while traveling to New Mexico to finish a book project I stayed with my old friend Dana Chodzko in Abiquiú. Dana had recently assumed the directorship of the sculpture department from the retiring Allan Houser at the Institute of American Indian Arts. Another friend, poet Arthur Sze, a professor in the writing department, introduced me to creative writing director Jon Davis. At this point I became involved with some of the most colorful poets and storytellers living: Simon J. Ortiz, Jim Barnes, Sherman Alexie, Sherwin Bitsui, and Elizabeth Woody.

In the Colorado foothills near Red Rocks Amphitheatre, I visited Linda Hogan's ranch and her beloved mustangs, Misty and Kelly. She spoke of her extensive involvement in Native issues, opening a door that took me ever deeper into her world. From there I headed to Arizona. Driving in the saguaro hills overlooking Tucson, I found MacArthur recipient Leslie Marmon Silko among

her rattlesnakes, rescued cockatoos, giant mastiffs, and lone pit bull. Her eclectic, solitary existence was intriguing, but as the sun started setting I knew I had to go. The combination of hearing all those "rattler" stories and even seeing a few left me more than a little shaken.

In Minnesota, I met many writers who reminded me that AIM originated in Minneapolis in the late 1960s. The state remains a strong center for cultural achievement and social action through the ongoing efforts of groups like the Minneapolis American Indian Center, which serves the needs of its thirty-five thousand members. Being with these generous and passionate writers kick-started this project, the anthology I'd hoped to make documenting Native experiences. The diversity and complexity of Indian culture started to take shape in my mind.

I proposed *Tending the Fire* to the University of New Mexico Press and they shared my enthusiasm for the undertaking. Returning to San Francisco, Joyce Jenkins of *Poetry Flash* introduced me to Kim Shuck, who in turn suggested many writers living in California and Oklahoma who might be interested. Through Kim I met long-standing San Francisco KPOO radio documentary historian Mary Jean Robertson, who has hosted *Voices of the Native Nation* for over forty years. Her historical perspective as an activist for social change was an essential element for the project.

The Association of Writers & Writing Programs met in spring 2015 in Minneapolis. Native writers were prominently featured in symposia and presentations. At the conference I encountered many

kindred spirits and renewed friendships with writers I'd photographed before: Simon J. Ortiz, Gerald Vizenor, Allison Hedge Coke, and Roberta Hill. At the roundtable discussions I met Linda Rodriguez, Kim Wieser, Deborah Miranda, Louise and Heid Erdrich, and Eric Gansworth. Despite the differences in landscape and tribal affiliations, I found a common core belief in the importance of environmental stewardship. Native writings are often rooted in traditional stories and a worldview of the interconnectedness of all life, which has survived in spite of a long colonial history. With so much sincerity of purpose I felt honored to be present in their community.

There have been many miles and high points on my journey. In Tahlequah, Oklahoma, the capital of the Cherokee Nation, I filmed storyteller Sequoyah Guess as he spun time-honored folktales for children at summer camp. He is the descendant and namesake of the inventor of the Cherokee alphabet, whose work facilitated the transition from an oral tradition to a written one.

A gathering of writers from Pembroke, North Carolina, met in Chapel Hill in support of my endeavor. After photographing Pura Fé, Charly Lowry, Ladonna Richardson, Bobby Richardson, and A. Kay Oxendine, we moved to the branch library to find a quiet place to record their poems and songs on video. Afterward, as we were about to go our separate ways, we joined hands in prayer. I don't think it was just the heat, as I was emotionally overcome by the friendship extended to me.

Traveling through the Smoky Mountains in sweltering July heat I was especially looking forward to visiting the Museum of the Cherokee Indian. The museum showed what Native peoples were coerced to endure from the Indian Removal Act of 1830. The forced removal of the Choctaw and Cherokee nations from their traditional lands and their relocation farther west led to the Trail of Tears. The devastation of this event nearly eradicated the Native American population of the southeastern United States.

Near Lake Placid in Saranac Lake I visited Mohawk elder Maurice Kenny. He graciously offered me hospitality for the night after my long, dark drive from Connecticut. Maurice once lived in Greenwich Village and his unflagging spirit and pesto dinner took me back in time. It was the perfect ending to my six-hour trek to upstate New York.

In much of the Catskills there was no GPS reception, so it was tricky driving at night to meet Susan Deer Cloud at her home in Livingston Manor. Susan's gracious welcome and hospitality, like that of Maurice's, knew no bounds. Her optimism was a magnet for my spirit, connecting me with prodigious Mi'kmaq author/poet Evan Pritchard and expat Lance Henson on his last day stateside before embarking for Bologna, Italy. While in New York City on the Lower East Side, I made the acquaintance of Laura Ortman, a gifted fiddler and storyteller in Allison Hedge Coke's all-star band Rd Klā.

Walking the Miwok Trail in the coastal

mountains of northern California, I recently mulled over my experiences with Native artists while working on *Tending the Fire*. The expansive landscape I viewed from James Luna's porch on Palomar Mountain belied the fact that ten years ago 92 percent of this high chaparral ecosystem had burned, taking with it more than thirty homes. I marveled at nature's capacity for rejuvenation, like the phoenix rising, as there was no visible evidence of the devastation caused by the fire. This same resilience to adversity shone in James and the many Native artists I photographed. To me, the new home of James Luna is a metaphor for the tenacity of his culture to thrive despite persistent discrimination and roadblocks.

From moccasins to Nikes, Native Americans today are as modern as the Space Age, and each in their own way carries forth the cultural heritage "from whence they came." Their abiding legacy as the first people of this continent has found its voice in the hard-won wisdom of their art and activism. Let's learn from this belated opportunity to look and listen to these Native voices.

Christopher Felver
Sausalito, California, 2016

CONTRIBUTORS

Francisco X. Alarcón (1954–2016) served as director of the Spanish for Native Speakers Program at the University of California, Davis. Alarcón was the author of numerous books of poetry including *Canto hondo*/Deep Song, *Borderless Butterflies: Earth Haikus and Other Poems*, *Sonnets to Madness and Other Misfortunes*, *No Golden Gate for Us*, *Snake Poems: An Aztec Invocation*, and *Body in Flames*. He was the recipient of the Chicano Literary Prize, the PEN Oakland Josephine Miles Award, the Fred Cody Lifetime Achievement Award at the Northern California Book Awards, and several Pura Belpré Honor Awards for Latino Literature from the American Library Association.

Sherman Alexie is a winner of the PEN/Faulkner Award for Fiction, the PEN/Malamud Award for Short Fiction, a PEN/Hemingway Award for Best First Fiction, and the National Book Award for Young People's Literature. Alexie is a poet, short story writer, novelist, and performer. He has published twenty-four books and in 2013 released the twentieth anniversary edition of his classic book of stories, *The Lone Ranger and Tonto Fistfight in Heaven*. A Spokane/Coeur d'Alene Indian, Alexie grew up in Wellpinit, Washington, on the Spokane Indian Reservation. Alexie has been an urban Indian since 1994 and lives in Seattle with his family.

Indira Allegra has been awarded the Windgate Craft Fellowship and the Jackson Literary Award, and is a recipient of an Oakland Individual Artist grant. She has forthcoming work in *Red Indian Road West* and has contributed works to *Cream City Review*, *HYSTERIA Magazine*, *Writing the Walls Down*, *Yellow Medicine Review*, *Art and Thought*, *Cherokee Writers from the Flint Hills of Oklahoma*, and *Sovereign Erotics: A Collection of Two Spirit Literature*, among others. Allegra's short films have screened at festivals such as MIX NYC, the Perlen Hannover LGBT Festival, Outfest Fusion, and the Bologna Lesbian Film Festival.

Feminist poet and novelist **Paula Gunn Allen** (1939–2008) was the author or editor of many influential publications including *Studies in American Indian Literature*, *The Sacred Hoop*, *Spider Woman's Granddaughters*, *Voice of the Turtle*, and *Song of the Turtle*.

Crisosto Apache is a Mescalero/Chiricahua Apache from New Mexico where he is an adjunct professor of English composition at Brown Mackie College in Albuquerque. His work includes Native LGBTQI / "two spirit" advocacy and public awareness. Crisosto's writings have been published in *Black Renaissance Noire*, *Yellow Medicine Review* (2013/2015), *Denver Quarterly*, *Toe Good Poetry*, *Hawaii Review*, *Cream City Review*, *Plume Anthology*, and *Common Place*. Crisosto also appeared on MTV's *Free Your Mind* advertising campaign for poetry.

Annette Arkeketa (Otoe-Missouria/Muscogee Creek) is a producer, director, videographer, screenwriter, playwright, poet, and advocate for American Indian filmmakers. She is founder of Hokte Productions, an independent film and video production company where her most recent productions include *PAHDOPONY: See How Deep the Water Is*, a biography of Comanche artist Juanita Pahdopony, and *Chief George*, a short documentary about George Akeen (Cheyenne/Wichita) and his historic peacekeeping mission to Jerusalem. Arkeketa's publications include *Ghost Dance* in *Keepers of the Morning Star*, and *Hokti* in *Stories of Our Way*.

Born in New Mexico of Indio-Mexican descent, **Jimmy Santiago Baca** learned to read and write after he was sentenced to five years in a maximum-security prison where he also discovered a passion for poetry. After his release, Baca published his first collection of poems, *Immigrants in Our Own Land*. Now the author of more than fifteen books, he is the winner of the Pushcart Prize, the American Book

Award, the Hispanic Heritage Award, and the Cornelius P. Turner Award, which recognizes one GED graduate a year who has made outstanding contributions to society in education, justice, health, public service, and social welfare. Baca also founded Cedar Tree Inc., a nonprofit that works to give people of all walks of life the opportunity to become educated and improve their lives.

Native American activist **Dennis Banks** is a cofounder of the American Indian Movement (AIM) that championed Native American self-sufficiency, traditions, and values. AIM's demand for federal recognition of century-old treaty rights led to violent clashes with authorities including the occupation of Wounded Knee, South Dakota, in 1973. Banks has subsequently led walks across America, Japan, and Europe for peace, the environment, and health issues. He has appeared in several award-winning movies and documentaries, and continues to travel the globe lecturing about and teaching Native American experiences. Banks and his family harvest wild rice and maple syrup on the Leech Lake Reservation in northern Minnesota where he was born Nowa Cumig.

Pushcart Prize and American Book Award winner **Jim Barnes**, a native of Summerfield, Oklahoma, and former Distinguished Professor of English at Brigham Young University, is of Choctaw, Welsh, and "mongrel" American descent. A longtime editor of the *Chariton Review*, he now serves as poetry editor for Truman State University Press and first-round judge for the annual T. S. Eliot Poetry Prize. Barnes is the author of several books of poetry including *Visiting Picasso*, *Paris*, *The Sawdust War*, and *The American Book of the Dead*. His work has appeared in a wide variety of publications and has been featured in over fifty anthologies of contemporary fiction and poetry. Barnes was Oklahoma Poet Laureate for 2009–2010.

Of Cherokee/Celtic/Teutonic descent, **Kimberly L. Becker** is author of *Words Facing East* and *The Dividings*. Becker's poetry has been featured in journals such as *Drunken Boat* and *Fulcrum* and anthologized in volumes such as *Women Write Resistance* and *Indigenous Message on Water*.

Kimberly was also a featured reader for the *Florida Review*'s "Native Writers in DC" at the National Museum of the American Indian. She has written for the Cherokee Youth in Radio Project, adapting traditional Cherokee stories into plays.

Duane Big Eagle is Hominy District Osage Indian born in Claremore, Oklahoma, and has taught creative writing to young people with the California Poets in the Schools Program for four decades. Big Eagle has received several awards for his poetry including the W. A. Gerbode Poetry Award, taught Native American Studies at the college level, and served as a founding board member of the American Indian Public Charter School in Oakland, California. He is also a traditional American Indian singer and Osage Southern Straight dancer.

Sherwin Bitsui is Diné from White Cone, Arizona, on the Navajo Reservation, and is the author of *Flood Song* and *Shapeshift*. He is of the Bįį'bítóó'nii' Tódi'chii'nii clan and is born for the Tlizilłani' clan. Bitsui's honors include a Lannan Literary Fellowship, a Native Arts and Culture Foundation Fellowship for Literature, a PEN Open Book Award, an American Book Award, and a Whiting Award. Bitsui lives in San Diego, California, and teaches at San Diego State University and the Institute of American Indian Arts in Santa Fe, New Mexico.

Julian Talamantez Brolaski is a two-spirit poet of mixed Apache, Latin, and European heritage. He is the author of *Advice for Lovers* and *gowanus atropolis*, and coeditor of *NO GENDER: Reflections on the Life & Work of kari edwards*. Brolaski is also the lead singer and rhythm guitar player in the Oakland-based country band The Western Skyline.

Lauralee Brown is a vocalist/entertainer/artist who enjoys singing, performing, writing poetry and songs, and drawing. Over the years Brown has been involved in many musical and performance endeavors including (as a very young person) the precocious comedy duo Collingwood Fats & Flats; the "all original" rock/jazz fusion group The Calling; the Keyhole Mystery Theater Company; the '50s and '60s

band The Tom Cats; the mostly original folk rock group Reeking Havoc; and the alternative country rock band Moonlight Rodeo, among other projects. Brown currently sings in a four-woman group known as The Femmes Fatales and is the vocalist for The Pete Lind Band. She also performs jazz and beyond with her group Lauralee Brown and Company. Brown's interests in using her voice also led her to work at Radio Sausalito, where she produced and hosted *Your Sausalito Music Scene* and *Bay Area Jazz Spotlight*. Brown founded and hosted Rancho Nicasio's singer-songwriter series and now hosts a singer-songwriter lounge at the Corkscrew Wine Bar in Petaluma. She is also co-manager/emcee for West Coast Songwriters Organization's San Rafael Chapter at the Fenix Theater.

Joseph Bruchac is a writer and traditional storyteller from the Adirondack Mountains region of northern New York where he lives in the house he was raised in by his grandparents. His work often reflects his Abenaki Indian ancestry. Author of more than 130 books in several genres for young readers and adults, his experiences include running a college program in a maximum-security prison and teaching in West Africa. Winner of the Lifetime Achievement Award from the Native Writers' Circle of the Americas, his newest book is *Four Directions: New and Recollected Poems*.

Annette Saunooke Clapsaddle, an enrolled member of the Eastern Band of Cherokee Indians, teaches English, history, and Cherokee studies at Swain High School in Qualla, North Carolina. As assistant to Principal Chief Hicks, Annette produced *Cherokee Elders: Our Greatest Generation* and a series of children's books. Her recent publications include *Naked Came the Leaf Peeper*, "It All Comes Out in the Wash," and "Camouflage" from *Night is Gone, Day Is Still Coming*. She is a recipient of the William H. McKim Prize from Yale University, the Morning Star Award for Creative Writing from the Native American Literature Symposium, and was a finalist for a PEN/Bellwether Prize for Socially Engaged Fiction. From 2013 to 2015, she served as the executive director of the Cherokee Preservation Foundation, and recently began her role as coeditor of the *Journal of Cherokee Studies*.

Allison Hedge Coke's fifteen authored or edited books include *Streaming* and *Sing: Poetry from the Indigenous Americas*. Her latest fiction is *Way the Crow Flies*. She teaches for the Red Earth MFA, the VCFA MFA in Writing and Publishing, and the Jack Kerouac School of Disembodied Poetics Summer Writing Program at Naropa University, directs the Literary Sandhill Crane Retreat, performs with Rd Klā, and is directing the film *Red Dust: Story of Climate Change Resiliency*. Hedge Coke came of age working fields, waters, and in factories. Her heritage includes Metis, Huron, French, and Portuguese.

Travis Coke lives in the Chinese beachside city of Weihai. A professor at Shandong University and columnist for the *Comics Cube*, his work has appeared in *Yellow Medicine Review*, *Látó*, *Sing*, *A Sense of Regard*, and elsewhere. He is a founding editor of *Future Earth Magazine*.

Elizabeth Cook-Lynn is a scholar and author born and raised in Fort Thompson, South Dakota (agency of the Crow Creek Sioux). She has written some fourteen books including *New Indians, Old Wars*, *A Separate Country*, and *Anti-Indianism in Modern America*. Her latest is a novel called *That Guy Wolf Dancing*, her novellas are published as a collection called *Aurelia*, and her only collection of poetry is entitled *I Remember the Fallen Trees*. "Writing, for Indians in our time," she believes, "represents an accomplishment in the modern world as important as the landscape shrines we know so well in our own homelands, or the architecture of Europe and other parts of the world, and provides one of the important keys to helping us remember who we are."

Jonny Cournoyer is a member of the Rosebud Sioux Tribe and a multidisciplinary artist with a primary focus on filmmaking, photography, and composition. At an early age he became an avid documentarian and archivist after he was armed with his grandfather's Argus C3 rangefinder camera. In 2014 his debut documentary *Across the Creek*, based on contemporary visions of the Rosebud and Pine Ridge Indian Reservations in South Dakota, premiered on PBS and was later screened at the White House in November 2015. Also a musician since early childhood, a selection

of his compositions have appeared in both short and feature films as well as on several episodes of Sesame Street. Jonny is a Sundance Institute Native Lab Producer Alumni, a member of the International Cinematographers Guild Local 600, and he calls the Laurel Canyon neighborhood of Los Angeles home. He creative work focuses on environment, place, history, and generations, and he always walks with one foot in the art world and the other in the film industry.

Alice Rose Crow-Maar'aq was born and raised on the Kusquqvak in southwest Alaska and nests in Spenard. Invited as a moderator and reader for a cross-genre reading *Raising our Voices* at the AWP16 Conference and Bookfair, Crow's work is forthcoming in *As/Us: A Space for Women of the World*, and appears on the blog *Brevity* and in *Plume*; *Hinchas de Poesia*; *Camas*; *Yellow Medicine Review*; *River, Blood, and Corn*; *Retort*; *Frontiers*, and *Standards*. Her book-length collection, *An Offering of Words*, is under review. An Island Institute Fellow, Crow is a member of the Orutsararmiut Native Council and an original Calista and Bethel Native Corporation shareholder.

Lucille Lang Day has published ten poetry collections and chapbooks, including *Becoming an Ancestor*, *The Curvature of Blue*, and *Infinities*. Her first poetry collection, *Self-Portrait with Hand Microscope*, received the Joseph Henry Jackson Award, and her latest chapbook, *Dreaming of Sunflowers: Museum Poems*, won the Blue Light Poetry Prize. Day is also the author of a children's book, *Chain Letter*, and a memoir, *Married at Fourteen: A True Story*, which received a PEN Oakland Josephine Miles Literary Award and was a finalist for the Northern California Book Award in Creative Nonfiction. Her poems, short stories, and essays have appeared widely in magazines and anthologies and she is founder and director of a small press, Scarlet Tanager Books. She is of Wampanoag, British, and Swiss/German descent, and recently published an anthology entitled *Red Indian Road West: Native American Poetry from California* with Lakota poet Kurt Schweigman.

Susan Deer Cloud is a Catskill Mountain Indian and a recipient of a National Endowment for the Arts Literature Fellowship, two New York State Foundation for the Arts Poetry Fellowships, and an Elizabeth George Foundation Grant. Some of her books are *Hunger Moon*, *Braiding Starlight*, *Fox Mountain*, *Car Stealer*, and *The Last Ceremony*; even so, she still relishes oral storytelling. As part of her devotion to getting out the "voices of the voiceless," Deer Cloud has edited three anthologies, *Confluence* and *I Was Indian (Before Being Indian Was Cool): An Anthology of Native American Literature I & II*, and also edits the Re-Matriation Chapbook Series of Indigenous Poetry. Reel Indian Pictures producer **Ramona Emerson** is a Diné writer and filmmaker. She has worked as a professional videographer, writer, and editor for over twenty years. Ramona is a Sundance Native Filmmakers Lab Fellow, a Time Warner Storyteller Fellow, and a graduate of the 2013 CPB/PBS Producers Academy at WGBH Boston. She is working on her novel *Shutter*, and is currently in production on her documentary *The Mayor of Shiprock*, which has been funded by Vision Maker Media/CPB/PBS. Emerson also received a Tribeca All Access grant for a new media/app design for The Shiprock Experience, a companion and community development project being created alongside the documentary.

Ojibwe enrolled at Turtle Mountain, **Heid E. Erdrich** is the author of four collections of poetry including *Cell Traffic*, but her most recent book is a work of nonfiction , *Original Local: Indigenous Foods, Stories, and Recipes from the Upper Midwest*. Her writing has won awards from the Minnesota State Arts Board, Bush Foundation, Loft Literary Center, and First People's Fund. Her book *National Monuments* won the Minnesota Book Award. In 2013 she was named a City Pages Artists of the Year. Heid's poem-films have been screened widely at festivals and have won a Judges Award, a Best of Fest, and a Best Experimental Short award. She is an independent scholar and curator, a playwright, and founding publisher of Wiigwaas Press, an Ojibwe-language publisher.

Louise Erdrich has written novels, nonfiction, children's books, and poetry. Her book *Plague of Doves* was a finalist for the Pulitzer Prize. Her latest book, *The Round House*,

received the National Book Award. She is the owner of Birchbark Books and is a member of the Turtle Mountain Band of Chippewa in North Dakota.

Jennifer Elise Foerster is the author of *Leaving Tulsa* and a recipient of a Lannan Foundation Writing Residency Fellowship. She was also a Wallace Stegner Fellow in Poetry at Stanford University. Of German, Dutch, and Muscogee descent, Jennifer is a member of the Muscogee (Creek) Nation of Oklahoma.

Eric Gansworth (Onondaga), a writer and visual artist from the Tuscarora Nation, is Lowery Writer-in-Residence at Canisius College. His books include *If I Ever Get Out of Here*, *Extra Indians* (American Book Award), and *Mending Skins* (PEN Oakland Award). Gansworth has had numerous art shows and has been widely published.

Diane Glancy (Cherokee, English/German) is a professor emerita at Macalester College. Her newest books are *Fort Marion Prisoners and the Trauma of Native Education* (creative nonfiction), *Report to the Department of the Interior* (poetry), and three novels, *Uprising of Goats*, *One of Us*, and *Ironic Witness*. Glancy has received a Lifetime Achievement Award from the Native Writers' Circle, two National Endowment for the Arts Fellowships, a Minnesota Book Award, an Oklahoma Book Award, an American Book Award, and a Sundance Screenwriting Fellowship. In 2013, Glancy finished her second independent film, *Four Quarters*, about the effect of education on Native Americans.

Jewelle "Still Water" Gomez (Cape Verdean/Ioway/Wampanoag) was raised by her mixed-race great-grandmother, Gracias Archelina Sportsman Morandus, in Boston in the 1950s and '60s. She was proud to be given her Wampanoag name in 2005 in tribute to her forebears. Her fiction, poetry, and plays reflect her multiethnic, lesbian, and feminist perspective. She is the author of three produced plays and seven books, including the cult favorite vampire novel *The Gilda Stories*, winner of two Lambda Literary Awards.

Rain Prud'homme-Cranford Goméz is a Louisiana mestiza (Louisiana Creole-Choctaw-Biloxi/Mvskogean descent) specializing in Native and Creole cultural and rhetorical studies. She is the former University of Oklahoma Sutton Doctoral Fellow in English and winner of the First Book Award in Poetry from Native Writers' Circle of the Americas for *Smoked Mullet Cornbread Crawdad Memory*. Her critical work has appeared in *American Indian Culture and Research Journal*, *Southern Literary Journal*, *Louisiana Folklife*, *Mississippi Quarterly*, and *Undead Souths: The Gothic and Beyond*, while her creative work can be found in various journals including *Tidal Basin Review*, *Natural Bridge*, *Sing: Poetry from the Indigenous Americas*, *Mas Tequila Review*, *Yellow Medicine Review*, and many others.

Sequoyah Guess is a full-blood Cherokee, an enrolled member of the United Keetoowah Band of Cherokee Indians, and a descendent of the original Sequoyah who, in the early nineteenth century, developed the syllabary—the Cherokee writing system. He is a traditional storyteller and filmmaker in addition to being the author of many books including seven novels, a short story collection, and a language guide: *Kholvn*, *U'ktan: The Ancient One*, *Gramma's Stories and Others I've Heard*, *Something in the Light*, *Blood Law*, *Red Eye*, *Practical Keetoowah/Cherokee*, *Sgili*, and *Nocturne*. Guess is officially recognized as a Tradition Keeper for the United Keetoowah Band.

Q. R. Hand Jr. is of African, European, Sri Lankan, and Cherokee descent. He worked with the Northern Student Movement in north Philadelphia and central Harlem in the mid-1960s and received training in antipoverty programs in Ohio, New York, and California. Since his retirement as a community mental health worker he has continued writing and reading/performing with the Wordwind Chorus and the Revolutionary Poets Brigade in the San Francisco Bay Area.

Joy Harjo of the Mvskoke Nation is an acclaimed poet, musician, writer, and performer. Her seven books of award-winning poetry include *She Had Some Horses*, *The Woman Who Fell from the Sky*, and her newest, *Conflict Resolution for Holy Beings*. Her awards include the New Mexico Governor's Award for Excellence in the Arts, a

Rasmussen US Artists Fellowship, the William Carlos Williams Award from the Poetry Society of America, and a Guggenheim Fellowship. She has been featured on HBO's *Def Poetry Jam,* the *News Hour with Jim Lehrer*, and a Bill Moyers series on poetry. She has released four albums and won a NAMMY for Best Female Artist. Her one-woman show, *Wings of Night Sky, Wings of Morning Light*, premiered in Los Angeles and will soon be in book form. She has a commission from the Public Theater of NYC to write the musical play *We Were There When Jazz Was Invented*, which will revise the origin story of American music to include Southeastern indigenous music. She travels internationally to perform solo and with her band Joy Harjo and the Poetic Justice Revival. Harjo is also at work on a new album and is the vice president of the Mvskoke Arts Association. She teaches part-time at the University of Illinois, Urbana-Champaign.

Lance David Henson is the author of twenty-eight books of poetry and recently won the Ostana International prize in Italy for his translations of poetry from the Cheyenne language. He is a member of the Cheyenne Dog Soldier Society, a martial artist, and a member of the Native American Church. Henson has participated in the Cheyenne Sun Dance for thirty-two years. He is a member of the Hall of Fame of Oklahoma College of Liberal Arts and an adjunct professor at the Cheyenne Tribal College in Weatherford, Oklahoma.

Poet, mosaic artist, author, blogger, and award-winning journalist **Trace L. Hentz** (formerly DeMeyer) is the former editor of the *Pequot Times* in Connecticut and editor/cofounder of *Ojibwe Akiing* in Wisconsin. Her writing, interviews, and poetry have been published in newspapers and journals in the United States, Canada, and Europe. A mix of American Indian (Shawnee-Cherokee), French Canadian, and Irish, her books include *One Small Sacrifice, Unraveling the Spreading Cloth of Time: Indigenous Thoughts Concerning the Universe, Sleeps with Knives* (writing as Laramie Harlow), *Becoming* (as Laramie Harlow), *Two Worlds,* and *Called Home.* Hentz also founded Blue Hand Books as a publishing collective for other Native authors.

She has contributed to many acclaimed books on adoption and has been a presenter and panelist at the American Indian Workshop in Europe and numerous universities in the United States and Canada.

Scholar, poet, and visual artist **Inés Hernández-Avila** is a professor of Native American studies at the University of California, Davis. She is Nimipu (Nez Perce), enrolled on the Colville Reservation in Washington, and Tejana, and one of the founders of the Native American and Indigenous Studies Association (NAISA). Hernández-Avila has been awarded a number of honors including an American Council of Learned Societies fellowship. Her most recent publication (coedited with Norma E. Cantú) is *Entre Guadalupe y Malinche: Tejanas in Literature and Art.*

Charles Allan "Charlie" Hill (1951–2013) was born in Detroit, Michigan, of Oneida-Mohawk and Cree ancestry. In 1962 he moved to the Oneida Reservation with his family. He majored in speech and drama at the University of Wisconsin and performed with the Broom Street Theatre Group. He left college for Los Angeles to become a stand-up comedian. As an actor, writer, and the first Native American stand-up comedian, he combined humor with social commentary and political activism. His numerous credits included *The Richard Pryor Show, The Tonight Show with Johnny Carson, The Tonight Show with Jay Leno*, and the Emmy-nominated *On and Off the Res' with Charlie Hill.*

Roberta J. Hill, who has also published under the name Roberta Hill Whiteman, is an Oneida poet, fiction writer, and scholar. She is a professor of English and American Indian Studies and is affiliated with the Nelson Institute for Environmental Studies at the University of Wisconsin, Madison. Her poetry collections include *Star Quilt, Her Fierce Resistance, Philadelphia Flowers*, and her newest collection, *Cicadas: New and Selected Poetry.* Her poetry has appeared in many magazines, journals, and anthologies, including *Sing: Poetry from the Indigenous Americas.* Her short fiction has appeared in *The Deadly Writers' Patrol, Crossing Rivers, Crossing Worlds: The African Diaspora in Indian Country*, and *Powwow: American Short Fiction from*

Then to Now. She has read poetry and presented scholarship throughout the United States, Canada, Australia, New Zealand, Brazil, Colombia, Portugal, and China.

Geary Hobson is a professor of English at the University of Oklahoma and is affiliated with its Native American studies program. He is the author of a number of scholarly monographs and the novel *The Last of the Ofos*. He has also published poems, short stories, critical articles, book reviews, and historical essays in the *Greenfield Review, Arizona Quarterly, Contact/II, Western American Literature, World Literature Today, Y'Bird*, and other journals. Among his current projects are *The Literature of Indian Country*, a critical and historical study of Native American writing and publishing from 1968 to 1992; a second novel; a second book of poems; and a second collection of essays and other nonfiction.

Linda Hogan (Chickasaw) is a member of the faculty at the Indian Arts Institute, a former Writer in Residence for the Chickasaw Nation, and a professor emerita of the University of Colorado. Hogan is an internationally recognized public speaker and writer of poetry, fiction, and essays. Her recent books include *Dark. Sweet, Indios, Rounding the Human Corners*, and the well-regarded novel *People of the Whale*. Her other books include the novels *Mean Spirit*, a winner of the Oklahoma Book Award, the Mountains and Plains Book Award, and a finalist for the Pulitzer Prize; *Solar Storms*, a finalist for the International Impact Award; and *Power*, also a finalist for the International Impact Award in Ireland. In poetry, *The Book of Medicines* was a finalist for the National Book Critics Circle Award. Her other poetry has received the Colorado Book Award, a Minnesota State Arts Board Grant, an American Book Award, and a prestigious Lannan Fellowship. In addition, she has received a National Endowment for the Arts Fellowship, a Guggenheim Fellowship, a Lifetime Achievement Award from the Native Writers' Circle of the Americas and the Wordcraft Circle, and the Mountains and Plains Booksellers Spirit of the West Literary Achievement Award. Her most recent awards have been the 2016 Thoreau Prize from PEN and the Native Arts and Culture Award. Hogan was inducted into the Chickasaw Nation Hall of Fame in 2007.

Eidson Distinguished Professor of American Literature at the University of Georgia **LeAnne Howe** is the author of novels, plays, poetry, screenplays, and scholarship that deal with Native experiences. A Choctaw Nation of Oklahoma citizen, her latest book, *Choctalking on Other Realities*, won the inaugural MLA Prize for Studies in Native American Literatures, Cultures, and Languages. She received the Western Literature Association's Distinguished Achievement Award for her work. Howe's other awards include a Fulbright Scholarship, the Lifetime Achievement Award from the Native Writers' Circle of the Americas, and a United States Artists Ford Fellowship. Howe's current projects include a new book, *Savage Conversations*, and a novel set in the Middle East.

Andrew Jolivétte, professor and chair of the American Indian studies department at San Francisco State University, is an accomplished educator, writer, speaker, and sociocultural critic. He is the author of five books, including *Research Justice: Methodologies for Social Change* and *Indian Blood: HIV and Colonial Trauma in San Francisco's Two-Spirit Community*. Jolivétte's writing has been featured in the *American Indian Cultural and Research Journal, Ethnic Studies Review Journal, Yellow Journal of Medicine, Journal of Critical Mixed Race Studies*, and several anthologies. A Creole of Opelousa, Choctaw, Atakapa-Ishak, French, African, and Spanish descent, Jolivétte is the former tribal historian for the Atakapa-Ishak Nation located between southwest Louisiana and southeast Texas.

em jollie edits two print journals (*Naugatuck River Review* and *The Silkworm*) and one online journal (*Toe Good Poetry*). Her work has appeared in *Yellow Medicine Review, Blue Earth Review, Jellyfish Review*, and other various publications. She has a chapbook, *Giveaway Poems*, a forthcoming chapbook titled *A Field Guide to Falling*, and is working on a full-length manuscript. Braided through jollie's DNA are nine different lineages, a number of which are Euro-American and several of which are indigenous; she thus identifies as a full-blood breed, a modern Métis, an irreverently complex mix of human . . . one who is here to honor and celebrate Beauty.

Joan Naviyuk Kane is the author of *The Cormorant Hunter's Wife*, *Hyperboreal*, and *The Straits*, for which she has received the Whiting Award, the Donald Hall Prize in Poetry, an American Book Award, the Alaska Literary Award, and fellowships from the Rasmuson Foundation, the Native Arts and Cultures Foundation, and the School for Advanced Research. Inupiaq with family from King Island and Mary's Igloo, she raises her sons in Anchorage, Alaska, and is an MFA faculty member at the Institute of American Indian Arts in Santa Fe, New Mexico.

Maurice Kenny, well-known poet and fiction writer, is an emeritus Writer in Residence at the State University of New York at Potsdam. His epic *Tekonwatonti: Molly Brant (1735–1795)* remains in print and he recently coedited *Adirondack Reflections* and *North Country Reflections*. Kenny was inducted into the New York State Writers Hall of Fame in 2014.

Bruce King is an accomplished Santa Fe painter, musician, director, screenwriter, and playwright born on the Oneida Reservation outside Green Bay, Wisconsin.

Multiple Pushcart Prize nominee **Sharmagne Leland-St. John** (of Colville and Spokane descent) is a lyricist, artist, and filmmaker. Her collections of poetry include *Silver Tears and Time*, *Contingencies*, and *Cradle Songs*.

Chip Livingston is the mixed-blood Creek author of the short story/essay collection *Naming Ceremony* and two poetry collections, *Crow-Blue, Crow-Black* and *Museum of False Starts*. His creative writing has appeared recently or is forthcoming in *Ploughshares*, *Prairie Schooner*, *New American Writing*, *Indian Country Today*, *Mississippi Review*, *Florida Review*, and on the Poetry Foundation website. Livingston is on the creative nonfiction faculty of the Low Rez MFA program at the Institute of American Indian Arts in Santa Fe and on the poetry faculty of the Mile High MFA program at Regis University in Denver.

Charly Lowry is a singer-songwriter from Pembroke, North Carolina, with roots in the Union Chapel Community. As a college student, Charly fronted Mr. Coffee and the Creamers, a Motown/soul cover band and that experience was a catalyst for her to begin the journey of living as a musician. For over a decade, Charly has attained regional and national success as both a solo artist and lead singer of the alternative rock/soul/folk band Dark Water Rising. In addition to performing with Dark Water Rising and The Ulali Project, she often shares the stage with funk/soul band The New Mastersounds. In 2004, Charly had the opportunity to compete on *American Idol*, where she ventured through several rounds of auditions to make it to the Top 32 performers that season. Charly has served as a Lumbee ambassador for the Lumbee people, traveling throughout the country to attend various conferences, powwows, and other gatherings.

Internationally renowned performance and installation artist **James Luna** (Puyukitchum/Luiseño) resides on the La Jolla Indian Reservation in California. Since 1975, he has had over forty-one solo exhibitions, participated in eighty-five group exhibitions, and has performed internationally at venues that include the Museum of Modern Art (NYC), Whitney Museum of American Art, New Museum of Art, San Francisco Museum of Art, Museum of Contemporary Art San Diego, Los Angeles County Museum of Art, National Gallery of Canada, and the Museum of Contemporary Native Art. He has received numerous grants and awards and was selected as the first Sponsored Artist of the Smithsonian's National Museum of the American Indian presented at the Venice Biennale's 51st International Art Exhibition in Venice, Italy.

Lee Marmon is noted for his portraits of New Mexico's Pueblo people and their ancient dwelling sites. Born in Laguna Pueblo, Marmon was encouraged by his father to pursue photography by recording their neighbors. Marmon's career has taken him around the world to London, Prague, New York, and Palm Springs, California, as the official photographer for the annual Bob Hope Desert Classic for seven seasons. He has served many of the Indian tribes in the United States as recorder of their economic progress, their culture, their tribal governments, and family events. Marmon worked with the Acoma and Zuni Pueblos, and helped with the founding of the Indian Pueblo Cultural

Center. His most recent book publication is *Laguna Pueblo: A Photographic History*.

Molly McGlennen was born and raised in Minneapolis, Minnesota, and is of Anishinaabe and European descent. An associate professor of English and Native American studies at Vassar College, she is the author of a collection of poetry, *Fried Fish and Flour Biscuits*, and a critical monograph, *Creative Alliances: The Transnational Designs of Indigenous Women's Poetry*, which earned the Beatrice Medicine Award for outstanding scholarship in American Indian literature.

Actor, writer, artist, musician, and activist **Russell Means** (1939–2012) had a long and dynamic career as a public figure. An Oglala Lakota (Sioux), Means was involved in the famous Alcatraz Island (1969–1971) and Wounded Knee (1973) occupations as a member of the American Indian Movement (AIM) and went on to champion a number of libertarian political causes. He published his autobiography, *Where White Men Fear to Tread*, in 1995.

An enrolled member of the Ohlone-Costanoan Esselen Nation of California, poet **Deborah Miranda** was born in Los Angeles to an Esselen/Chumash father and a mother of French ancestry. Miranda's poetry collections include *Indian Cartography*, winner of the Diane Decorah Memorial First Book Award from the Native Writers' Circle of the Americas, and *The Zen of La Llorona*, nominated for a Lambda Literary Award. Miranda also received a Writer of the Year Award for Poetry from the Wordcraft Circle of Native Writers and Storytellers. Her mixed-genre collection *Bad Indians: A Tribal Memoir* won a Gold Medal from the Independent Book Publishers Association and was shortlisted for the William Saroyan Award.

The author of *Bone Songs*, **Gail Mitchell** is a poet living in San Francisco.

Of Kiowa and Cherokee ancestry, **N. Scott Momaday** won the Pulitzer Prize for Fiction in 1969 for his novel *House Made of Dawn*. He is the author of a wide range of notable books including *The Way to Rainy Mountain*.

Catherine Nelson-Rodriguez lives and is enrolled on the La Jolla Indian Reservation. She is a self-taught artist and oil is her preferred medium, but she also creates Native images, portraits, clay figurines, jewelry, and tribal basketry. Nelson-Rodriguez was awarded the Lassen County Arts Council Fellowship and has had numerous art exhibits, both group and solo. The Indian Health Council commissioned her to design a logo for the Peace Between Partners program. Nelson-Rodriquez's work is in the collections of the Smithsonian Institute and the Museum of the American Indian.

Linda Noel is of Koyungkowi (Konow) descent, from the northern Sierra region of Plumas, Yuba, and Butte counties in California. She grew up in Mendocino County and resides in Ukiah, where she is a poet laureate emeritus. Noel has a chapbook titled *Where You First Saw the Eyes of Coyote* and her poetry has been included in many anthologies.

dg nanouk okpik is an Inupiaq- Inuit from the Arctic Slope in Barrow, Alaska. okpik's work has been published in a wide range of journals and anthologies. Her first full-length book, *Corpse Whale*, received the Before Columbus Foundation's American Book Award.

Acoma Pueblo poet and writer **Simon J. Ortiz** is the Regents Professor of American Indian Studies and English at Arizona State University. His many books include *Woven Stone*, *Out There Somewhere*, *From Sand Creek*, *Beyond the Reach of Time and Change* (editor), *After and Before the Lightning*, *The Good Rainbow Road*, and *Men on the Moon*. Ortiz has been the recipient of awards from the National Endowment for the Arts and honors including the New Mexico Humanities Council Humanitarian Award, the Lila Wallace-Reader's Digest Writers' Award, a Lifetime Achievement Award from the Returning the Gift Festival of Native Writers, a Lifetime Achievement Award from the Western States Arts Federation, and the Golden Tibetan Antelope Prize for International Poetry. He is a member of the advisory boards for *Black Mountain Review* and *Malpais Review* and also serves as program manager and managing editor for *RED INK: An International Journal of Indigenous Literature, Art, & Humanities*.

Laura Ortman (White Mountain Apache) is a Brooklyn composer, musician, and visual artist. She has performed, recorded, and toured with New York bands Stars Like Fleas and The Dust Dive, among many others. She founded The Coast Orchestra, a Native American orchestral ensemble, which has performed the 1914 original score to photographer Edward Curtis's film *In the Land of the Head Hunters* to sold-out audiences at the National Gallery of Art in Washington, DC, and the American Museum of Natural History in New York. Ortman's most recent solo album is *My Soul Remainer*.

Writer A. Kay Oxendine is from the Haliwa-Saponi tribe and has worked as a newspaper owner, editor, graphic artist, and public radio host.

A former administrator at Comanche Nation College, Juanita Pahdopony has been published in a variety of academic/scholarly, poetry, and local, state, and national storytelling venues. She is a passionate advocate for tribal language preservation, culturally relevant education for children, and the protection of our planet's resources and animals.

Mary Grace Pewewardy (Hopi/Comanche/Kiowa/Assiniboine) is an undergraduate studying English writing and Native American Studies at the University of Oklahoma. She is an active participant in tribal cultural events and ceremonies. After graduation, she wishes to become an English teacher at reservation schools, helping to promote education to the younger Native American generation.

Evan T. Pritchard, of Mi'kmaq and Celtic descent, is a poet and author of over thirty books, including *No Word for Time*, *Native New Yorkers*, *Henry Hudson and the Algonquins of New York*, *Native American Stories of the Sacred*, *Bird Medicine*, and *Greetings from Mawenawasic!*. Pritchard is the founder of the Center for Algonquin Culture and lectures throughout the Northeast. He is a recent recipient of the Helen Wilkinson Reynolds Award for Excellence in History by the Dutchess County (New York) Historical Society.

Singer-songwriter Martha Redbone (Cherokee/Shawnee/Choctaw/African American descent) performs, educates, and lectures worldwide. Her albums include *Skintalk*, *Home of the Brave*, *News from Indian Country*, and *The Garden of Love: The Songs of William Blake*. A recipient of the New England Foundation for the Arts Award for Creation, Development, and Touring; and the Native Arts and Cultures Foundation Fund, Redbone is a member of WhyHunger.org's Artists Against Hunger and Poverty program and is on the advisory board of the ManUp Campaign, a global initiative to end violence against women and girls.

Ishmael Reed, professor emeritus at the University of California, Berkeley, and founder of the Before Columbus Foundation, which promotes multicultural American writing, is the author of thirty titles including the novel *Mumbo Jumbo*, as well as essays, plays, and poetry. Reed is the winner of a MacArthur Fellowship, the *Los Angeles Times* Robert Kirsch Lifetime Achievement Award, and the Lila Wallace-Reader's Digest Writers' Award. He has also been nominated for a Pulitzer and was a finalist for two National Book Awards.

Bobby J. Richardson, a member of the Haliwa-Saponi tribe, served eleven years in US Army Military Intelligence as a Russian linguist, three years as an undercover investigator, twenty years as a self-employed computer and networking systems consultant, and is currently embarked upon various misadventures in acting and independent filmmaking.

Ladonna Evans Richardson is a member of the Haliwa-Saponi tribe and has served her people as a member of the tribal council for the past five years. She loves the written word and feels an urgency to tell others "our story" through her poetry and other writings.

Mary Jean Robertson is the host of the longest-running Native radio program still on the air: *Voices of the Native Nation* on San Francisco's KPOO most Wednesday nights. She has been involved in many of the arts advocacy and Native political issues that have made their way to the Bay

Area. Mary Jean is currently working with others to put together a Native Cultural Center in San Francisco.

An Eastern Tsalagi (Cherokee), **Barbara Robidoux** is the author of two books of poetry: *Waiting for Rain* and *Migrant Moon*. Her poetry has also been published in the *Santa Fe Literary Review*, *Ribbons*, *American Tanka*, *Atlas Poetica*, *Hinchas de Poesia*, *Off the Coast*, and *Santa Fe Poetry Broadside*. Her fiction has appeared in *Yellow Medicine Review*, *Santa Fe Literary Review*, and the *Denver Quarterly*.

Linda Rodriguez's Skeet Bannion mystery novels, *Every Hidden Fear*, *Every Broken Trust*, and *Every Last Secret*, and books of poetry, *Skin Hunger* and *Heart's Migration*, have received many awards including the St. Martin's/Malice Domestic Best First Traditional Mystery Novel, the Latina Book Club Best Books 2014 Award, the Midwest Voices and Visions Award, the Elvira Cordero Cisneros Award, and the Thorpe Menn Award for Literary Excellence. She has also received Ragdale and Macondo fellowships. She was the 2015 Chair of the AWP Indigenous/Aboriginal American Writers Caucus and is a founding board member of Latino Writers Collective and The Writers Place, a member of Wordcraft Circle of Native American Writers and Storytellers, and part of the Kansas City Cherokee Community.

Wendy Rose retired from Fresno City College where she taught in the American Indian Studies Program for many years. She makes jewelry as Laughing Lizard Woman and sells it in her shop Oh Grow Up. Her many books of poetry include *Lost Copper*, *Now Poof She Is Gone*, and *Itch Like Crazy*. Rose explains that she gets "pigeonholed as an 'Indian poet' but there is nothing about my work that could be described as traditionally 'Indian.' I never lived on a reservation, never attended a BIA boarding school, and do not speak the language of my Hopi father. Much of the inner impetus to write is around the question: So what exactly makes me Native other than chromosomes?"

Self-taught poet **Kurt Schweigman** is an enrolled member of the Oglala Sioux (Lakota) tribe. His poetry appears in *Shedding Skins: Four Sioux Poets*. Schweigman was a featured poet at the Geraldine R. Dodge Poetry Festival and a recipient of an Archibald Bush Foundation individual artist fellowship in literature. He has won poetry slam competitions from California to Germany. In the past, Schweigman has published and performed as Luke Warm Water.

Kim Shuck is a poet and bead artist who has been published and shown in Asia, South America, and Europe, as well as all over North America. She served on the board of directors for California Poets in the Schools and has taught poetry from the elementary school level to the university level. She is the winner of the 2005 Diane Decorah award for her 2006 collection *Smuggling Cherokee* and her most recent collection of poems is *Clouds Running In*.

Cedar Sigo was raised on the Suquamish Reservation in the Pacific Northwest and studied at the Jack Kerouac School of Disembodied Poetics at the Naropa Institute. He is the author of eight books and pamphlets of poetry, including *Language Arts*, *Stranger in Town*, *Expensive Magic*, and two editions of *Selected Writings*.

Novelist, poet, storyteller, essayist, and photographer **Leslie Marmon Silko** is the recipient of many major awards including a Pushcart Prize and the MacArthur "Genius Grant." Her ancestry is a mix of Laguna Pueblo, Mexican, and Anglo-American. She is the author of many books including *Laguna Women*, *Ceremony*, *Storyteller*, *Almanac of the Dead*, and *Sacred Water: Narratives and Pictures*.

An enrolled member of the Kickapoo tribe of Oklahoma, **Arigon Starr** is a multitalented and multi-award winning musician, actress, playwright, and artist. Her comic *Super Indian* was originally produced as a nationally broadcast radio comedy series for the Native Radio Theater Project and Native Voices at the Autry. She penciled, inked, colored, and lettered the web-comic version of *Super Indian* and has published two compilation volumes of this work along with *Tales of the Mighty Code Talkers* comics. Starr is a founder of the Indigenous Narratives Collective (INC), a group of Native American comic book writers and artists.

James Thomas Stevens, Aronhiótas (Akwesasne Mohawk) is the author of eight books of poetry including *Combing the Snakes from His Hair, Mohawk/Samoa: Transmigrations, A Bridge Dead in the Water, The Mutual Life, Bulle/Chimére, (dis)Orient*, and *Ohwistanóron Niwahsohkòten* (The Golden Book). He is a Whiting Award recipient and teaches in the creative writing department at the Institute of American Indian Arts in Santa Fe, New Mexico.

Poet and ethnographer **Inés Talamantez** (Mescalero Apache) is an associate professor of religious studies at the University of California, Santa Barbara, where she is also affiliated with the women's studies and Latin American studies programs. Among her many publications, she is coeditor of *Teaching Religion and Healing*.

The inaugural poet laureate of the Navajo Nation, **Luci Tapahonso** is a professor of English literature and language at the University of New Mexico. She has been awarded the Lifetime Achievement and Storyteller of the Year awards from the Native Writers' Circle of the Americas along with a Distinguished Woman award from the National Association of Women in Education. Tapahonso's publications include the collections *Blue Horses Rush In* and *A Radiant Curve*.

Cecil Percival Taylor is a musician and poet known for his pathbreaking free jazz compositions. The pianist and composer has been awarded a Guggenheim Fellowship and has long been a member of *Down Beat* magazine's Critics Poll Hall of Fame.

Nazbah Tom is Diné, born and raised on their ancestral homelands in northeastern Arizona. They are published in *Turtle Island to Abya Yala: A Love Anthology of Art and Poetry by Native American and Latina Women* and *Passage & Place: Displacement & Movement, Freedom & Incarceration, Home & Im/Migration at the Intersection of Queerness*. Their first CD of poetry, *Language Nest*, is out now and they are currently working on a biospiritual allegorical play called "Sacred Script" that explores and deconstructs *dilbaa*, the

masculine presenting women of the Diné, as well as "SheepChronicles," poetry woven into folded paper, watercolor, and wool.

Rebecca Hatcher Travis is an enrolled citizen of the Chickasaw Nation. Her poetry book *Picked Apart the Bones* won the First Book Award from the Native Writers' Circle of the Americas. Her work has appeared in numerous anthologies, literary journals, and online. Ms. Travis, a member of Wordcraft Circle of Native Writers and Storytellers, resides near the land her ancestors settled in Indian Territory days.

David Treuer is Ojibwe from Leech Lake Reservation. He is the author of six books—four novels and two works of nonfiction. His most recent novel is *Prudence*.

Terra Trevor, of Cherokee, Delaware, and Seneca descent, is an essayist, memoirist, nonfiction and short story writer. She values the collective experience and has collaborated with other Native writers and is a contributing author of ten books, including *The People Who Stayed: Southeastern Indian Writing After Removal*, and the memoir *Pushing up the Sky*. Within the Wordcraft Circle of Native Writers and Storytellers mentoring core she helps beginning and emerging writers refine their skills.

Professor emeritus from the University of California, San Diego, **Quincy Troupe** is the author of twenty books, including ten volumes of poetry and three children's books. His awards include the Paterson Award for Sustained Literary Achievement, the Milt Kessler Poetry Award, three American Book Awards, the 2014 Gwendolyn Brooks Poetry Award, and a 2014 Lifetime Achievement Award from Furious Flower. Troupe recently released the book of poems *Errançities*, and is coauthor of *Miles: The Autobiography of Miles Davis; Earl the Pearl* with Earl Monroe, *The Pursuit of Happyness* with Chris Gardner, and the editor of *James Baldwin: The Legacy*.

John Trudell (1946–2015) (Santee Sioux) was a spokesperson for the Indians of All Tribes occupation of Alcatraz

from 1969 to 1971 and served as chairman of the American Indian Movement (AIM) from 1973 to 1979. Trudell released a total of fourteen albums combining spoken-word poetry and music including *Tribal Voice*, and *AKA Graffiti Man*, recorded with Jesse Ed Davis. In addition to his recording career, Trudell appeared in feature and made for TV films including *Thunderheart*, *Smoke Signals*, and *Dreamkeeper*, and authored three books of poetry and an anthology of lyrics, *Lines from a Mined Mind*.

Gerald Vizenor is a professor emeritus of American studies at the University of California, Berkeley. He is a citizen of the White Earth Nation, and has published more than thirty books. Vizenor received an American Book Award for *Griever: An American Monkey King in China* and for *Chair of Tears*, the Western Literature Association Distinguished Achievement Award, and the Lifetime Achievement Award from the Native Writers' Circle of the Americas.

Elissa Washuta is a member of the Cowlitz Indian tribe and author of *My Body Is a Book of Rules* and *Starvation Mode*. She serves as adviser for the department of American Indian Studies at the University of Washington and is a faculty member in the MFA program at the Institute of American Indian Arts.

Floyd "Red Crow" Westerman (1936–2007) was a member of the Sisseton-Wahpeton Sioux tribe of South Dakota. As a musician and actor Red Crow performed all over the world, successfully incorporating music into his longtime career as an activist. Among his many accolades, Red Crow received the Award for Generosity by the Americans for Indian Opportunity, a Congressional Certificate of Special Recognition, and was named Cultural Ambassador by the International Indian Treaty Council.

Orlando White is Diné of the Naaneesht'ézhi Tábaahí and born for the Naakai Diné'e. White teaches at Diné College and at the Institute of American Indian Arts and is a past recipient of a Bread Loaf John Ciardi Fellowship, a Lannan Foundation Residency, and a Truman Capote Creative Writing Fellowship. White is the author of several collections of poetry including *Bone Light* and *LETTERRS*.

Kimberly Roppolo Wieser (Cherokee, Choctaw, and Creek descent) is an assistant professor of English and an affiliated faculty member with Native American studies at the University of Oklahoma. She is the director of Native Writers' Circle of the Americas and serves as president of the Board of Wordcraft Circle of Native Writers and Storytellers. She is the coauthor of *Reasoning Together: The Native Critics Collective*, named one of the most important books in her field in the first decade of the twenty-first century by the Native American and Indigenous Studies Association (NAISA). She has written and published poems, stories, articles, book reviews, and reference entries for anthologies and for a variety of academic publications and American Indian newspapers.

Diane Wilson is a Dakota (Mdewakanton/Rosebud) writer whose memoir, *Spirit Car: Journey to a Dakota Past*, won a Minnesota Book Award and was selected for the One Minneapolis One Read program. Her second book of creative nonfiction, *Beloved Child: A Dakota Way of Life*, was awarded the 2012 Barbara Sudler Award from History Colorado. Wilson's work has been featured in several anthologies, including *American Tensions*, *Fiction on a Stick*, and *Homelands: Women's Journeys Across Race, Place, and Time*. She has received awards from the Minnesota State Arts Board, the Jerome Foundation, and a 2013 Bush Foundation Fellowship. Wilson is the executive director for Dream of Wild Health, a nonprofit farm serving the urban American Indian community in the Twin Cities.

Elizabeth Woody is the author of three books of poetry—*Hand Into Stone*, *Luminaries of the Humble*, and *Seven Hands, Seven Hearts*. She is a recipient of an American Book Award, the William Stafford Memorial Award for Poetry, and a "Medicine Pathways for the Future" Fellowship/Kellogg Fellowship from the American Indian Ambassadors Program of the Americans for Indian Opportunity.

INDEX

POSTSCRIPT

I would like to quote a very prejudicial doctrine that was handed down by the Supreme Court in 1823. It said that the Indian Nations do not have title to their lands because they weren't Christians. That the first Christian Nations to discover an area of heathen lands has the absolute title. This doctrine should be withdrawn and renounced to establish a new basis for relationship between indigenous peoples and other peoples of the world.

Floyd "Red Crow" Westerman (Lakota First Nation)

ACKNOWLEDGMENTS

This anthology celebrates those resilient spirits who shared their stories, poems, humor, and heritage in *Tending the Fire*. My heartfelt gratitude extends to everyone who generously contributed to its creation.

Special recognition goes to Kim Shuck, Linda Hogan, Susan Deer Cloud, Kim Wieser, and Allison Hedge Coke for offering guidance and introductions on my behalf within their Native communities.

To these friends who provided cheer, counsel, and enlightenment, smoothing the path along the way: Tony Abeyta, Arthur Sze, Joyce Jenkins, David Amram, Kirk Anspach, Rick DePofi, Michael Richter, Jay Daniel / Black Cat Studio, Kathy Cooper, Jennifer Jerde, Helen MacLeod, Alan Woll, Susan Johnson, Barry Woll, Ann Wright, Craig Bishop, Jon Davis, Sue Kubly, Ann Ruhr Pifer, Jack Darrow, Marcia Bellavance, Mark Baldridge, Melton Magidson, Douglas Brinkley, Chris de Boschnek, Eva Reitspiesova, Rita Bottoms, Claire Anna Baker, Gueorgui Gueorguiev, David Magidson, Robert Berman, Faye Brown, and Mary Joyce Keenan.

Appreciation goes to Swell Design for the initial prototype, and especially to Regan Ural for her design skills, attention to detail, and invaluable support in bringing this book to fruition.

A most sincere accolade must go to Mike Kelly, director of the UNM Center for Southwestern Research, for introducing me to John Byram at UNM Press. John's constant encouragement and understanding coupled with his wicked sense of humor helped make *Tending The Fire* a magical ride. And lastly, I'd like to thank Managing Editor James Ayers and everyone at UNM Press.

ABOUT THE PHOTOGRAPHER

Christopher Felver's distinctive visual signature is a lasting contribution to the legacy of our national cultural community.

Felver's previous books are *The Late Great Allen Ginsberg*; *Seven days in Nicaragua Libre*; *The Poet Exposed*; *Ferlinghetti Portrait*; *Angels, Anarchists & Gods*; *The Importance of Being*; *Beat*; and *American Jukebox*. His photographs are distributed worldwide and collected by museums and university libraries and have been featured in international exhibitions at the Center Georges Pompidou in Paris, the Whitney Museum in New York, the National Theatre in London, the Torino Biennale Internazionale, the San Francisco International Film Festival, La Biennale di Venezia International Film Festival, MOCA, and Guild Hall.

The National Gallery of Art in Washington, DC, the New York Public Library, and the Museum of Fine Arts, Boston have presented retrospectives of his films: *John Cage Talks About Cows*; *Cecil Taylor: All the Notes*; *West Coast: Beat & Beyond*; *Taken by the Romans*; *Donald Judd's Marfa Texas*; *Tony Cragg: In Celebration of Sculpture*; and *Ferlinghetti: A Rebirth of Wonder*.

chrisfelver.com

© 2017 by Christopher Felver
All rights reserved.
Published 2017

Printed in China
22 21 20 19 18 17 1 2 3 4 5 6

Library of Congress
Cataloging-in-Publication Data

Names: Felver, Christopher, 1946– author. |
 Ortiz, Simon J., 1941–
Title: Tending the fire : Native voices and
 portraits / photographs by Christopher
 Felver ; foreword by Simon J. Ortiz ;
 introduction by Linda Hogan.
Description: Albuquerque : University of
 New Mexico Press, 2017. | Includes index.
Identifiers: LCCN 2016012011 | ISBN
 9780826356451 (cloth : alk. paper)
Subjects: LCSH: Indians of North America—
 Portraits. | Indian poets—United States—
 Portraits. | Indians of North America—
 Biography. | Indian poets—United
 States—Biography. | Indians of North
 America—Social life and customs. | Indians
 of North America—Poetry. | American
 poetry—Indian authors.
Classification: LCC E89 .F45 2017 | DDC
 970.004/97—dc23 LC record available at
 https://lccn.loc.gov/2016012011
Front cover: Louise Erdrich
Back cover: Floyd "Red Crow" Westerman

Designed by Lisa C. Tremaine
Composed in Scala Sans